From Adams to Stieglitz

Lotte Jacobi, *Nancy Newhall*, 1943

WRITERS AND ARTISTS ON PHOTOGRAPHY

NANCY NEWHALL

From Adams to Stieglitz

Pioneers of Modern Photography

INTRODUCTION BY BEAUMONT NEWHALL

Foreword by Michael E. Hoffman

APERTURE

Library of Congress Catalog number 88-082884
Hardcover ISBN 0-81381-372-9; Paperback ISBN 0-89381-373-7
The staff at Aperture for *From Adams to Stieglitz* is Michael E. Hoffman,
Executive Director; Steve Dietz, Editor; Emanuel Voyiaziakis, Assistant Editor;
Shelby Burt, Sarah Adams and Laura Allen, Editorial Work-Scholars; Stevan
Baron, Vice-President of Production. Book design by Wendy Byrne.

Series Editor: Steve Dietz Series design: Wendy Byrne

Aperture Foundation, Inc., publishes a periodical, books, and portfolios of fine
photography to communicate with serious photographers and creative people
everywhere. A complete catalogue is available upon request. Address: 20 East 23
Street, New York, NY 10010.

Contents

Photographs viii

Foreword ix

Introduction xi

Controversy and the Creative Concepts 1

Ansel Adams: The Eloquent Light 11

Brassaï 15

Alvin Langdon Coburn: The Youngest Star 23

Emerson's Bombshell 49

Helen Levitt: Photographs of Children 60

The Photo League 61

Alfred Stieglitz 65

Paul Strand: Photographs, 1915–1945 71

Edward Weston 79

Brett Weston 87

Minor White 93

Alfred Stieglitz: Notes for a Bibliography 97

The Caption: The Mutual Relation of Words/Photographs 135

Photography Is My Passion 145

Bibliography 163

Picture Credits 167

Index 169

Photographs

frontispiece, Lotte Jacobi, *Nancy Newhall*, 1943

1. Ansel Adams, *Mount Williamson—Clearing Storm*, 1945 xv
2. Henri Cartier-Bresson, *Seville, Spain*, 1933 xvi
3. Nancy Newhall, *Ansel Adams*, 1944 12
4. Nancy Newhall, *Brassaï and Beaumont Newhall*, 1956 16
5. Beaumont Newhall, *Alvin Langdon Coburn, Edith Coburn, Nancy Newhall*, Wales, 1952 22
6. *Dr. P. H. Emerson in his study*, 1925 50
7. *Photo Notes*, Spring 1950 62
8. Nancy Newhall, *Alfred Stieglitz and* Equivalents *at An American Place*, 1943 66
9. Beaumont Newhall, *Paul Strand photographing whale ship*, Mystic, Connecticut, 1946 70
10. Nancy Newhall, *Edward Weston*, 1940 78
11. Nancy Newhall, *Brett Weston*, New York, 1948 88
12. Nancy Newhall, *Minor White*, 1950 94
13. Ansel Adams, *Alfred Stieglitz and Nancy Newhall, An American Place*, New York City, 1944 96
14. Ansel Adams, from John Muir's *Yosemite and the Sierra Nevada* (1948) 134
15. Nancy Newhall, *Lake Eden*, Black Mountain College, 1946 146

Foreword

*It is, to state the matter generally, an irrational notion that the eye should
see virtue of something issuing from it; that the visual ray should extend it-
self all the way to the stars. . . . ARISTOTLE, Sense and Sensibilia*

NANCY NEWHALL was one of those rare people, a gifted writer willing to devote
her great talents to photography and to its most inspired practitioners. Aristotle
may have been the first to link light, vision, and soul. Nancy was one of the
historic few who successfully articulated how this can be done through photo-
graphy, through genius.

Images of light recur in the titles of her books—*Fiat Lux*, the grand collaboration
devoted to the University of California that she produced with Ansel Adams; *The
Flame of Recognition*, the brilliant memorial issue of *Aperture* that she produced
from Edward Weston's *Daybooks*, presenting a selection of his extraordinary photo-
graphs; and *The Eloquent Light*, the first part of her two-volume biography of
Ansel Adams. In all of her work Nancy was not simply writing about photography.
She was bringing her own vision, her own gift for truth—in short, her own
light—to explore and expand her chosen subject, and to strive to articulate the
fullest possible experience of the medium.

The work she was engaged in was both a challenge and an adventure in those
early days, just after the end of World War II. Most of this century's greatest
American photographers were alive and working—Paul Strand, Edward Weston,
Dorothea Lange, Imogen Cunningham, Brett Weston, Minor White, and Ansel
Adams. Nancy and her brilliant husband, Beaumont Newhall, were all too aware
that these artists had few avenues to the public, either through exhibitions or
publication. They knew that a foundation of excellent criticism was essential for
the appreciation of the artists' work, and indeed for an understanding of the
potential of the medium itself. Beaumont, of course, went on to become photo-
graphy's foremost historian while Nancy devoted her energies and skills to critical
and biographical studies.

To read this volume of her selected writings is to encounter a sensitive witness
to the unfolding of a great art form. Through her lucid prose she extends the
possibilities of seeing and of inner illumination. At all times, she is a superb
prose stylist and a delight to read.

Nancy's contributions went beyond writing and editing. Without her, there
would have been no Aperture—no periodical, no publishing program that to date
has produced about 300 titles to standards she would have demanded. She was

an Aperture founder in 1952, and an inspired friend of its first editor, Minor White. Those warm, spirited evenings in Nancy's and Beaumont's home in Rochester, New York, provided the germination for much that grew and developed in Aperture's pages.

On a personal note, I first discovered the possibilities of an extra dimension of photography—that inner awakening—from her Edward Weston memorial issue of *Aperture*. It was 1958 and I was sixteen. Six years later *Aperture* had abandoned publication. Largely because of Nancy's and Minor White's inspiration and encouragement, I undertook the heady task of renewing this unique communal venture.

Publishing *From Adams to Stieglitz* has been a labor of love for all of us at Aperture. Here is the work of a wonderfully generous writer, and I hope that it brings inspiration and pleasure. It could only have been accomplished with the generous guidance and support of Beaumont Newhall. Aperture's editor, Steve Dietz, has ensured its compilation and realization.

MICHAEL E. HOFFMAN
New York City, 1989

Introduction

Painter, poet, author, editor, photographer, museum curator—Nancy Newhall was a woman of great perception and many talents. In her passionate dedication to the survival of the earth and to the equality of all mankind, she was ahead of her time.

Nancy Newhall was born in Swampscott, a seaside town north of Boston, in 1908. As a student she contributed poems—in French as well as English—to the magazines of the preparatory schools she attended. She even translated Latin verse into English rhymed couplets. At Smith College she concentrated on creative writing, theater, and painting. For the *Smith College Monthly* she made woodcuts for its covers and illustrations.

After graduating in 1930, she attended the Arts Students League in New York. Her first one-person show of paintings at the Grace Horne Galleries in Boston in 1933 won high praise. The *Boston Herald* critic wrote:

> Not only does the young artist show command of her medium, but she also shows an amazing sureness of touch. She draws exceedingly well. She is capable of filling a small canvas with brilliant sunshine without resorting to tricks. Her shadows are vibrant with illumination.

We first met in 1933, when I was a graduate student at Harvard University and she was living in nearby Swampscott. Our common interest in art drew us together and led to our marriage in 1936. I was then on the staff of the Museum of Modern Art, New York, and was preparing a large—850 print—exhibition of the history of photography. Our honeymoon was a trip to Europe seeking loans for the show from photographers, private collectors, and museums.

Photography 1839-1937, the first exhibition of the history of photography to be held in an American art museum, was a great success; it paved the way for the founding of a Department of Photography at the museum in 1940.

I was appointed curator of photography and a Photography Committee was formed, with David H. McAlpin, a trustee and generous benefactor, as the chairman, and Ansel Adams as the vice-chairman. I spent ten weeks working with Ansel in New York to inaugurate the new department, which we announced with an exhibition. He became a close friend and colleague, and both introduced Nancy to Alfred Stieglitz and encouraged her to write Stieglitz's biography. For more than two years Nancy kept detailed notes of her many conversations with Stieglitz.

In 1942 I was commissioned first lieutenant in the Army Air Corps and served in the Mediterranean Theatre of War for two and a half years. Nancy offered to serve as a substitute curator during my absence from the museum. She was, somewhat reluctantly, appointed assistant in charge of photography, and later acting curator.

A Photography Center was established in a nearby mansion lent to the museum by a trustee. The museum's collection of over 2,000 photographs — old and new — was housed there as well as a library of books on photography. The Center was free to all and became very popular. To Nancy's surprise, a friend of ours, Willard D. Morgan, editor and publisher of photography books, was appointed director of photography. His tenure was short; on May 1, 1944, he resigned, and the full responsibility of the Center fell on Nancy.

She organized several small exhibitions, a program of lectures and a workshop by Ansel Adams, and a symposium of photographic critics. It is sad to relate that the Photographic Center was forced to close in June 1944 because the mansion had been sold by the owner. The collection of photographs and books was moved to the already overcrowded library of the museum's main building.

To celebrate its fifteenth anniversary, the museum held the largest exhibition in its history: "A general survey of the living arts," to quote the catalog. Each department put on show the choicest works of art in its collection. Nancy wrote me, "The show should be the crowning show of shows for us and our work and faith." It was a large exhibition of 274 photographs, mostly from the permanent collection. At the opening it won high praise. Nancy proudly sent me a copy of a letter she had received from Stephen C. Clark, the chairman of the museum's board:

> The photographic section of Art in Progress does honor to the Department. It is well thought out and excellently installed. On behalf of the Trustees I wish to express our appreciation and to thank you.

Nancy also organized and installed two retrospectives: one of Paul Strand and the other of Edward Weston. Although the work of these photographers was frequently shown, these were the first large retrospectives that they had yet been given. Each show was accompanied by an illustrated catalog with a biographical essay by Nancy, which are included in this collection.

In the spring of 1945 I returned to America, and on September 20 I was released from active duty in the Air Force. I had expected to resume my former position as head of the Department of Photography of the Museum of Modern Art, and I hoped that Nancy would be retained as curator. But the trustees felt otherwise. They proposed to appoint Edward Steichen as the director of photography. Since Steichen's interest was in photojournalism and mine in photography as an art, I resigned from the museum.

Nancy now began to write and edit photographic books. *Time in New England*, was a collection of photographs by Paul Strand with quotations by New England writers from the Pilgrim fathers to the present. It was published in 1950. For

Arizona Highways magazine she wrote a series of essays to accompany photographs by Ansel Adams. Two of these, *Death Valley* and *San Xavier del Bac*, a mission church near Tucson—were reprinted as books. Her masterpiece, written for the Sierra Club, was *This Is the American Earth* (1960), an impassioned and poetic plea for the conservation of our natural resources, with photographs by Ansel Adams and other photographers.

Nancy used to say, laughingly, "When I married Beaumont, I married photography." Despite her early success, she gave up painting in 1937 and began to photograph. Almost at once she showed a highly individual style. Her portraits were bold, her landscapes lyrical, her architectural subjects detailed and foursquare. Her work with the camera is little known, for she seldom exhibited her prints, and only occasionaly were they reproduced.

In 1974, Nancy and I vacationed in the Grand Teton National Park in Wyoming. It was one of her favorite locations, and she had written about it in a book with Ansel's photographs. On our last day we were rafting down the Snake River when suddenly a huge tree, undermined by the unusually high water, crashed upon the raft and struck her. She died a few days later from the serious injuries she had received.

<div style="text-align: right">

BEAUMONT NEWHALL
Santa Fe, 1989

</div>

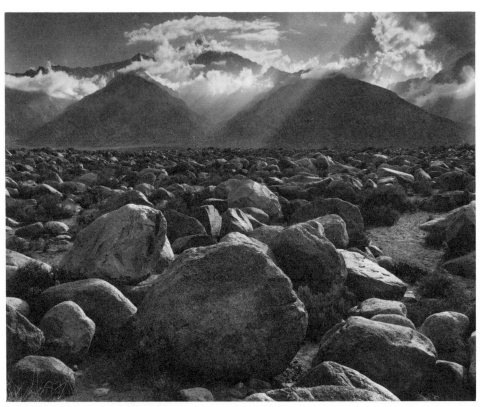

1. Ansel Adams, *Mount Williamson—Clearing Storm*, 1945

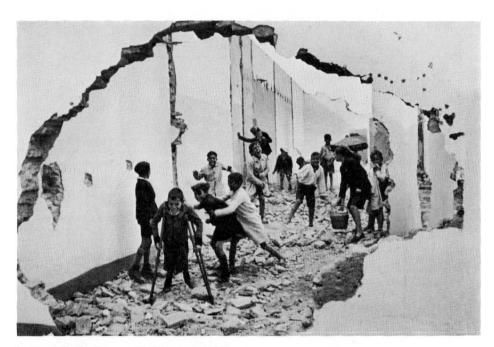

2. Henri Cartier-Bresson, *Seville, Spain*, 1933

Controversy and the Creative Concepts

LAST FALL, IN PARIS, I found myself involved in hot defense of the ideals and methods of photographers in the West; this spring, in San Francisco, I found myself involved in equally hot defense of the photographers in Paris. Convinced of its own passionate logic, each group refuses to believe the other has any logic at all and condemns its philosophy or its subject matter or its technique or its motives or its concepts in toto as full of error and headed for limbo. And then there are the men apart, monolithic on the horizons, whom both extremes misunderstand with irritated affection and respect. In all this there is little animosity; there is bewilderment and concern—WHY do the others stick so stubbornly to ideas so obviously mistaken?

Perhaps it is time that a few of the most controversial concepts were set forth side by side so that they may be seen for what they are—vital, thoroughgoing principles. Each, for at least its chief protagonist, is a whole way of living and working so as to attain an ideal in photography.

The following is a catalogue of concepts and the men who have generated them; it is not complete. There are others that should be here and, I hope, will be here, set forth by their creators and believers who know them better than I; *Aperture* is a forum for the ideas and images of creative photography. Each of the individuals briefly outlined here has opened for many of us a region unknown before. I have tried to set them down as I have seen them; the words I ascribe to them I have heard them say. I have tried to present their concepts from the inside out, with justice and without favoritism.

There is no need for any photographer with a different concept to agree; there is *great* need to recognize the intensity and integrity of such concepts, and to rejoice that now, in our medium, there are such ardent beliefs and strong individualities. In flaccid periods the work is flaccid, too. In spite of its failures, its waste, and its unsolved problems, NOW (the 1950s) is one of the important periods in creative photography. And the force of the emerging future is behind it.

THE EUROPEAN PHOTOJOURNALIST; HENRI CARTIER-BRESSON To take Europe first: Europe, as Henry Miller said, is "art-ridden." Photographers walk humbly between walls weighted with a thousand or two thousand years of overwhelming art—even when they have thrown any rivalry into the gutter and

have dedicated themselves to what only photographers can do. Photography in Europe is an eye, a magic eye, an incredible and incontrovertible eye. Delacroix said no man could paint great "machines"—canvases like his—unless he could sketch a man falling from a fourth-story window before he hit the ground. European photographers feel they must be faster still: present a totality in an instant, an instant almost beyond the human eye.

Of course there are still in Europe, as in America, photographers who emulate painting. Some, as here, follow the genre and impressionist styles favored by the older pictorialists; most of them now, since Man Ray and Moholy-Nagy in the 1920s led the onslaught of the "new vision," followed the forms of the abstract and surrealist movements, making photographs, negative prints, double printing, and so forth. But along with the "new vision," which hit Europe a little later than America, came a delight in the unique revelations of the camera. Man Ray discovered the strange juxtapositions of reality in the photographs of Atget; Moholy-Nagy discovered the weird shapes and movements seen in trick photographs, scientific photographs, press photographs. At the peace conference Erich Salomon was photographing people, unposed, in dim, available light, using a small camera with a huge aperture lens; with the same approach and type of instrument Alfred Eisenstaedt was making informal and moving stories. A new concept grew up and crystallized behind Henri Cartier-Bresson and his uncanny gift of seeing, as someone said, almost on the inner eye.

Camera and Seeing View cameras, and big cameras generally, were regarded as impossibly slow, cumbersome, and conspicuous. Only the 35 millimeter and the twin-lens reflex were in repute. Fast and little and light, the new cameras were for seeing; they were for people. Loaded with lengths of inexpensive film, they led to a new way of working. You found your subject and merged as far as possible with its background; if you could, you became invisible. If not, you got accepted, and took photographs until you were forgotten. Then you photographed the developing action until the climax was reached and you achieved the ONE picture out of the whole roll, or even several rolls, which summarized the whole. For this kind of picturemaking you must be forever alert. The action happens just once in all time. There is no retake ever. No prearrangement, no direction will ever bring the same unmistakable flash of insight into actuality.

The little cameras became a part of the man using them. I am sure Henri Cartier-Bresson puts on his Leica as automatically as he puts on his shoes. He is never without it. He carries no parcels ever, so that he may always be instantly ready. At any moment the worn case may appear open; without looking down, without haste, he sets the shutter and the stop. With a slow flow of a hunter anxious not to attract the gaze of his wild game, he raises the camera to his eye, clicks, and as slowly lowers it. No one has noticed so quiet and natural a motion. He seldom uses a light meter. It attracts attention. He has learned to "feel" the light as the old photographers did. He

dresses inconspicuously; who would look at a slight fair man in an old raincoat? He can vanish from your side in a street only moderately crowded; you can scan it carefully and not see him. Then, just as suddenly, his camera back under his arm, he reappears smiling, at your elbow. He drinks a little wine, and that liberally doused with water; he lives for the strange revealing flash, the magic moment, and he refuses to miss it because his timing is slowed by wine or anything else. In a busy restaurant he will stand up and sit down again; he has made a portrait of a man at another table. But he loves night, because the houses become transparent; he does not need to vanish, he can just wait and look, and his presence in the shadows will not disturb what is happening within. "Isn't it marvelous?" he asks with a shining face when what he has seen fills him with affectionate delight and often a wry humor. He characterizes the best French photography as "sharp, dry, and kind," but his own often goes beyond his definition when his pity or anger is stirred.

His seeing of an apparently unpredictable accident is as precise as that of Weston or Strand with an 8 x 10 and a relatively static subject. He never crops nor allows editors to do so. He paints to make his sensitivity to plastic forms and values more acute, as well as for the private pleasure painting gives him. Line, tone and form interest him; textures do not, and he scouts the idea held by Americans that a mastery of texture is a sign of maturity.

The Print Is a Step Between Seeing and Publication The print, to him as to most European photojournalists, is just a transition between the seeing and the publication. It is something to toss by the dozen into the laps of editors; it is nothing by itself. The one aspect of technique that engrosses Europeans is how to increase speed in photographing indoors or at night. Developing and printing they usually leave to a technician in a laboratory. Enlarging is routine, the technician following the photographer's indications on the contact sheets. The image—the seeing—is important; the print is not, and to American eyes is execrable—not even half "realized." The print to a European is only a proof; his image is not complete until reproduced where a million eyes can see it. If his intention then appears clear and forceful, he is content.

When a print is required for exhibition, Cartier-Bresson works directly with the technician, and works for a quality much like that of a good gravure. He chooses semimatte paper, he enlarges to 11 x 14 or 16 x 20, and insists on tones like those of a wash or charcoal drawing. He wants his image sharp enough to be convincing, but the sharpness Americans find requisite seems to him a fetish, beyond and apart from what is necessary.

For Cartier-Bresson, as for most Europeans, there is just one endless and multiform subject: people, and the places and events they create around themselves. For him, they alone have significance; their gestures light up vistas sometimes exquisite, sometimes amusing, sometimes tragic or appalling. He feels that in his own early works he often paid too much attention to the astounding designs and mysterious

appearances created by chance, and he censures others who succumb to such
meaningless and egotistical pyrotechnics. The merely pretty horrifies him: "Now, in
this moment, this crisis, with the world maybe going to pieces—to photo-
graph a *landscape!*" He has no doubt of the sincerity or the stature of Weston or
Adams or Strand, but, although he feels closer to Weston, they mystify him; looking
at their work. "Magnificent!—But I can't understand these men. It is a world of
stone." To the explanation that through images of what is as familiar to all men as
stone, water, grass, cloud, photographers can make visual poetry and express
thought beyond translation into other media: "Do you think that by photographing
what is eternal they make their work eternal?" To photograph a house instead of the
man in it seems to Cartier-Bresson inconsistent, and to find meaning in such images
seems to him dangerously personal and close to mysticism. The further idea that, in
the American West, man appears trivial and civilization a transient litter: "It is, I think,
philosophically unsound." Man to Europe and to many in the American East, is
still the proper study of man. The earth, the universe, eternity?—"They are too big,
too far away. What can we do about them?"

Devoted to this European concept of a photographer's function there are individu-
als as different from Henri Cartier-Bresson as Bill Brandt, wandering with his Rollei
like a pleasant spirit through the nostalgic and romantic byways of Britain, or
Brassaï, with his immense gusto for the human comedy just as it stands, and his
ability to become by osmosis a natural part of any milieu that interests him.

THE AMERICAN PHOTOJOURNALIST Beyond question, the concept of
photojournalism dominant in America is that developed at *Life*. That concept is a
composite. No one individual produced it; no one photographer is its archetype. The
Life photographer may have become a type in the popular consciousness—extrovertial,
hasty, hung with gadgets—but in actuality such characteristics are common to a
wide range of violent and specialized individuals.

Forming the style of *Life* at its inception were photographers as different in
approach as Alfred Eisenstaedt, bringing his warm and human version of the
European concept; Margaret Bourke-White, who had studied with Clarence White,
with her magnificent interpretations of industry; and Peter Stackpole, who, in
photographing with a Leica the building of the San Francisco Bay Bridge, tried to
combine the brilliant print quality of Group f/64, then at its peak, with the human
directness of the documentarians, then just forming.

Behind the *Life* concept as it evolved was a nation for whom photography and
its developing forms has been for a century the most satisfying visual communica-
tion. Behind the American photojournalist there were the battles led by Stieglitz and
the Photo-Secession for photography as an art; the journalist inherited a conviction
that his medium is important and quite possibly, in the future, second to none. From
Stieglitz, Strand, Weston, Adams—the so-called purists—he acquired standards
unmatched elsewhere for precision of technique and intensity of statement,

standards that never fail to stagger and upset the European, who is required to conform to them. And from the documentarians—another name that needs reexamination—he absorbed a sense of dedication to coming to grips with whatever was before him; from Walker Evans, an approach to architecture; from Dorothea Lange, an approach to people.

For the American photojournalist, what he does is no sketch of such actualities as happen to be beyond human eye and hand; it is the total presentation. And probably the most important presentation, not only to the present but to the future. He feels a duty to the idea or the people he photographs, to the men and women who will see his interpretation now, and to history. He resents any falsification or distortion of what he tries to interpret. His work is heavier and more complete than that of his European colleague; the grace and wit that help Europe to put up with history are not yet his concern, nor his country's.

The concept developed at *Life* centers about the subject and how it may best be interpreted. When there is time, the photographer who in the editor's opinion is best suited to the assignment is sent forth; when there is an emergency, any photographer who happens to be nearest, no matter what his specialty, is expected to handle it capably.

The American is much more versatile than his European colleague. He rarely limits himself to one camera, because that implies limitation of subject matter. He will use a miniature with the fastest known lens, load it with the most sensitive film made, and instruct the lab to use special developing technique, when he is working with people in available light. The next night he may string up a hundred flash bulbs down some vast dark area and make a carefully calculated exposure with a view camera. And be out before dawn the next morning with color on his mind. He will use all cameras, all techniques, all gadgets known to him in order to present his subject properly.

He is a much better technician than the European. The exigencies of time, space, and publication impose laboratories and technicians upon him. He insists on the finest possible processing; he is grateful that the burden of that inevitable disappearance into the darkroom is lifted from him. But he still feels frustrated, resentful, and a little guilty when he does not lift his own negatives out of the hypo, make his own choice and print it himself. When he does make a print for exhibition, it is a good print, if not a great one by American standards.

But the contact sheets and the enlargements are still dumped wholesale into the editor's lap. The selection, the layout, and the slant given to the story are still the editor's. The photographer may provide the most dynamic reason for the magazine's existence; he may get a salary in the upper brackets, but he is trusted only as a kind of remote control eye. Individually and collectively the photojournalists complain about this, and gradually they make progress.

Like advertising and fashion photographers, the journalist gets sick of the endless stuff he spins out of himself on celluloid and more sick of fast and superficial coverage

on assignments he does not have time to penetrate and absorb. Special privilege is pleasant and so are large expense accounts; the drive, the pace, and the contact with strange people and vivid places is exciting. But the life of the journalist is a life without roots, without family, except as glimpsed, married, and begotten between assignments. A life in constant motion, at top speed, in which he is forever both the hunter and the hunted. A life in which a man can soon be worn out, burned out, and bored out, even when he is thoroughly aware of the occupational hazard.

The American photojournalist is not particularly bothered by painters; the great gage that lies dimly or strongly on his or her consciousness is that of the great purist photographers. He may not agree with them any more, he may feel they are limited or misled, but by God they did—and do—what they believe in to the utmost that is in them, and they live—somehow—and die still creators. He plans to save so that he can stop next year and do his own work; he plans to take half the year off; he announces he will take only assignments he believes in. If he is powerful and indispensable, he may get the magazine to sponsor his personal projects. Magnificent essays have been born of this approach, and through them a new concept of the photojournalist's stature and function can be seen emerging; the photojournalist as creator, planning and directing his projects, and assuming ultimate responsibility for his interpretation. Toward this new concept many leading photographers are working, including individuals as diverse as Eliot Elisofon, indefatigable explorer of primitive cultures and of the potentials of color, and W. Eugene Smith, whose identification with his themes is so intense that he and we become participants as present and unseen as the wallpaper or a shadow in the street.

EDWARD WESTON Photography can get infuriatingly complex; entangled in wires and batteries, in straps and cases, in miles of celluloid, and fragile mechanisms persistently a little out of kilter, the photographer has moments when he feels like Laocoön. Living can be another endless coping with illusions of leisure, and to any American photographer reflecting on the entanglements he endures in order to earn further entanglements, there is apt to occur the image of a quiet little man named Edward Weston.

A little man from whom there issued, as from a volcano, immense forms and concepts. A little man with a big camera and a bare simplicity in his living and working. In the twentieth century, Weston is as startling an apparition as he is logical. And of all the challenges that haunt the conscience of the creative American photographer, Weston's lies perhaps the most uneasily.

From the moment when, at fourteen, Weston was given a box camera, he lived for the hours when he could be alone with his camera. It was his companion in delight, and if he could have earned his living thus, he would have been content. But no creative photographer can, as yet, live by the sale of his personal work. Any passable painter does, but in photography men with the stature of a Picasso or a Rouault get so meager a return that they must depend on something else for a livelihood.

Weston chose portraiture, because he would then at least own the tools he needed. Press, journalistic, fashion and advertising photography were all embryonic around 1910, but if they had been full grown, Weston would probably still not have chosen them. He was active; he chafed at being tied to a studio all day; he loved expeditions with his camera. But the core of his being was meditative and apart; he rose early to be alone and pour forth in his daybook the molten stuff inside. He was not a man who liked to be hired. Something in him broke even his own harnesses. He had wanted a home; he welcomed each of his four sons. In portraiture he achieved a decent living and high professional and salon honors. But increasingly he hated pandering to human vanity; increasingly he hated dodges and respectable false fronts; increasingly he desired the time and energy to create. He was sick of illusions, even his own. Perhaps especially his own grand gestures as an artistic personality. At thirty, when most men who have made an early success settle in, Weston began to grow.

It wasn't easy; probably it has never been easy. Nor were the sacrifices necessary all his own. But he felt that without the integrity and power creative photography gave him, he would have nothing to give to anyone.

The Years of Decision During the years of his growth, he was alone. There was then no other photographer on the West Coast with the same concern in creation. Rumors of Stieglitz in New York reached him, and articles about Stieglitz helped him think, but a few hours with Stieglitz, during a brief journey East, seemed merely to confirm what he already knew. What, for Edward Weston, lay beyond, he would have to find for himself. And what lay beyond was difficult to define. He worked toward it through the sudden flashes of vision and the unreasoning responses every photographer knows. The acute senses of his friends among the painters and writers probably helped him the most; in his daybook he meditated on their comments as he reviewed his new work.

An instinct for the simple and vital, and a disgust for artificiality and waste, helped him both in his work and his living. Yet so strong is tradition and so slow is growth it took him years to husk away old habits of thought and get down to his clear concept. He fought his way through impressionism, through haze, soft focus, papery surfaces; through the arty arrangements and fragmentary angle shots of the cubist fringe.

Artificial light he discarded as a nuisance and crudity; the subtleties of natural light engrossed him. More and more he found himself using his enlarger only for his portrait work; a diffuse enlargement, he found, was the simplest way to avoid horrifying his sitters by their own faces. His own work he printed by contact. More and more he wanted nothing—no tone, no tactility of surface, not even the impress of himself—between him and the sharp forms and textures of reality. But reality for him was not the ordinary peeling of a picture from an object. He came to realize that what moved him most was form—the unseen forms hidden in the commonplace, forms of force, growth, tension, erosion. He found them in smokestacks, in rocks

and faces, in shells and vegetables; he saw them in a cloud, a hill, a naked body, a wave, a tree. "How little subject matter counts!" he wrote. A nude back like a pear, a cypress root like a livid flame, feathers in the wing of a dead pelican seen as barbs of light in a dark sky, a stone like lace—he discovered them with amazement.

He found that, for him, everything—his life, his work—was a matter of dynamics and of focus. Now and then he sold enough prints to dream, fleetingly, of being free from portraiture—"If only I could live by the sale of my personal work!" But since he could not—and for only three and a half years out of nearly fifty did he achieve freedom—he determined to be as free as possible. If he eliminated everything unessential, everything that cost too much in cash, time, and energy, then he would not have to earn it; more hours of daylight would be his and more strength to create with. His thinking went much like that of Thoreau: a hunk of excellent cheese costs little and can be eaten in the hand, but a poor steak costs a lot and besides you have to cook it and clean up afterward. He evolved a housekeeping simple as an Arab's; no cookery during daylight except a pot or two of superb coffee.

The Technique His technique was equally bare and vital. An 8 x 10 view camera for his personal work; a 4 x 5 Graflex for people. Negatives developed in a tray, in pyro, by inspection. Contact prints, on glossy paper, made under a frosted bulb hung overhead to facilitate any necessary dodging. A dry-mounting press and a stack of smooth white mounts. That was all. The classic and ancient tools of his trade, essentially the same during the century of photography's existence, were what he chose as the most potent and flexible. He made some of his best early things with an old Rapid Rectilinear he picked up for five dollars; later he had fine new lenses, but, as he said, when people remarked that he must have a marvelous lens, "Good photographs, like anything else, are made with one's brains." His use of a light meter—urged on him by friends—was also independent; he used it all over the sphere of vision to help him in what he had done for so many years—"feel the light." Then, after adding everything up, he usually doubled the result; he likes a massive exposure. And *natural light only.* He used it to do extraordinary things—full sun for a body outlined by shadow or for a head seen against the sky or the black of an open door; foglight for his huge sculptural forms; skylight for his sitters as they moved and talked, sitting in some old chair, in front of his waiting lens. He even got to the point in his professional work where he could hang out a sign UNRETOUCHED PORTRAITS and get away with it. He had really learned to see. Props and devices were quite unnecessary.

He could never wait to develop a batch of exciting new negatives. Printing was something else; the day before was spent in scrupulous cleansing, organizing, mixing; this is true of all major American photographers; for Americans, the print is the test of both negative and photographer. For Weston, there was a special emphasis: in his early years, he had seldom been able to afford more than one sheet of expensive platinum or palladium paper for his own work and he had had to

learn to gauge his exposure so accurately that the first full sheet, or at most the second, was worth exhibiting.

You don't toss prints like this wholesale into the laps of any audience. Weston, like most creative Americans, keeps his prints with tissues between them, to protect the delicate surfaces from abrasion. He shows them one by one, on their immaculate white mounts, on an easel, under the skylight by day, under a photoflood by night. He has learned that twenty to twenty-five prints are about all the sensitive spectator can see with his full intensity—a far cry from the hundred or so expected from the photojournalist by an editor and shuffled through in five minutes.

Mass-Production Seeing Yet in actuality Weston has evolved, and proved to his own satisfaction, by his own example and that of others, notably Ansel Adams, the theory that photography is the medium above all others for "mass-production seeing." The painter, in Weston's opinion, is slowed by his hand. In the course of a long lifetime, the painter can realize only a fraction of what he conceives. For the photographer, conception and execution can be and usually are almost simultaneous, and sometimes so fast that they go beyond conscious thought. At the present moment—in the summer of 1953—Weston is engaged in trying to make a great and lasting demonstration of this idea: with the help of his son, Brett, he is printing the thousand negatives he considers the best. There will be eight prints from each; from albums, museums, collectors, and individuals can choose and order by negative number what they wish. Probably no more startling idea was ever proposed to museums, traditionally conditioned to the small output of painters and the high cost of even a slight sketch. For the price of one so-so contemporary piece of painting or sculpture, the entire masterwork of one of the greatest photographers is for sale. And for less than a bad watercolor or scratchy etching, the massive and sculptural images of a man who could write, with a laugh, "The painters have no copyright on modern art!" And who again, when somebody wrote an article about him titled, "Edward Weston, Artist," circled the "artist" with a heavy pencil and wrote, "Delete, or change to 'photographer,' of which title I am very proud."

Purism Nevertheless, Weston was annoyed when, thanks to some dramatic statements he published, and to the spectacular crusade of Group f/64, of which, with Ansel Adams and Willard Van Dyke, he was a founder, he found himself in a niche labeled the Great Purist. He refused to be shackled even by his own hard-won concept, the subjects he had made his own, or the dismay of his friends. He reserved for himself the right to "print on a doormat if I feel I can make a better print that way."

One tenet held by purists is never to touch or arrange; Weston had always arranged his shells and peppers, and now he composed satires out of people and objects. Threatening to return to soft focus, he took the idylls so often attempted by the pictorialists and did them with enormous mastery. At the last of his hours with his camera, before Parkinson's disease made seeing and coordinating too difficult, he

was tackling with pleasure a new kind of vision for him—color. And in black-and-white, he was pursuing his huge forms through their disintegration and their sinking back into the matrix of the earth.

Interpretations and the Wilderness Freudian interpretations of his work infuriate Weston. If the same forms recur throughout creation, and people can see in them no more than sexual symbols, he feels that is a pathetic and possibly patholog-ical reflection of the people. And like other Western photographers, he has been accused of theatricality—a charge any good Westerner whether born or made (Weston was born in Chicago) puts down to pure envy. For in judging the work of the West, facts unfamiliar to the East and to Europe must be taken into account, and the basic fact is *wilderness*. In the West there are immense distances where any track of man is either invisible or ridiculous. The oldest civilizations on this continent are there, in the Indian pueblos and the Spanish foundations; so are some of the most advanced manifestations of the newest civilization. None of them seem more than trivial and transient in the face of the vast spaces and the stark and monumental forms of the earth. The proper study of man in the West is the powers and functions of the earth, and how he may live with them during his brief tenancy. This is the philosophy reflected in Weston's photographs; that in man, as in the rest of nature, the same forces are at work. With amazement, with humility and a sense of unlimit-ed resource, Weston pursues them through the strange beauty of their endless metamorphoses.

Weston is probably the most tolerant of the major photographers; he expects no one to follow his personal concept, knowing that every creator makes his own concept as inevitably as a river makes its own course to the sea. His recognition of the electric quality of achievement in others is instant and generous, no matter how different from his own. But few of Weston's followers follow him in this, and most of them recoil at the slightest deviation from the concept. They cannot see an image that is not printed on cool and glossy paper; enlargement distresses them. A blur or a patch of soft focus is like a speck in the eye. A miniature camera is a toy, and its results miniscule, inconsequential, and a nuisance to look at. People seldom interest the Weston followers as subjects, apart from an occasional portrait. And they would rather earn their living as carpenters or masons than turn their cameras on what does not interest them, and sully their delight for mere cash. Yet with the majority of them, this rigidity is a temporary phase; they emerge with a strong discipline from the silent dominance of Weston's vision, and begin to evolve their own approaches. For themselves, there may be fallacies and limitations in his concept, but it still stands monumental in its simplicity, a challenge and a catalyst.

Aperture, no. 2, 1953.

Ansel Adams
THE ELOQUENT LIGHT

SNOWLIGHT, STORMLIGHT, FOGLIGHT, rain that itself becomes drops of light, autumn leaves that become cascades of light, twilight and the rising moon— all these and many more are eloquent for Ansel Adams. And dawn is the greatest light of all. Time for him is a continuum wherein the moment of death is the moment of birth. "Photography," he once wrote, "makes the *moment* enduring and eloquent." The moment he seeks for his photographs is the moment of revelation, when in a passing light or mood he sees his subject in a new significance. In such photographs "the external event" and "the internal event," as Coleridge said must happen in art, become one. The dates of their making drop away. They stand at the confluence of past and future; they become timeless.

Behind such images can be felt Adams's deep love of music and the severe discipline acquired during the years he studied to become a concert pianist. "I have been trained," he wrote to a friend, "with the dominating thought of art as something almost religious in quality. . . . I existed only for the quality of art in relation to itself —the production of beauty without other motivation." To him in his maturity, as a professional photographer: "The negative is the score; the print is the performance."

Into composing the score he puts the full force of his imagination. He has close to total perception; crossing a threshold, meeting a person, entering a new region, the myriad disparate facets of presence strike him simultaneously with almost physical force. He is like a man dancing on barbs until he discovers how he can make this character, mood, or meaning inform a photograph. Reality surrounds him with what he calls "configurations in chaos." From these vague shapes, kinetically observed, the photographer selects, composes, intensifies, and transforms until he achieves "an entirely new and different experience which is remote from actuality in many ways." With his uncanny sensitivity, speed, and power of visualization, Adams evokes from chaos his aerial images wherein beauty is discovered in a seemingly limitless range of forms, effects and emotions. Most artists throughout their lifetimes pursue only a relatively few forms; Adams is protean.

If it is a poet who perceives the aerial image, it is an arithmetician who converts it, as well as "the perversity of the inanimate" will let him, into a negative. Then further transformations take full orchestra. Adams once compared the experience of

3. Nancy Newhall, *Ansel Adams*, 1944

"a truly fine print to the experience of a symphony—appreciation of the broad, melodic line, while important, is by no means all. The wealth of detail, forms, values—the minute but vital significances revealed so exquisitely by the lens—deserves exploration and appreciation. It takes time to *really* see a fine print, to feel the almost endless revelations of poignant reality…" By this time, people in most of the countries of the world have found themselves transfixed before a photograph by Ansel Adams.

Through the changing idealisms of the decades, Adams has emerged more and more himself, his vision and message increasing in depth and power. Both vision and message were formed by his first day in Yosemite Valley, when he was fourteen. Since that day in 1916, he has rung the quality of all the experiences and achievements of his life against the majesty of the Sierra Nevada, John Muir's "range of light," and the immensity of the Pacific.

This exhibition indicates the scope and versatility of his work. He produces fine books and brochures wherein the typography is distinguished and the reproductions of facsimile strength. He experiments with a new process which, he declares, "has already revolutionized the art and craft of photography—and is still barely across the threshold of development." He applies his skill and intelligence to the functional purposes of commercial illustration, and some of the photographs he makes on such assignments rank with his finest creative work. He abstracts—or "extracts," as he prefers to call it—from humble and common objects a formal brilliance and rich decoration. He photographs people with humor, insight, compassion, and a sculptural intensity. And over and through all these, through the places he loves, California, Yosemite and the High Sierra, the Southwest, Hawaii, Alaska—run his huge themes—"forces familiar with the aeons of creation and the aeons of the ending of the world."

In his work the immense and monumental, the exquisite and lyrical, the luminous and the sombre, the tragic and the ecstatic appear together. He is not afraid of emotion or of beauty. "We are passing through an age of the denial of beauty.…I am not ashamed to use this term, beauty; I do not consider that it is limited to the pretty, the precious, the esoteric or the shallow. It is the ingredient that determines the ultimate function…the ingredient of excitement and revelation."

Most contemporary art seems to him "peripheral." He is deeply disturbed by "the sour negations, oblique obscurantisms, and the slick evaluations so common in the arts of our time." He wonders why so many artists should be "mostly concerned with the expression of their egos." For himself, "There is too much clear sky and clean rock in my memory for me ever to wholly fall into self-illusion."

He states his credo: "I believe in growing things and in things which have grown and died magnificently. I believe in people, and in the simple aspects of human life, and in the relation of man to nature. I believe man must be free, both in spirit and society, that he must build strength into himself, affirming 'the enormous beauty of

the world' and acquiring the confidence to see and express his vision. And I believe in photography as one means of expressing this affirmation. . . .

"To photograph truthfully and effectively is to see beneath the surfaces. . . Impression is not enough. Design, style, technique—these too are not enough. Art must reach further than impression or self-revelation. Art, said Alfred Stieglitz, is the affirmation of life. And life, or its eternal evidence, is everywhere.

"Some photographers take reality as the sculptors take wood or stone and upon it impose the dominations of their own thought and spirit. Others come before reality more tenderly and a photograph to them is an instrument of love and revelation. A true photograph need not be explained, nor can be contained in words.

"Expressions without doctrine, my photographs are presented here as ends in themselves, images of the endless moments of the world."

From *The Eloquent Light* (Aperture: New York, 1963).

Brassaï

81 RUE DU FAUBOURG ST.-JACQUES, Paris—a tall apartment house on a corner. In the square below, a street fair stood melancholy in the late afternoon light. The flying carousel, with a huge metal dove among its boats, the immense, undulating serpent on which to rush round and round, the alley lined with shooting galleries, the little automobiles on trolleys, bright as Christmas balls—all were deserted. The carnival people were going back under the autumn trees to their painted carts drawn up on the cobbles; there were voices and a tinkle of crockery, a door slammed, a washtub was hung out to dry. The dribble of daytime customers was over; the fair awaited the night.

As in the entries of most Paris apartment houses, there was only the gray light from the street and a dim glimmer within the lodge of the concierge. "M. Brassaï…? Au fond, à gauche, prenez l'ascenseur, cinquième étage!" By groping, the little elevator was found and the frantic little doors pushed back; under the weight of a foot the floor sank—and a light went on. Slowly, creakingly, the little cage rose beside the circling stairs and came shakingly to a stop. I can never escape soon enough from French elevators, nor from the feeling that somehow one ought to pat them for their labors, like aged but faithful donkeys.

Years ago, fleetingly, we had met Brassaï, like a ball of energy, and kind. He had given us the photograph, of climbers on an icy mountain slope, with which we had begun our personal collection. The door opened. A dark vivid girl—Gilberte, Mme. Brassaï, or, dropping the pseudonym, Mme. Gyula Halász. And Brassaï himself —the same ball of energy, with the same extraordinary eyes. The eyes of great photographers are often extraordinary; Stieglitz's deep and dark, as though you were looking through a lens into the darkness beyond; Weston's, hot, slow, absorbing; Adams's brilliant under the wild flying brows that see everything at once like a 180° lens. Brassaï's eyes are black, sparkling, enormous; he seems able to throw them at anything that interests him. Henry Miller once called him "The Eye of Paris":

Brassaï has that rare gift which so many artists despise—*normal vision*. He

4. Nancy Newhall, *Brassaï and Beaumont Newhall*, 1956

has no need to lie or to preach. He would not alter the living arrangement or the world by one iota; he sees the world precisely as it is....For Brassaï is an eye, a living eye...the still, all-inclusive eye of the Buddha which never closes. *The insatiable eye*...the cosmologic eye, persisting through wrack and doom, impervious, inchoate, *seeing only what is.*

Brassaï's little room for thinking and talking is a magpie's nest, a room formed by a boundless curiosity and amusement. During its mutations through the years, probably anything could have been found here, even the dull and the conventional suddenly transformed by association. Jumping jacks and playing cards and posters and a calendar on which he has pasted his photograph of a cat's eyes gleaming in the dark; a cluster of masks hung on the corner of a bookcase; a statue of St. Sebastian with holes for arrows into which he has stuck cigarettes; a row of primitive paintings under the ceiling, and under them a row of daguerreotypes; then a jungle of pharmacists' vases with electric lights shining behind them and past the silhouettes of strange buds and branches; small sculptures from Mexico and Africa; tiny skulls; shells of mother-of-pearl; a horrifying fiesta figure from Seville, dead white, faceless, with a tall peaked hood reminiscent of the Inquisition; soap made with the water from the holy spring at Lourdes. Boxes of negatives; a glass case full of Brassaï's own sculptures on pebbles, meant to be held and seen in the hand. The back wall, topped by large earthen pots, crammed with dummies of incipient books with boxes of prints marked *Picasso I, Picasso II, Paris de Jour, Nus, Portraits,* etc. From the balcony, over pots mantled with ivy, you look across the square and the chimneypots of Paris.

Brassaï brought out a flood of photographs, all 11 x 14-inch glossies. We spread them on the couch, on the floor, we stacked them against the chair and the table legs. Paris by day and by night—the Paris that has obsessed untold numbers of men like a dream, like a passion, the imperceptible men and the famous ones, the frugal, the acquisitive, the spendthrift; the humble little gatherer of information for the city directory. Victor Banthélemy, who began his great collection of photographs by asking everywhere he went if they had old photographs of Paris; Atget, drinking his tea and going forth under his 8 x 10 down the dark alleys and misty boulevards of a Paris still asleep; Daumier, with his savage insight and rending pity; Toulouse-Lautrec, mordantly observing the death-in-life night world; Balzac—whom Brassaï vaguely resembles—preoccupied with his *Comédie humaine.*

Brassaï is not Paris-born; he is not French. "I was born in Transylvania on September 9, 1899, at nine at night. Nothing but nines or multiples of nines in my birthdate. This figure has pursued me all my life. I live always at no. 81...." Brasso, the medieval town on the edge of the Orient, where he was born and whence he takes his pseudonym, he first left when he was four; his father, a professor of French literature, came back to his beloved Paris to refresh himself for a year at the Sorbonne. For that year little Gyula (Jules) Halász and his brother

lived the enchanted life of little Parisians. In 1924 he came back again, after study-
ing art in Budapest and Berlin. And Paris, the huge, the manifold, began to call him,
especially down its vistas through the night.

"For a very long time I had an aversion to photography," wrote Brassaï in his
1952 album. "Up to my thirtieth year I did not know what a camera was." One dark
night, standing on the Pont Neuf with his old friend and fellow countryman, the
photographer André Kertész, he found out. Kertész's camera was up on its tripod,
and it seemed to Brassaï that they had been talking near it or over it for a very long
time. "Well, take your picture and let's go." "It's being taken," Kertész said with a
smile. "Wait another fifteen minutes and we'll have it." Brassaï went to see that
negative developed. And the next day he bought the camera Kertész advised, a little
Voigtländer, 6-1/2 × 9 cm., with Heliar 4.5 lens. "I had a whole profusion of images
to bring to light, which during the long years I lived walking through the night
never ceased to lure me, pursue me, even to haunt me, and since I saw no method of
seizing them other than photography, I made a few tries." These obsessive images,
about to be made into Brassaï's first book, *Paris de Nuit,* 1933, seemed to Henry
Miller "the illustrations to my books…I beheld to my astonishment a thousand
replicas of all the scenes, all the streets, all the walls, all the fragments of that Paris
wherein I died and was born again. There on his bed, in myriad pieces and arrange-
ments, lay the cross to which I had been nailed.…" The walls of Paris, eroded by
rain, age, and man, and scratched by him with his own weird obsessive symbols of
death and sex; its roofs, windows, cobbles, incised by daylight or illumined against
the night and the mist. The immense and endless panorama of its people: the
concierges and their cats, the cafés, the brothels, the curious oldsters with their
pitiful trades, the shadowy parks and the glittering Metro, the lighted fountains and
the powerful confusion of the dim market.

And beyond Paris: the medieval hospital at Beaune, with nuns in white coifs; the
Rabelaisian feasts of Burgundy, with whole hogs in jelly, decorated, miles of
banquet tables hemmed with wineglasses, chefs and gourmets in academic robes.
Midnight mass on Christmas in a remote village, with a young shepherd holding a
lamb in his arms. The strange rock-borne town of Les Baux-de-Provence, where the
sheep emerging from crags and grottoes in the pumice seemed to Brassaï like souls
summoned up from purgatory. Holy Week in Seville—the medieval hoods among
baroque splendor and the dancing skirts. The Côte d'Azur, and a white boat like
dream on the sand.

But always and forever Paris again. And his friends, Picasso, Rouault, Braque,
Matisse, Eluard, Breton, Prévert.

Brassaï is not, like Henri Cartier-Bresson, an invisible man. People look at him
and his camera naturally and comfortably. He can go along any street into any life
from top to underside of society and become, by osmosis, accepted into it. What
Cartier-Bresson sees with a shock or a tingle to heart or intellect, Brassaï sees as
part of the Human Comedy; where Cartier-Bresson watches for the all but invisible

instant, the almost incredible accident that turns the world inside out, Brassaï watch-
es for the moment devoid of *transience,* the moment when character is totally
visible, with its roots down into time and place. Brassaï has a huge gusto and an
unshakable objectivity; he can see without revulsion or exaggeration the whole
horror and wonder of humanity. Toward the flow of reality around him, he has the
humility that marks the great photographer.

> …The object is absolutely inimitable; the question is always to find that sole transla-
> tion that will be valid in another language. And now, immediately, there is the *diffi-
> culty of being faithful to the object,* the fear of betraying it (for all literal translation is
> treason), which obliges us to recreate it or reinvent it. The compelling pursuit of
> *resemblance,* of representation (whatever may be said about it today) *leads us far,
> much farther than "free" imagination or invention. It is what excites in art those
> pictorial, verbal, or other discoveries that constantly renew expression.* The sources
> are always exciting, but they flow formless.… How to capture them, how retain them
> without *form?* Not being a stenographer, nor a recording machine, my course seems
> clear: to cast the living thing into an immutable form.… In a word, *I invent nothing, I
> imagine everything."*

In this humility transfixed by reality as perceived, Henry Miller found a saving
grace, a losing the soul to find it, much needed in these days.

> I realize in looking at his photos that by looking at things aesthetically, just as much as
> by looking at things moralistically, or pragmatically, we are destroying their value,
> their significance…The object and the vision are one…Every man today who is really
> an artist is trying to kill the artist in himself—and he must, if there is to be an art in
> the future. We are suffering from a plethora of art. We are art-ridden. Which is to say
> that instead of a truly personal, truly creative vision of things, we have merely an
> *aesthetic* view.

And he realized also, what is true of all genuine photographers, that Brassaï "by
depersonalizing himself … was enabled to discover his personality in everything."

In Brassaï's reporting, you do not find the dominant image that contains the
whole, nor the image that exists as a lyric for its own sake. The reality is within; it is
felt through his photographs. Nor does Brassaï make photographs beautiful in
American eyes; these are routine glossies, blowups from his Rolleiflex or 6 x 9 cm.
plate negatives, roughhewn, and crudely dodged. "Art-ridden" by the past, few
photographers on the Continent today regard a print as anything more than a transition
from the seeing to the publication in newspaper, magazine, or book. A Brassaï is all
there at first look. But what a look! You will never forget that macabre witness for
Toulouse and Baudelaire, Bijou, the superannuated prostitute wreathed in tulle and
fake pearls, nor can you wash out of your memory such graffiti as the hanged man
gouged into the stone. These are the blink of a Goya or Balzac-like eye.

Brassaï's realities are seen with such mass and volume that with ease he was able
to have his photographs of cafés, street corners, Metro corridors enlarged back to
the size of the originals to serve as decors for the ballet, *Le Rendez-Vous,* written by

Jacques Prévert, with music by Kosma, and for the play, *En Passant*. These decors, he insists, must always be lighted as the originals were lighted; the scenes he made for Jean Cocteau's *Phèdre* were ruined by the use of alien light. Photography being light, it offers, as transparency or flat, extraordinary potentials for theatrical illusion, and Brassaï must here be a pioneer in a new field.

The strangeness of the commonplace continues to haunt Brassaï. Into a series of colored folders he keeps putting photographs that are weird or witty metamorphoses of each other; he is assembling a kind of encyclopedia of life "as a stranger from another world might see it." And he goes further; by writing—"the eye ceding its place to the ear, I seek to *sharpen* my thought." Subjects such as Sleep, around which he groups images for his encyclopedia; *The Story of Marie,* 1949, a char-woman heard through her talk and her thoughts; sketches of the people he has photo-graphed—the concierge of Notre Dame de Paris, whom he bribed to let him go up onto the roof of the cathedral at night; the man-aquarium, who swallows live frogs and fish and then spews them up again still flapping; the old artificial-flower maker and her jealous dove; the ancient news vendor, as much a part of the corner as the lamppost.

Nothing Brassaï might do would surprise his friends; he has too much energy, too wide a horizon to be confined to one or two outlets, even the endlessly multi-form mediums of photography and writing. He had been keeping his drawing to himself and a few very close friends. "One day when Picasso came to see me, a little before the war, I brought these drawings out of my boxes. He was seized by them: 'Why have you abandoned drawing, Brassaï? You have a mine of gold and you exploit a mine of salt!' Since then he has never ceased to exhort me to take up drawing again." During the Nazi occupation, Brassaï succumbed to what he calls "my old demon" of drawing. Exhibited, they won him considerable acclaim; thirty were published in 1946. Dynamic and lusty, they are related to his sculptures, and like those little pebbles that fit into the palm of the hand, like his photographs, too, they have a magnitude far beyond their size. They could grow with ease to dominate a wall, a square, or a mountainside.

Naturally Brassaï is now working in film, and the one surprising thing is that he didn't find himself involved in cinematography years ago. His first film, *"Tant qu'il y aura des bêtes,"* he describes as "entirely musical—musical also in its use of images—a kind of ballet that unrolls itself without a word, even of commen-tary." Eight hundred people attended its preview in one of the great movie houses on the Champs-Élysées: "…and I am very happy.… They laughed a great deal, and they were moved to tears." He is now at work on his second film.

It was dark and rainy when we emerged again into the street. A faint drizzle shone on the cobbles and haloed the lights of the fair. A rainy Monday night: the carnival people did not expect much business. Under their canopy of canvas, the little automobiles bumped crazily, incessantly. But the dove and the serpent were immobile. The proprietors of the shooting galleries shouted hoarsely as we

approached: "Shoot the heads off the wedding party!—Try your luck with bow and arrow!—Hit the enemy bomber with a machine gun!" Here and there a solitary man picked a chained gun up from the counter. We walked toward the bright comfort of a café, Brassaï, in his flat black hat, holding over us an ineffectual but solicitous umbrella. We were walking through his Paris, through the obsessive images of the night.

Camera, (Lucerne) May 1956.

5. Beaumont Newhall, *Alvin Langdon Coburn, Edith Coburn, Nancy Newhall*, Wales, 1952

Alvin Langdon Coburn
THE YOUNGEST STAR

ALVIN LANGDON COBURN—the sonorous name comes echoing down to us from the first decades of the twentieth century, borne by the voices of Alfred Stieglitz, George Bernard Shaw, Henry James, Ezra Pound and many others. Most of the voices are silent now, but the center of all this reverberation, Coburn, himself an ardent, gentle man who celebrated his eightieth birthday on June 11, 1962, still goes forth with his camera when there are storms upon the mountains or great lights on the towns or shimmering shadows on the seas.

Through Coburn—his remarkable memory, his faithful diary, his voluminous scrapbooks, his collections of paintings, rare inscribed books, and photographs by his friends—we can look back into those first decades. In his own photographs we meet face to face the writers, painters, musicians, sculptors, photographers who in those years were groping for the concepts that still dominate our thinking. We see these men without dramatics, as they were wherever they were when a friend who was often a colleague saw them. We see cities—London, New York, Paris, Pittsburgh, Boston, Edinburgh—each with its individuality revealed by the moods of light and season. We see the shapes of the new century—skyscrapers, bridges, smokestacks—evolving, thrusting, leaping into space. And we see all this through the eyes of a photographer of the company of Stieglitz, Steichen and Clarence H. White. A member of the Photo-Secession, a friend of the cubists, vorticists, and imagists, Coburn worked with the literary titans of the day toward a new medium of words and pictures. Celebrated even then for having an eye that saw pictures where others saw nothing, he looked down from the skyscrapers and made "a cubist fantasy" of what he saw; a little later he dared separate form from subject and made the first true abstractions in photography. Most of these achievements were crowded into seventeen short years.

"Possibly the youngest star in the firmament," wrote Alfred Stieglitz in 1904, when Coburn was twenty-one: "... an indefatigable, enthusiastic worker and student." In photography, which tends to be an art of the mature mind, Coburn was an infant prodigy.

He was born in Boston on June 11, 1882, with ten generations of Massachusetts behind him. Boston in those days still had its look of London; even now, a Bostonian

in London feels he has come home. From the Puritan divines and the Transcendentalists, Boston inherits its deep interest in the study of religions; from the Puritans also, as well as from Emerson, Thoreau, and their friend the sculptor Horatio Greenough—who was the first to hail the beauty of functional forms—Boston inherits its feeling for the austere and plain, the lean, the light, the vital. And from its long sea-faring past, comes Boston's love of the Orient, its ascetic mysticism and its splendor. Every old New England family cherishes jades, porcelains, and lacquered chests inlaid with ivory and mother of pearl, brought back in the clipper ships from China. "From a very early age," wrote Alvin, "I have been interested in things Chinese; I could eat with 'chop sticks' almost as soon as I could with a knife and fork."

When Alvin was seven his father died, and his mother, a remarkable woman whom Stieglitz was to list as "not the least" of Coburn's many advantages, took him to visit her family in California. Here Alvin met the peoples, foods, arts, and even the landscapes of both the Orient and the Mediterranean, for California, when fogs sweep in from the Pacific, becomes a Chinese landscape, while under a hot sun and a deep blue sky its white cities stand sharp as Spain upon its massive hills.

In California, on his eighth birthday, two uncles gave him a 4 x 5 Kodak camera with fifty exposures in it, and showed him how it worked. Back home in Dorchester, Massachusetts, in the old red house among the horse chestnuts, Alvin was soon coating blue print paper in dim, shuttered rooms and setting his printing frames out in the sun. The results, he soon perceived, were "villainous." He plunged to the other extreme, arty techniques such as gum and glycerine. Such attempts to evade straight photography he regards as the measles and mumps of the growing photographer, easy to survive when young, but serious and sometimes damaging to the adult—another reason, he believes, why photographers, like musicians and linguists, should begin as children.

The Orient continued to excite his eye and his thinking. From 1890 to 1897 the great Orientalist Ernest Fenollosa was bringing to the Boston Museum of Fine Arts treasures from China and Japan. Instead of household objects, Boston now beheld sculpture, architecture, screens and scrolls, ceremonial bronzes, robes worn by priests and emperors. For the first time, undoubtedly, Boston learned that the highest and purest art of China and Japan is apparently the simplest: exquisite calligraphic strokes of black or grey on pale silks or papers.

By the time he was fifteen, Alvin's photographs were being exhibited in Boston. That same year, 1898, he climbed up Beacon Hill to a house filled with mystery and incense, and together with what seemed all Boston society, crowded up narrow stairs to see an exhibition of the strange, sombre "sacred photographs" of F. Holland Day. For a year Day had let his hair and beard grow while, like a player in a village Passion Play, he prepared himself to pose as the Christus in the Crucifixion.

Day was a distant cousin of Alvin's—everybody was related in an earlier Boston —and Alvin ventured to bring him a portfolio of his own efforts. Day's response

was to take him as pupil and protégé. To any Bostonian, a year or two of study in Europe appears the proper preparation for a career, so in the summer of 1899, Day shepherded Alvin and his mother to England. Here Day took the boy to the photographic great to study techniques and observe approaches. One of the first was Day's friend Frederick Evans—"red headed, bandy-legged, dynamic," as Alvin describes him—a retired bookseller renowned for his photographs of cathedrals and the perfection of his platinum prints. Evans remarked with pleasure that Coburn had "*none* of that cheeky indifference as to the taking of pains, to mastery of technique, to hard work" so common among American amateur photographers at the time. Alvin even taught Day, his master, how to develop and print. Previously Day had regarded the image on the groundglass as the climax of creation; the darkroom drudgery could be done by assistants, providing one kept a critical eye on results. Alvin, however, not only composed his image to the edge of the groundglass but visualized his finished print on that groundglass before he made the exposure. By 1900 he could take a mudflat, a few random fenceposts and a distant cart dumping rubble and make a photograph of a shimmering space linked by dark accents to broken lights and darks. "The Dumping Ground" is an immature image, but the daring perception behind it is already visible.

Three of Alvin's prints were hung in the 1900 London Salon, then the leading international annual, and nine more were considered by Day worthy of the extraordinary exhibition, "The New School of American Photography," which he was putting on at the Royal Photographic Society. Day's show was not fully representative; Alfred Stieglitz, to whose zeal the New School owed much of its fire and originality, refused to send his work. Nevertheless, the iconoclastic and poetic force of the Americans shocked London; there was outrage and wild applause.

In Paris, Coburn met the tall young American photographer and painter Eduard Steichen, three years older than himself but already beginning to be known for the theatrical power of his portraits and the brio of his multiple gum prints. The facile gum process did not tempt Coburn to handwork, as it did Steichen and many others. He used gum to enrich his platinum prints. Platinum has a silvery delicacy and a long scale of greys, but its whites are watery and its darks pale; Coburn used a coating of gum mixed with vandyke brown pigment to deepen the blacks and make the whites gleam.

In Paris he met French pictorialists such as Robert Demachy, who almost succeeded in making a photograph look like a poor pastel by Degas. Coburn began to feel that the exclamation most pictorialists hoped to evoke: "Why, it looks like an etching!" (or a pastel) was not a compliment but an impertinence. For himself, he intended to be a photographer, and he desired that his work be judged as photographs.

He and his mother continued on through France into Switzerland and Germany, then back to Boston in 1901, and out to California in 1902. They were brisk Bostonians and this was the era of the globetrotters. They could go where they liked; they had independent means. Blithely they crossed the continents on the thundering

trains; blithely they boarded the ocean liners, and heard from their decks the deep whistle blasts find new echoes among the fast rising towers of New York City.

Coburn was full of curiosity and delight, and he was tireless. While in California, he photographed four of the Spanish mission churches. The series of articles he wrote about them for *Photo-Era* marks the beginning of his interest in interpreting places. Then back to Boston again, and down to New York.

Here Alvin was welcomed by the newborn Photo-Secession. Stieglitz, infuriated by wishy-washy pictorialists who could not recognize genius when they saw it, by big business which cared nothing for quality, and by art museums which refused to recognize photography as art, had suddenly "seceded" and formed a group of the most brilliant and dedicated photographers in America. He called it "The Photo-Secession." Steichen, now back from Paris, Clarence H. White, and Gertrude Käsebier were among the first to join him. Again Coburn studied and observe—and photographed. Of Stieglitz, the catalyst, with his extraordinary force and tender-ness, Coburn wrote many years later: "…of course he was the heart and soul of the movement…did wonderful work for the recognition of Pictorial Photography, but he was a bit of a Dictator and liked to run things his own way! I was young and full of the zest of life, and did not always agree with his policy, but I was very fond of him, and I owe him much kindness and encouragement." And of Clarence H. White:"… one of the finest artists photography has produced…He is never dramatic, but always subtle. He exploits the Platinum process in all the delicacy of its tonal range. He is never cheap or commonplace, but always original, and his influence on American pictorial photography cannot be overestimated." Coburn was drawn also to Gertrude Käsebier, old, valiant, and kind, for whom each portrait was a new adventure.

The Photo-Secession elected Coburn to membership on December 26, 1902. They were bringing out the first number of their magnificent quarterly, *Camera Work,* tipping in with their own hands the sensitive photogravures on Japan tissue which Stieglitz had watched and cosseted throughout their engraving and printing. They did not yet have a gallery. Coburn's first one-man show was held at the Camera Club of New York in January 1903. Stieglitz found in his work "much that was original and unconventional."

For a while Coburn worked in Käsebier's studio; then he went back to Boston and opened his own studio. But studios, to Coburn, who later had one in New York and then another in London, were places to work and display prints rather than businesses. He was still the student; the summer of 1903 he spent with the painter Arthur Dow, a friend of the Photo-Secession, and used palette or camera as he chose. Here his eye was sharpened rather than weakened, like many of his contem-poraries, by a further study of Japanese art. He saw the pale creeks winding through the Ipswich marshes as a dragon form; he transformed what one critic described as "the back of a row of city houses over a six-foot board fence" by "taking the most severe lines and the blankest of blank spaces and reducing them to a work of art by the use of delicate tonality." Sadakichi Hartmann, the brilliant and erratic critic who

chose the pseudonym, Sidney Allan, commented that Coburn was "beginning to see objects, insignificant in themselves, in a big way." On November 21, 1903, the Linked Ring, an international society then composed of leading photographers only, elected Coburn to membership.

The first number of *Camera Work* to present a portfolio of Coburn's work appeared in April 1904, and it was there that Stieglitz hailed him as "the youngest star." These were great honors, but Coburn humbly went on learning. If one year Frederick Evans felt he lacked a keen observation of light, the next year Evans could write of "London Bridge"—"perhaps the very truest rendering of sunlight photography has yet achieved." And Sadakichi Hartmann, after praising his landscapes: "...he seems to have a natural gift for line-and-space compositions and has solved various problems which even would have set a Stieglitz or a Steichen thinking...." remarked that: "His portrait work, however, is at present rather unsatisfactory. He seems to lack the gift of the characterization."

Coburn's response to this was to plunge into a a project that was to engross him, off and on, for the next eighteen years: "Photography...brought me into touch with many of the people I was eager to meet: the pioneers and advanced thinkers and artists of that time." With the help of Periton Maxwell, editor of the New York *Metropolitan Magazine,* he made a list of leading literary figures, most of whom were British, and began a course of intensive reading: "...it was my practice before meeting my subjects, to saturate myself in their books so that I might previously come to know something of the inner man."

In the spring of 1904, Coburn went again to England; suddenly he saw London in its splendor. He scribbled to Stieglitz: "Blessed is the man who found his work—after all there is no place like London. I have never really done any photographic work before—wait until you see the new stuff!"

Late in July, he decided to begin his portrait series with the fiercest and least predictable lion of them all. He wrote a little note to George Bernard Shaw, asking if he might come to Welwyn, where Shaw was living that summer, and make his portrait. Shaw, an enthusiastic dabbler in photography, already knew Coburn's work; he wrote back yes, and instead of lugging all that stuff, would Coburn like to use any of his own three cameras, or his lenses, or his Cristoid films? He had no darkroom but the bath could be converted. One's admiration for great men seldom extends to a trust in their cameras; Coburn preferred his own 8 x 10. August 1 was a Bank Holiday; there were no carts or carriages to hire. But there at the station was Shaw, with a long staff to sling the camera on; each taking one end, they trotted off coolie fashion. Shaw was the perfect model—"with enough of the actor to know the value of a pose." Coburn, changing films in the bath-darkroom made at least fifty exposures. It was the beginning of a lifelong friendship.

The next author Coburn approached was that strange figure, G. K. Chesterton, poet, journalist, critic and mystic. Chesterton was also living deep in the country.

But nobody met Coburn at the station and there was not even a wheelbarrow to hire. Coburn toiled on alone under his load; it was a hot, hot day. Suddenly he saw, sitting in the shade of a tree and clad in a green Tyrolean suit, Chesterton himself, busily scribbling away at a column on cabbages. Coburn made the portrait on the spot, and took the column back to London with him.

By the second week in September, Coburn had photographed five more authors, and a painter, Frank Brangwyn. Feeling this project well begun, and that he could do with a little respite, he went up to Scotland and acquired three more projects. Two he caught by contagion from J. Craig Annan of Glasgow, a fellow member of the Linked Ring. As a boy, living in Rock House, at the foot of Calton Hill in Edinburgh, Annan heard his father tell how his friend, the landscape painter David Octavius Hill, photographed against these same walls and doors the divines, great ladies, poets, explorers and sculptor—even the huntsmen and small kilted boys—of the middle 1840s. Moved by the noble simplicity and dignity of the few prints he saw, Annan made prints from the calotype negatives in the original spirit. Praise from such artists as Whistler helped him launch the excited rediscovery of this for-gotten pioneer. Coburn resolved to collect the work of early masters himself. From Annan he acquired the same concave mirror Hill and Adamson had used to reflect light into the shadows when sunlight fell too harshly.

He saw Annan making, from Hill's negatives as well as his own, magnificent photogravures. If Annan could etch and ink and print such things himself, then Coburn could do no less than try. P. H. Emerson, the physician and poetic documentarian who in the 1880s fired the opening guns in the battle for photography as an art in its own right, had been the first to experiment with and recommend photogravure. The three years Stieglitz worked as a professional photoengraver lay behind the beautiful gravures in *Camera Work.* There was no doubt in Coburn's mind that a photogravure, when made by the artist himself or supervised from start to finish by him, could equal an original print in intensity. Further, a photogravure was permanent, and a thousand copies or more could be run off with ease.

The city of Edinburgh was the greatest excitement. With Stevenson's *Edinburgh —Picturesque Notes* as his guide, Coburn lugged his 8 x 10 up steep alleys to look back at the Castle, entered ancient and once noble closes, waited in Greyfriars Cemetery until cats came to bask on sunlit, ancient tombs. Love of places, and patience to wait like "a cat at a mousehole" for the moments of their transfiguration, became a part of him forever.

Then he went back to London and the pursuit of portraiture. There were other problems than his own shyness and hesitation to intrude. The novelist George Meredith was said to have a horror of photography. So Coburn, one beautiful October day, "took a little portfolio of my work under my arm. I had no letter of introduction, though I could easily have obtained one. I just walked up the drive to his little ivy-clad house, with a song in my heart to match the day, and my luck was with me. I was at

once shown into his presence." This was a mistake; Meredith was expecting another visitor.

"...what a head! I think I have never seen any modern person who was even remotely like him. He resembled an ancient Greek bust, a head of Zeus, calm in its tranquillity, regal in its dignity. And what a model of perfect gentle courtesy; he never let me know that an error had been made in my favor, but looked at my portfolio with obvious interest, even enthusiasm...he was firm in his determination not to give me a sitting. He said that he did not want to be photographed in his age and made to look like an old monkey, as Tennyson had been." This was not Coburn's opinion of the magnificent portraits Julia Margaret Cameron made of Tennyson, though Tennyson himself wrote under one print, "The dirty monk."

Coburn did not press Meredith; he noted his exclamation, "How beautiful!" over a print of a young mother suckling her child, and next day, sent him the print with a note on what a pleasure it had been to meet him. Meredith wrote back, "You heap live coals on my head." Contritely, he offered to introduce Coburn's "poetically artistic work" to some editor of illustrated journals, or would Coburn prefer to photograph his daughter? Coburn chose the daughter, who insisted first on a family group and then on each member separately. When Coburn saw that luminous head at last in his groundglass, he felt much as the maligned Mrs. Cameron did: "When I have had such men before my lens...the photograph taken has been almost the embodiment of a prayer." He wrote, "If I have done no other thing in my life, I have made a worthy portrait of George Meredith."

Nevertheless, Coburn was slow in outgrowing his timidity in the presence of the great. A year later, when Shaw took him to meet and photograph H. G. Wells, whose startling novels projected life in the twenty-first century: "...I remember how nervous I was, and how I spilled a cup of very hot tea in my lap, and how I had to put on a pair of Wells's trousers while my own were dried! I really was a very shy young man in those days."

In New York the winter of 1905, he was commissioned by *Century Magazine* to do a series of portraits of American authors, including Mark Twain and Henry James, to whom he was instantly drawn: "There are some people you cannot help liking the moment you see them, and Henry James was, for me, such a person."

At the 1905 London Salon, a reviewer noted:

A.L. Coburn...has made a leap this year...and with Eduard Steichen shares the honors of the American section.... Mr. Coburn, it is clear, has not endeavored to pose his sitters to suggest characterization, but has relied upon the management of light to convey his intention. Sparkling illumination surrounds the buoyant head of Mark Twain and one thinks of trifles light as air. A grey film seems interposed between the observer and the grim seer, Chesterton....

On November 24, 1905, "The Little Galleries of the Photo-Secession" opened at 291 Fifth Avenue, New York. Three small rooms in quiet colors, with lowered ceilings and good light—that was all, yet they were to be the center of storm and

triumph, they were to blaze with controversy and beauty. Steichen, being also a painter, proposed, and Stieglitz agreed, that they would from time to time show "art productions, other than photographic."

The first year was devoted to photography; the achievement of American, British, German, Austrian and French photographers was seen in one-man, two-man, and small group shows. As early as 1906, a member of the Photo-Secession, Joseph Keiley, could state in *Camera Work:* "…the real battle for the recognition of pictorial photography is over. The chief purpose for which the Photo-Secession was established has been accomplished—the serious recognition of photography as an additional medium of pictorial expression."

Early in 1906, the Royal Photographic Society decided to give Coburn a one-man show. Shaw, when Coburn told him the news, said, "You will need someone to beat the big drum for you. I will write you a preface." In those days Shaw took great delight in turning the guns of art critics on themselves; if they disdained photography as easy and mechanical, he claimed that painting was easier, quicker and more mechanical than photography. Neither could he ever resist dropping a few bombs among the duller photographers. In the preface for Coburn's catalogue he managed very neatly to do both.

> Mr. Alvin Langdon Coburn is one of the most accomplished and sensitive artist-photographers now living. This seems impossible at his age—twenty-three; but as he began at eight, he has fifteen years' technical experience behind him. Hence, no doubt, his remarkable command of the one really difficult technical process in photography—printing. Technically good negatives are more often the result of the survival of the fittest than of special creation: the photographer is like the cod which produces a million eggs in order that one may reach maturity.

He then proceeded, by a series of delicate insults, to infuriate, enchant and convulse his audience by his comments on outstanding photographers noted for their prowess in printing; as for Coburn:

> If he were examined by the City and Guilds Institute, and based his answers on his own practice, he would probably be removed from the class-room to a lunatic asylum. It is his results that place him 'hors concours'.

Then Shaw really hit his stride:

> Look at his portrait of Mr. Gilbert Chesterton, for example! 'Call that technique? Why, the head is not even on the plate. The delineation is so blunt that the lens must have been the bottom knocked out of a tumbler; and the exposure was too long for a vigorous image.' All this is quite true; but just look at Mr. Chesterton himself! He is our young Man Mountain…who is not only large in body and mind beyond all decency but seems to be growing larger as you look at him—'swellin' wisibly' as Tony Weller puts it. Mr. Coburn has represented him as swelling off the plate in the very act of being photographed, and blurring his own outlines in the process…You may call the placing of the head on the plate wrong, the focussing wrong, the exposure wrong, if you like, but Chesterton is right; and a right impression of Chesterton is what Mr.

Coburn was driving at.... It is the technique that has been adapted to the subject. With the same batch of films, the same lens, the same camera, the same developer, Mr. Coburn can handle you as Bellini handled everybody; as Hals handled everybody; as Gainsborough handled everybody; or as Holbein handled everybody, according to his vision of you. He is free of that clumsy tool—the human hand—which will always go its own single way and no other. And he takes full advantage of his freedom instead of contenting himself, like most photographers, with a formula that becomes almost as tiresome and mechanical as manual work with a brush or crayon. In landscape he shows the same power. He is not seduced by the picturesque, which is pretty cheap in photography and very tempting; he drives at the poetic, and invariably seizes some-thing that plunges you into a mood, whether it is a cloud brooding over a river, or a great lump of a warehouse in a dirty street. There is nothing morbid in his choices: the mood chosen is quite often a holiday one...the mood that comes in the day's work of a man who is really a free worker and not a commercial slave. This is done without any impoverishment or artification; you are never worried with that infuriating academicism which already barnacles photography so thickly.... Mr. Coburn goes straight over all that to his mark, and does not make difficulties until he meets them, being, like most joyous souls, in no hurry to bid the devil good morning.

The boom of the big drum was heard on both sides of the Atlantic. Sheaves of Coburn's photographs were appearing in the magazines: *The Metropolitan Magazine,* New York, February 1906: eight photographs, "Photographic Impressions of New York." *The Pall Mall Magazine,* London, April: seven photographs, "A New Aspect of London." *The Metropolitan,* May: five photographs, with an article on Coburn by Shaw. *The Pall Mall,* June: six photographs interpreting the setting for Charles Dickens's unfinished mystery story, "Edwin Drood," with a preface by one of Dickens's daughters. And *Camera Work,* July: five photographs, with the Shaw preface, and a portrait by Shaw of Coburn.

Meanwhile Coburn, like any apprentice, was studying two nights a week at the London County Council School of Photoengraving: he was "proud to be a crafts-man as well as an artist." He went on with his portraits. At Meudon, in April, he made a heroic and vigorous head of Rodin, to whom Steichen had become almost another son. In Paris, he watched Steichen develop, in his own dark room, a color transparency with little more difficulty than an ordinary negative. There were many such color processes, but Coburn joined Steichen in believing that Autochrome, this new three-color process developed by the Brothers Lumière, was the finest so far. It produced only a transparency, unstable like all transparencies dependent on dyes, but the image gleamed like a jewel from its dark mirrored case. They all fell in love with it, amateurs, artists, publishers. Stieglitz introduced it to New York on September 30, 1906, with a show at '291' of Autochromes by Steichen, Frank Eugene, and himself. Coburn wrote Shaw, what about a portrait in Autochrome? Shaw, whose red beard was fast going grey, wired back, "Hurry, while there is still some color." When they got together, they decided a plaid might help; this portrait heads an early biography of Shaw.

But Coburn's search for the lights and moods that reveal both places and peoples was leading him in another direction just then: photographs to interpret words. The ghost of Stevenson had been his first guide, and Dickens his second; now he began to work with living masters. The most fascinating of many collaborations began in June 1906, with a letter from Henry James, now back in England and living at Lamb House, Rye. He was preparing a collected edition of his novels and tales, and needed a new portrait as frontispiece. Would Coburn come down to Rye and photograph him? Coburn "produced a result that evidently satisfied him, for he subsequently suggested that I should make photographs to be used in other volumes of the forthcoming collected edition: and thus began our friendship." Coming from James this was an extraordinary proposal, for, as he wrote in his preface to *The Golden Bowl,* he regarded illustration in general as "a lawless incident," and feared

> the picture-book quality that contemporary English and American prose appears more and more destined, by the condition of publication to consent, however, grudgingly, to see imputed to it....Anything that relieves responsible prose of being while placed before us, good enough, interesting enough, and if the question be of picture, pictorial enough, above all *in itself,* does it the worst of services, and may well inspire in the lover of literature certain lively questions as to the future of that institution.

Nevertheless, James found it

> charming...for the projector and creator of scenes and figures...to see such power as he may possess approved and registered by the springing of fruit from his seed...One welcomes illustration in other words, with pride and joy; but also with the emphatic view that, might one's 'literary jealousy' be duly deferred to, it would quite stand off and on its own feet, and thus, as a separate and independent subject of publication, carrying its text in its spirit, just as that text correspondingly carries the plastic possibility, become a still more glorious tribute.

What he proposed to Coburn was that together they should hunt through the camera for "images always confessing themselves mere optical symbols or echoes... small pictures of our 'set' stage with the actors left out...." There were to be twenty-four of these and each would serve as a frontispiece to one of the twenty-four volumes of *Novels and Tales.*

They knew, of course, that every connotation of light, mood and detail must be right, and this hunt through reality for images which by now existed in his own mind, "from the moment I held it up to my fellow-artist in the light of our fond idea"—fascinated James. "The looking so often flooded with light the question of what a subject, what character...is and isn't."

The first image found was of James's own home, Lamb House, which appeared in *The Awkward Age* as "Mr. Langdon's." In October, Coburn went to Paris, "armed with a detailed document from James explaining exactly what he wanted me to photograph." One symbol was to be a porte-cochère in the Faubourg St.-Germain: "His knowledge of the streets of Paris in this particular quarter was amazing. He

enumerated nine or ten streets I was to traverse.... His letter continued: 'Once you get the type into your head, you will easily recognize specimens by walking in the *old* residential and 'noble' parts of the city.... Tell a cabman that you want to drive through every street of it, and, having got the notion, go back and walk and stare at your ease.' This was thoroughness! This was H.J.'s way of himself approaching a problem." Another of the six subjects to be found in Paris was "the pedestal of some pleasant old garden-statue. Go to the Luxembourg Gardens to look for my right garden-statue (composed with other interesting objects) against which my chair was tilted back." James finished these instructions "with the kindly benediction: 'My blessing on your inspiration and your weather.' "

When they were able to "gloat together over the results," James was "even as a boy, always displaying an unquenchable and contagious enthusiasm over every detail concerning these illustrations. That was what made it such a joy to work with him."

Coburn's next expedition was to Italy: two images to be found in Rome, two in Venice. He found himself in Venice at Christmas—"never before or since have I felt so cold and damp"—and his instructions included how to approach a certain place "either on foot through narrow winding footways, or by gondola, with the advantages of each method."

The next images were to be of London; Coburn and James went hunting together, these two cosmopolitan gentlemen, one old and one young, and found it definitely an adventure. There was the lovely afternoon they found the perfect house at the perfect moment, and hungry and exhilarated, sought a teashop but found only a bakery, and went down the street munching large buns like schoolboys. There was the day they took a hansom cab out to Hampstead Heath in search of a certain group of trees, and James left his gold-headed cane with the driver as assurance of their return.

James concluded that "London ends by giving one absolutely everything one asks...we had, not to 'create,' but simply to recognize—recognize, that is, with the last fineness." Thus they could wait in Portland Place, confident that "at a given moment the great featureless Philistine vista would itself perform a miracle, for a splendid atmospheric hour, as only London knows how; and that our business would be then to understand."

James regretted that the small format chosen for the *Novels and Tales* did not permit full-size gravures: "This series of frontispiece contribute less to ornament, I recognize, than if Mr. Alvin Langdon Coburn's beautiful photographs, which they reproduce, had had to suffer less reduction; but of these which have suffered the least, the beauty, to my sense, remains great...."

The last three images were to be found in New England and New York. Stieglitz asked Coburn for a one-man show in the spring; Coburn wrote him from London on January 12, 1907: "I am working hard on a lot of new things in black-and-white and colour which I always make with the idea in the back of my head, what will A.S. think of it? It keeps me up to the mark I can tell you!" A week or so later with Baron

Adolph de Meyer, another young photographer about to be presented at "291," Coburn finished an "Exhibition of Modern Photography" at the Goupil Gallery, then crossed to New York, found James's images, helped hang the show at the "Little Galleries," —Stieglitz commented that it drew "crowds second to none"—went to Washington to photograph Theodore Roosevelt in the White House on April 1, and a few days later was hanging another one-man show at the St. Botolph Club in Boston.

This pace became characteristic; for the next few years, Coburn shuttled between the continents, now in London, helping the Salon put up its increasingly dull annuals, now in New York where "291" was beginning to show, more and more often, the work of painters and sculptors, unknown beyond the Left Bank, who bore such names as Matisse, Cézanne, Picasso, Braque, Brancusi. Of the new group at "291," Coburn was most attracted to "that great modern American painter, Max Weber, who had the vision—even in those early days—to see the possibilities of photography as a field of artistic endeavor." Weber was exhorting photographers to photograph design and emotion; subject was immaterial—golf clubs, a table, the side of a barn—anything could serve as a springboard. Coburn had been doing exactly that for years.

Coburn's work was now in constant demand by publishers and editors; four photographs of flowers and old gardens for the American edition of Maurice Maeterlinck's *The Intelligence of Flowers;* nine photographs to go with John Masefield's *Liverpool, City of Ships* in the *Pall Mall,* for March, 1905. Portraits for biographies; Autochromes of Charles Freer's fine collection of Oriental art in Detroit; photographing the sandhogs who were digging the tunnels under the rivers of Manhattan, going down with them into those rough, dark and leaky burrowings. To Dublin, to make portraits of the leaders of Irish Renaissance:"…I captured Yeats by flashlight, reciting one of his poems. He wore a velvet coat and a flowing black tie at a dinner given in his honour by Lady Gregory." Yeats was also getting out a *Collected Works* in 1908, and refused to have any other photographer than Coburn, "who," he wrote, "is celebrated in our world." But Coburn's portraits were uncomfortably perceptive; in the end Yeats chose pastels and drawings which showed him as he wished he were. To Connecticut, to spend a weekend just before Christmas, 1908, with Mark Twain at "Stormfield"; to the White House again, for a portrait of the new President, Taft.

Month by month, sometimes week by week, the magazines crowd the record: in the United States, *Harper's, Everybody's, The Metropolitan, Cosmopolitan, The Century , Literary Digest;* in Britain, *The Sketch, The Pall Mall, Illustrated London News, International Studio.* Demands for pictures came from France and Germany also; of course there were always the photographic magazines and, whenever Stieglitz wished, *Camera Work.*

Anytime he could, whatever hemisphere he happened to be in, he departed for a week or more of wonder and delight with his camera. A spring wandering through Italy, from Venice through the hilltowns down to the ruined temples of Sicily;

another spring sailing down the coast of Spain in a steamer with a load of sardines; a summer in the medieval and baroque villages of Bavaria and the mirrored old towns of Holland; an autumn in Scotland or Ireland. He never felt he knew a place until he had photographed it. He waited for "the visions of life that flash and are gone like the sun glancing from the white side of a ship at sea." Clouds and water could hold him for hours—"the subtle play of sunlight on moving water...the poetry of liquid surfaces."

For two nights a week during the last three years, whenever he was in London, he had been studying photogravure. In 1909 he bought a charming old house in Hammersmith so close to the Thames that he called it "Thameside" and now and then had problems when the river rose in flood. In "Thameside" he set up not only a darkroom but two presses, and began work on two books and a set of large gravures. He etched and steel-faced his plates, ground his own inks, and pulled proofs on various papers until he had a model his printer could follow to the end of the run. The printer, having been trained on postage stamps, made his first proofs in "a beautiful bright blue." Nevertheless, between them, they produced fifty thousand impressions in two years.

The first book of these gravures was *London,* 1909, twenty plates with a preface by Hilaire Belloc, on the peculiar growth and significance of the city, which has no relation beyond title with Coburn's photographs. But the second book was *New York,* 1910, and H. G. Wells understood both the function of photographs and the writer's function; in a page and a half, briefly and brilliantly, he gave the photographs wide dimensions of thought and action; he summarized the dynamics of rock, rivers, sea, people that were crystalizing into Manhattan, even to "the exhilaration of the air." He foresaw:

> Our time will go to our descendants heavily and even over-abundantly documented, yet still I fancy these records of atmosphere and effect will gleam, extremely welcome jewels, amidst the dustheaps of carelessly accumulated fact....Mr. Coburn has already done his share in recording that soft profundity, that gentle grey kindliness which makes my mother London so lovable....And now here he has set himself...to give in a compact volume the hard, clear vigour of New York, that valiant city which even more than Venice rides out upon the sea...its lights increase and multiply until they blind the stars. A hundred years hence people will have these photographs, but I wish Mr. Coburn could show me pictures of New York a hundred years from now.

Wells's next book, *The Door in the Wall,* 1911, contained ten gravures by Coburn.

The theater was another of Coburn's passionate delights; he began photographing, mostly for *The Sketch,* scenes and individual characters from Galsworthy's *Justice,* Meredith's *The Sentimentalists,* and, with special pleasure in the imaginative costumes, Maeterlinck's mystic allegory, *The Bluebird.* During a rehearsal of *Androcles and the Lion* in 1913, he caught Shaw himself in a magnificent lunge, brandishing a sword, telling the producer what he wanted.

He and Shaw planned a book together on "How to Solve the Irish Problem," and

Coburn went to Ireland in the fall of 1910 to serve as Shaw's eyes. After that Coburn sailed for America, but arrived in Buffalo just too late for the opening, on November 4, of the great Photo-Secession show. Coburn had had a hand in arranging for this exhibition, but it was Stieglitz who made it and Max Weber who directed the installation, bringing the height of the huge classic galleries down by ceilings of blue gauze so that the photographs could gleam and glow in intimacy. The show was an immense success; the Gallery bought thirteen photographs, among them Coburn's "El Toro," for its Permanent Collection. But for many mem-bers there was a feeling of farewell. The Photo-Secession had done its work; it was dying and would soon be dead. Stieglitz had come to feel that the creative excitement was gone from photography; that photographers were becoming smug and arty, imitative not only of other arts but of each other. From then on the walls of "291" and the pages of *Camera Work* rarely showed photographs; one show of De Meyer, and one of Stieglitz himself—during the Armory show. Then no more until 1916, when Stieglitz found in the young Paul Strand the dynamic new vision he was seeking.

From Buffalo Coburn went to Pittsburgh, and photographed the steel mills, river steamers, railroad yards in the steam, smoke and snow of December. The drama of industry—the pouring of white-hot steel, the sparks around a welder—excited him. Then to Boston, where, in January 1911, he photographed Beacon Hill in the bare low lights and treeshadows of winter; to New York, where he made a portrait of Max Weber. Then be boarded a train for California.

For the first time Coburn understood what it is to be tired; the pace, the production had been incessant. He went up to Yosemite Valley. There was still snow on the peaks and domes thousands of feet above its exquisite river meadows and forests. For months he immersed himself in this beauty; camped out, climbed, hiked, dreamed, watched the clouds, exulted in storms, lights, horizons.

For him, this tremendous reality became most meaningful under cloud-light. Half Dome became a huge, hooded, shimmering shape, accented by the snowdrift still lingering on its peak and the dark stain of melting down its face. The wind-flowing, snow-bent pine on Sentinel Dome he saw as "a Chinese tree," a beautiful arrangement of tones against a pale sky.

In September he went down to the Grand Canyon. To photograph from its terrifying rims and capes was not enough; he hired a guide, and went down the steep trails cut into its precipices. Whenever storm-shadow, sunlight, or rain isolated one of the vast "temples" or gave recession to the abyssal sea of rocks, he photographed; his organization is subtle and daring. At the bottom, a mile almost straight down, he and his guide, with cameras, lenses, film, food, water, and other equipment necessary for survival, crossed the dangerous Colorado in "a wire cage slung on a cable which you operated by a hand-turned wheel to pull yourself over. On the far side, it was necessary to catch semi-wild donkeys with which to continue your journey…." He camped in unknown and nameless canyons, deep in the

"isolated and awful grandeur, with only the rattlesnakes, the wild donkeys, and 'Old John' for company, under the glory of the stars."

In January 1912, he came back; in snow, what would the Canyon look like? In his excitement he ventured a few feet too far: "...from an overhanging cliff in the winter's snow, my foot suddenly penetrated the ice-crusts, and through the hole I saw the abyss of the gorge five thousand feet below! I had gone out on a shelf of nothing more stable than ice...."

Back in Los Angeles, looking through his negatives, he kept thinking of Shelley's ode, "The Cloud." He had the poem handsomely set in type, and bound together with six original platinum prints in an edition limited to sixty copies. The photographers around Los Angeles wanted to see his work; he put on two shows for them. Of nearby Long Beach he made an infinite picture—people small and dark on the sands, bright lights on the Pacific, fog on the horizon—and photographed a roller coaster for sheer delight in the pattern made by its struts and chutes.

Then he headed East again; to Boston, where W. Howe Downes of the *Boston Transcript* acclaimed "the surpassing beauty" of *The Cloud,* and commented that the Grand Canyon "has been the despair of art...Coburn with his camera has been the first to give us any idea of the grandeur and mystery and sublimity...." Then he went down to New York to organize "An Exhibition Illustrating the Progress of the Art of Photography" for the Montross Galleries.

New York, in 1912, he saw with new eyes. After Yosemite and the Grand Canyon he could not wait to look out from its tallest towers. He had plodded up trails to much greater heights; here he could float up in an elevator, cameras and all. He photographed the nearby towers, their endless rows of windows, their plunging verticals. Looking straight down he saw paths shovelled through the snow on Madison Square forming an octopus.

In the section "New York from its Pinnacles" of the catalogue of his one-man show at the Goupil Gallery next year, he wrote:

> How romantic, how exhilarating it is in the altitudes, few of the denizens of the city realize; they crawl about in the abyss intent upon their own small concerns....Only the birds and a foreign tourist or two penetrate to the top of the Singer Tower from which some of these vistas were exposed.
>
> No one can deny the verity of the camera, yet surely 'The Thousand Windows' is almost as fantastic in its perspective as a Cubist fantasy; but why should not the camera artist break away from the wornout conventions, that even in its comparatively short existence have begun to cramp and restrict his medium, and claim the freedom of expression which any art must have to be alive?

The day after the "Progress of Art" show opened, he married the enchanting Miss Edith Clement of Boston. With his bride he sailed for England; it was his twenty-third crossing since 1900. He has not returned to America since.

Focus, to Coburn as to Stieglitz, White and Evans, was simply an additional control of the image. Coburn, for instance, with a slight degree of out-of-focus, could

make the traffic on "London Bridge" into a dancing river of specular lights; with a degree more, in "El Toro," at the one bullfight he ever attended, he could make the bull a menacing silhouette and the matador a gleam. Mostly, however, the masters preferred a soft clearness, left the blobs of extreme out-of-focus to would-be artists among the amateurs, and the other extreme of needle-sharpness to commercial photographers. Now, however, Coburn found himself desiring more clarity. In the *Pall Mall,* in June 1913 he wrote:

> I wish to state here very emphatically that I do not believe in any sort of handwork or manipulations of a photographic print or negative. I would much rather have a hard, sharp, shiny old-fashioned silver print…than the modern trash, half photography, half very indifferent draughtsmanship…I cannot refrain from quoting Shaw again: 'A man may imitate the noises of a barnyard, and do it very well, but it is an unpardonable condescension all the same.'

By the spring of 1913, edge and texture had become, for Coburn, as important as tone, and the patterns made by repeated forms an increasing delight. In Paris he photographed such motifs as the buttresses of a bridge across the Seine, and chimneypots making a structure of accents upon the rooftops. He met Gertrude Stein and "was privileged to go to one of her 'At Homes,' and see her wonderful collection of modern paintings… it was through her that I met and photographed Matisse."

With the portrait of Matisse leaning on a stepladder with his glowing palette in his hand, Coburn concluded supervising the thirty-three photogravures for his book *Men of Mark,* which appeared in the fall of 1913. He wrote in his introduction:

> I have not attempted to do anything eccentric in the way of portrayals, but I have studied my men and their works with enthusiasm, and in each instance I have tried to catch and reveal the elusive something that differentiates a man of talent from his fellows, and makes life worth while, worth struggling with towards ever greater understanding.

Immediately he plunged into a new series of portraits; he had in mind not only *More Men of Mark,* but also a series of prominent women, and still another of musicians.

That October he went down to Dorchester to photograph the novelist Thomas Hardy; they spent a wonderful afternoon scuffling through autumn leaves to the old Roman amphitheatre. Then the writer and editor Holbrook Jackson: "Between us, we nearly blew the roof off a laboratory in Sheffield with a half-pound tin of flash-light powder which was supposed to be damp, but, somehow, wasn't!" The next was that brilliant and truculent figure Ezra Pound, who had recently defined the Imagist movement in poetry and was soon to champion vorticism, the English variant of cubism. "And then there was Ezra Pound!" wrote Coburn, in *More Men of Mark,* 1922. "But why do I speak of him in the past tense? Is not our Ezra always with us? At almost any private view of the very latest thing in Super-Modern Art are not his Leonine Mane and Large Lapis Coat Buttons to be found at the very

heart and center of the Vortex?...our Ezra is a fine fellow—a terrible adversary, but a staunch friend."

The series continued, under all sorts of difficulties: "I always make it a point to work under any conditions in which I find my sitter—"; Anatole France on a stair landing: "we were a bit cramped for space—"; Georg Brandes, the controversial Danish critic, in an "olive-green fog"; the painter Augustus John in his Chelsea studio; the sculptor Jacob Epstein on a bitter cold balcony; H. H. Asquith at Downing Street a few months before World War I.

Coburn, of course, was still photographing place and atmosphere, and one of his most exquisite interpretations appeared in a little book *Moor Park, Rickmansworth,* in 1914; twenty plates of the beautiful and ancient country house, its doorways and mantels, its gardens and deer park.

In 1914, too, Coburn had privately printed for his fiends another *London,* this time with an essay by G. K. Chesterton, and ten of his new photographs. Seven photographs of ships appeared with John Masefield's poem "Ships" in *Harper's Monthly* that Christmas.

Music was another of Coburn's passions, and particularly the music of the early twentieth century. This was then recorded so rarely that he bought a mechanical piano and had a machine made by which he could cut rolls of music not commercially available, such as Debussy, Ravel and Scriabin. He and J. Dudley Johnston "even had made for us two rolls, one each of the first composition of Stravinsky ever to be cut for the Pianola!" Coburn also "was very interested in the *patterns* made by the holes punched in the paper, and experimented with the sounds made by patterns merely conceived visually! I found that the patterns of Bach were especially beautiful." Among the musicians he photographed were Sibelius, Delius, Moiseiwitch, and Stravinsky.

In 1915 he shocked pictorialists on both sides of the Atlantic by putting on, at the Albright Art Gallery in Buffalo, New York, and at the Royal Photographic Society in London, "The Old Masters of Photography." This was chosen from his own collection of the work of Hill and Adamson, Julia Margaret Cameron, Dr. Thomas Keith and "Lewis Carroll." Some were original prints, some his own prints from the original negatives. It was a summary and a challenge; pictorialists wondered what, if any, advances in the creation of photographic images had been made during the last half-century.

Through Ezra Pound, Coburn found himself getting deeper and deeper into "the Vortex." All the arts were in flight from reality—music, painting, poetry, dance, theater. Pound, as literary executor of Ernest Fenollosa's Oriental papers, had become fascinated by the notes on the classic No dramas of Japan, with their stylized and symbolic use of mask, gesture, music, dance. William Butler Yeats, with his love of the symbol and distrust of the naturalistic, began to write plays in the No tradition. His *At the Hawk's Well,* with Michio Ito as the Hawk, and all players in masks and costumes by Edmund Dulac, was first given in Lady Cunard's living room in April

1916, then revived a few days later by Lady Islington for a war charity. Of course, it was Coburn who photographed the dancers and actors.

Early in 1916 Coburn photographed the vorticist painters Wyndham Lewis and Edward Wadsworth. He wrote of them in 1922:

> Now, you know, I am very fond of these revolutionaries. They care not for the musty conventions of classical art, or the vested interest of the art dealer. 'Theirs not to reason why,' theirs but to square and cube and vorticize, as the spirit moves them...I wonder what will happen when *they* get to be established classics! Even now, in a few short years, this possibility is not without the pale of reason. For is not Picasso realizing large rewards for paintings which only yesterday, it seems, were laughed to scorn?

He was equally prophetic about photography; in *Photograms of the Year,* 1916, he issued a challenge:

> ...why should not the camera also throw off the shackles of conventional representation...? Why should not its subtle rapidity be utilized to study movement? Why not repeated successive exposures of an object in motion on the same plate? Why should not perspective be studied from angels hitherto neglected or unobserved? Why, I ask you earnestly, need we go on making commonplace little exposures that may be sorted into groups of landscapes, portraits and figure studies? Think of the joy of doing something which it would be impossible to classify, or to tell which was top and which was the bottom!...I do not think we have begun even to realize the possibilities of the camera.

Elsewhere in the same *Photograms* it was remarked with some irritation that "Alvin Langdon Coburn never settles down," and just then he was preparing to be more unsettling still.

"There was a notion at that time that the camera could not be abstract, and I was out to disprove this." He clamped three mirrors together in a triangle, poked his lens into it, and photographed the multiple reflections of bits of glass and wood laid on a table with a glass top. "The principle was similar to the old kaleidoscope....The patterns amazed and fascinated me."

Pound came to see; Coburn caught his profile reflected in the mirrors, and made an amusing repeated silhouette reminiscent of a Rorschach test. He called it "The Center of the Vortex." Pound christened the device the "vortescope" and the results "vortographs."

When the London Camera Club asked Coburn for a one-man show, he answered yes, if he could show whatever he wished. He chose eighteen vortographs—and thirteen of his own paintings.

To the catalogue, Pound contributed a preface—anonymous at the time, but later reprinted, somewhat shorn, in *Pavannes and Divisions,* 1918. No matter how infuriating one might find Shaw, the lunge and riposte of his wit were a delight. Pound's preface, on the other hand, resembles a series of carefully dropped bricks. One recipient of a brick was Coburn's painting, which Pound dismissed as

> roughly speaking, post-impressionist...there is no connection between Mr. Coburn, as painter, and the group known as the vorticist group.

I am concerned here solely with vortography. The tool called the vortescope was invented late in 1916. Mr. Coburn had been long desiring to bring cubism or vorticism into photography....In vortography he accepts the fundamental principles of vorticism....

These principles, he explained, were based on Pater's "All arts approach the condition of music," and Whistler's "We are interested in a painting because it is an arrangement of lines and colors." Through vortography, he proclaimed:

THE CAMERA IS FREED FROM REALITY.

A natural object or objects may perhaps be retained realistically by the vortographer if he chooses, and...if they form an integral and formal part of the whole.

The vortescope is useless to a man who cannot recognize a beautiful arrangement of forms on a surface....His selection may be *almost* as creative as a painter's composition. His photographic technique must be assumed.... These things, however, can be discussed with any intelligent photographer, assuming that such persons exist....

Vorticism has reawakened our sense of form, a sense long dead in occidental artists. The modern will enjoy vortograph No. 3, not because it reminds him of a shell bursting on a hillside, but because the arrangement of forms pleases him, as a phrase of Chopin might please him. He will enjoy vortograph No. 8, not because it reminds him of a falling Zeppelin, but because he likes the shape of arrangement of its blocks of dark and light....

The vortescope, however, appealed to Pound chiefly as a means of experiment.

Certain definite problems in the aesthetics of form may possibly be worked out with the vortescope. When these problems are solved vorticism will have entered that phase of morbidity into which representative painting descended.... That date of decline is still afar off....

Vortography stands below the other vorticist arts in that it is an art of the eye, not of the eye and hand together. It stands infinitely above photography in that the vortographer combines his forms *at will*. He selects just what actuality he wishes, he excludes the rest. He chooses what forms, lights, masses he desires, he arranges them at will on his screen...The dull bit of window-frame (vortograph No. 16) produces a fine Picasso, or if not a 'Picasso', a 'Coburn'. It is an excellent arrangement of shapes, and more interesting than most of the works of Picabia or of the bad imitators of Lewis.

Art photography has been stuck for twenty years. During that time practically no new effects have been achieved. Art photography is stale and suburban. It has never had any part in aesthetics. Vortography may have, however, very much the same place in the coming aesthetic that the anatomical studies of the Renaissance had in the aesthetics of the academic school. It is at least a subject which a serious man may consider....

Coburn might accept, a little ruefully, Pound's rejection of his paintings, but not the slur on photography. He added a postscript:

...I affirm that any sort of photograph is superior to any sort of painting aiming at the same result. If these vortographs did not possess distinctive qualities unapproached by any other art method, I would not have considered it worth my while to make them.

Design they have in common with other mediums, but where else but in photography
will you find such luminosity and such a sense of subtle gradations?

I took up painting as one takes up any other primitive pursuit, because in these days
of progress it is amusing to revert to the cumbersome methods of bygone days…so
perhaps my anonymous friend is right in not dwelling unduly on the paintings….
They are not, however, the most important part of the present show. People have been
painting now for several years, it is no longer a novelty, but this will go down to
posterity as the first exhibition of Vortography.

At the opening, according to one reviewer, Shaw proceeded "to praise the
Vortographs with faint damns," Pound gave "a psychological or even physiological
defense of vorticism and cubism and some sorts of cubism," and Coburn compared
making vortographs with reading the stories of H. G. Wells. He embarked on the
delights of abstraction; one avoided muddy tramps under an 8 x 10 by staying home
in front of the fire and manipulating a vortescope. He claimed the vortography
would do for photography what Cézanne and Matisse had done for painting, and
Stravinsky and Scriabin for music, pointing out to photographers that "all the
country of the unknown stretched out before them."

A fracas broke out in the photographic press. One man, after looking at a vorto-
graph every which way, from the back and with a looking glass, confessed: "This
vortograph is uncanny. It haunts me. I begin to see things in it. There is more in it
than meets the eye." Another diagnosed Coburn's condition as "Poseuritis…. The
complaint is caused by living in a vitiated atmosphere of adulation…self-expres-
sion…emotional golfclubs 'impossible to classify' or to 'tell the bottom from the
top.'" But Frederick Evans, grand old man and friend of Coburn's these many years,
led the attack in favor of "sane art" by benignly believing the whole issue no more
than the aberration of a generation hardly out of the nursery. "Not even the youngest
of us," he quoted, "is infallible." When the vortographs were shown in Glasgow, an
eyewitness reported: "No one member could explain what Mr. Coburn was aiming
at. What greater success could any modernist desire?"

British photographers, it appears, were bent one and all, gentlemen and crafts-
men to the last, on atrophy. There was plenty of fight going on in America; in 1917
Stieglitz and Steichen threw every photograph faked in technique or attitude out of
the Wanamaker Salon and gave the honors to youngsters like Paul Strand, Charles
Sheeler, and Edward Weston. Then Steichen, who was now in the Air Corps, went
to France and began photographing the enemy over the sides of airplanes; Stieglitz,
abandoned by his friends because he could not accept the anti-German hysteria of
those years, closed "291" and brought *Camera Work* to an end. But Coburn had not
been in close touch with "291" for some years; he and his wife both wore the uni-
form of the Red Cross and they were already rooted in Britain.

They fell in love with Wales, and went to live there. A neighbor across the bay was
David Lloyd George, then Prime Minister. Coburn met him at a concert, photographed
him in his home, and observed him at the tea table: "…the war was just at its sharpest,

all the earth was shaking with the thunder of it, and yet he could sit and chat about the weather and feed the little dog with crumbs.... I saw a very different man at Downing Street, where I went at his suggestion to photograph Foch and Clemenceau."

When the horror of the First World War finally ceased, most people, after the first wild burst of joy, felt stunned. To pick up what was left of their lives, to find themselves again, was slow and difficult, even in America. In Europe, the holes, the losses, the damages seemed almost irreparable. Many—and among them some of the most imaginative and creative younger artists—took refuge in a reckless, hysterical, iconoclastic cynicism; others sought solace in mysticism, or in some personal mixture of the two extremes. Coburn had escaped the worst horrors, but no sensitive person can avoid being involved with mankind. For him, the answer was, of course, mysticism, toward which, through his love of the Orient and his wide acquaintance among mystical poets, writers, and scholars, he had been drawn for years. He began to study and compare religions, and to explore such facets as the kabala, Freemasonry, astrology, alchemy. In the Druids, the early Christian mystics, and the Platonic ideals of the Good, the True and the Beautiful he began to find his way. Photography now seemed to him not an end but a means of capturing those moments when Beauty is reflected by the phenomena of this world.

He never ceased entirely to photograph—

> ...for this is impossible. Once the virus has entered the system it is there until time for us is no more. Whenever I went abroad, and this happened fairly frequently, I usually took a camera with me, and then photography flared up, blazed forth and filled me with the old wild enthusiasm of other and earlier days. Even in Wales, I climbed mountains as an excuse to use a camera on clouds, rocks and little lakes nestling in valleys overshadowed by the heights.

Living in the steep old town of Harlech he could not help photographing it, and in 1920 brought out *The Book of Harlech*. Two years later he brought out *More Men of Mark*. Among the gay, enthusiastic anecdotes of his introduction there appears this statement:

> I believe that most creative artists worthy of the name, of whatever school or medium, be it pen or brush, marble or scale of tones, have an inner world of inspiration which interpenetrates this world of action, and into this sanctuary they may, yea must, at times retire for meditation and refreshment. Some say in sleep this state is reached, and dreams the bringing back of some vague glimmerings to the waking life; but the way is more firm than this, and happy is he who finds the central way.

But Coburn could not retire to his sanctuary forever: "To see a beautiful thing of any sort, to dance with joy about it, but to hug it to one's self and never tell another, is fantastic and unthinkable, and leads only to stagnation and artistic indigestion." So Coburn came back into the world. Not however, to the art world. The shock tactics of the Surrealists were the antithesis of his own approach. He was not aware of what was happening in America: of what Stieglitz, who also chose what he called

"the affirmation of life," was doing in his hundreds of photographs of one beloved woman, Georgia O'Keeffe, and in his photographs of clouds, which he at first conceived as music and later called "Equivalents"—symbols of complex emotional experience. Steichen, after the analytical sharpness necessary to aerial photography, was now photographing a matchbox or a cup and saucer over and over again, until he mastered the permutations possible to straight photography; then, realizing how little art in any form had ever paid him, went into commercial and illustrative photography. Clarence H. White was teaching school and leading the society he had founded, the Pictorial Photographers of America; he died in Mexico City in 1925. Of the younger generation Coburn probably knew very little beyond what he had seen of Paul Strand in the last *Camera Work,* and of Edward Weston up to 1917 in the London Salons. Little or nothing of their new work was appearing in the magazines. Nor was he aware of the work of the young American painter and photographer Man Ray in Paris, and the young Hungarian painter and photographer Moholy-Nagy in Germany.

So Coburn pursued mysticism as ardently as, for seventeen brilliant years, he had pursued photography. He tried to tell photographers something of what he was finding; in November 1922 he lectured at the Royal Photographic Society on "Astrological Portraiture," and used twelve of his own portraits to illustrate the twelve zodiacal types, their inner and outer characteristics, and what photographers born under each sign were likely to choose as their approach. The lecture received a vote of thanks by acclamation.

Dudley Johnston was now president of the Royal, and on November 6, 1923, while reviewing the history of photography during the seventy years of the Society's existence, stated:

> The final shaping and concentration of all the ends into our modern pictorial practice was due, I consider, mainly…to the example of a photographer whose influence was first felt in this country in the early years of this century—Alvin Langdon Coburn. I do not think it too much to say that he made the greatest contribution to the artistic side of all its practitioners that have hitherto arisen. He gave us an outlook and cleared our vision. From his example we learnt to see the essentials of beauty in simple and commonplace things, to realize especially the beauties of light.

In 1924 the Royal gave Coburn a second one-man show, and at its opening he gave an address, "Photography and the Quest of Beauty," which, as he said, was "a matter which has been very close to my heart all the years of my life." For Coburn, such "wondrous modern creations as dynamos and aeroplanes…are as beautiful as a problem of Euclid. . . " For him, "Even our towns, which are often called ugly, respond to the opened eye of the artist, for nothing is irretrievably ugly…. Ugliness is only ignorance." He dreams of "a perfect world"; of photography as a way toward it.

> Real beauty is fundamental, unchanging and eternal. It is not a beauty of this or that; the earth, and the fruits thereof know it not save as a reflection from very far away….

We can photograph abstract beauty but not ultimate beauty. The mind can reach out for it, and in silent hope at the uttermost confines of its domains—aspire.

To the Royal, Coburn gave, in 1930, some of the finest things in his personal collection: exquisite platinum prints by Clarence White, rare Photo-Secession items, the concave mirror used by Hill and Adamson, the lens used by Julia Margaret Cameron, his own Vortescope and the Autochromes he made of Shaw and of the Freer Collection of Oriental Art. In 1931 the Royal elected Coburn, along with Steichen, an Honorary Fellow.

He went on laboring in "a world gone mad into wholesale decadence." He lectured, preached, published the Triads—threefold sayings by which the Druids and later the early Christians committed important truths to memory so that generation after generation could hand them down through centuries when few could read or write. For all this, Wales, at one of its national festivals where bards and choirs compete for honor, acclaimed him an Ovate. They gave him the bardic name of Mab-y-Troiedd—"Son of the Triads." He wrote a play, "Fairy Gold," with music by Sir Granville Bantock, for "children and grown-ups who have not grown up," which is based on the Druidic mysteries.

With his camera, Coburn loved to wander over the heaths and moors of Britain and Brittany:

> How many of us have come upon a Cromlech, or a circle of Druidic stones, on some forgotten height, far from the haunts of men, and felt a thrill in its presence, like a half-forgotten memory out of the past, of something wonderful which is our own?
>
> Realities do not die. They may be forgotten, but the door is never completely closed upon them.

In 1932 Coburn became a naturalized British subject. From time to time there came messages from a world Coburn had nearly forgotten. In 1938 Beaumont Newhall, rewriting, for the Museum of Modern Art, his *History of Photography,* discovered "New York from its Pinnacles," and wrote Coburn for permission to reproduce the "Octopus." In the late 1940s, during some research on the purist revolution, I came across the sparkling vortograph controversy, and was so delighted I wrote Coburn a note of belated congratulation. In 1950 a pocket-sized magazine, *Photo-Guide,* asked Coburn to write about Shaw as a photographer. Coburn delayed writing this article but finally, on November 2, 1950, took a train with the finished manuscript. London is a long journey from Wales; during those hours Shaw, who was ill but expected as usual to recover, suddenly died. *Photo-Guide,* seeing Coburn saddened by the news, published his article as it stood.

Every winter now the Coburns went to the Mediterranean; Edith had a serious heart condition and could no longer stand the damp chill of British winters. At first Coburn left his cameras behind, but the lights and skies of the Riviera were too beautiful to lose. He went out and bought "the French equivalent of a Kodak."

In 1952 Beaumont and I visited Coburn at Rhos-on-Sea, North Wales. Their home, "Awen,"—Welsh for "Inspiration"—was set in a bright garden near the sea. Its walls were lined with books and pictures—big gum platinums in the hall, a Matisse in the dining room, Webers accompanying you upstairs into a corridor like a tunnel through books. In the study attaché cases were stacked to the ceiling, each holding a file of negatives or papers.

We looked at portfolio after portfolio, book after book, which confirmed our postulate that the scope of Coburn's photographs was immense and prophetic. We worked out a show, planned a journey to the States for the Coburns if Edith's doctor thought it wise.

George Eastman House bought ten original platinum prints, and Alvin gave it many gravures. Later he did an article for *Image* on Frederick Evans. Then came a transcript of his first broadcast on July 17, 1953, for the BBC's Third Programme: "Illustrating Henry James by Photography." This was only the beginning: he broadcast his experiences on photographing George Meredith and Mark Twain; he did a fourth broadcast on "Musicians in Focus." In 1954, Stevenson's *Edinburgh—Picturesque Notes* appeared, united at last with Coburn's photographs, of which the earliest he chose was dated 1905 and the latest 1950.

Edith's doctor forbade her to attempt by either air or sea the long journey and consequent activities of returning to the States. The most they dared was to go by flying boat to Madeira in the winters. Coburn found Madeira "a natural paradise," and he took a camera with him: "I must confess it is *not* a miniature camera. I simply cannot compose on a microscopic finder. I like to know what I am getting. My camera is an ancient and honourable one, battle-scarred with much use, and it has a nice, large, bright finder which shows me what is likely to be on the resulting film." The first winter in Madeira, 1954-55, he made some three hundred exposures: "And my joy in getting back into my stride again, photographically, knew no bounds."

He didn't think it could happen again in Madeira, and took his camera along only at the last moment. But it did happen again, and very differently from the first winter. So with the third—

> I have now come to the conclusion that the better you know a place, the more you can find in it to photograph. One remembers how Claude Monet painted, over and over again, the same haystack in the same field at different hours of the day, and how he hired a room opposite Rouen Cathedral, that he might paint it in every gradation of light and shadow. This repetitional aspect of a subject, to get it in its most perfect lighting, is an exercise of patience and discrimination in which the photographer has to give himself a special form of training; the movement of a cloud's shadow across a landscape 'makes all the difference'. You see the wonderful thing happen, but perhaps you have not time to get your camera out to snare it, and so you wait patiently (or even impatiently—in any case you wait) until the miracle repeats itself.
>
> It really does not so very much matter *what* we photograph. It is the manner of our beholding which is of the greatest importance.

In October 1957 the Royal Photographic Society gave Coburn a third one-man show. It was to be hung in what, in memory of devoted services to the Society, was now called the Dudley Johnston Room. The President and Secretary were worried: would Coburn be able, at seventy-five, to climb all those stairs? "I believe they expected I might come with crutches, or in a wheeled chair, or at the very least with a stick, but I assured them that I still climb mountains—and with a camera—and that I have made over 1,000 exposures during the last three years!" For this show he selected and hung—himself—twenty-four prints, of which seven were made in Madeira in 1956 and 1957,and gave a lecture entitled "Retrospect" to the Society on October 22, 1957. "I do not think anyone else can claim to have had two exhibitions of their work in the precincts of the Society fifty years apart!"

Then his dear wife Edith, his darling and his devoted companion all these years, died. Coburn preached more and more often in the little stone church by the sea; he went out more and more often with his camera.

The rediscovery of his significance continued. In 1961 D. J. Gordon, Professor of English at the University of Reading, England, while assembling portraits of William Butler Yeats for an exhibition.

> …was very much struck by a photograph reproduced in a volume of 1909 and never since; it was signed 'Alvin Langdon Coburn'… I telephoned to a leading authority on the history of photography and said to him, 'Who is Alvin Langdon Coburn and where can I find his negatives?' He laughed and said—'Ask Mr. Coburn'—and proceeded to give me an address in a seaside resort in North Wales. This all sounded to me very improbable. I found a telephone number and was answered by the voice of Mr. Coburn.

To Gordon, the portraits Coburn made of Yeats in 1908, "with their nervous intensity, total absorption, ugliness and power of the lower jaw, and curious air of shabbiness, are the most convincing images of Yeats at that period." He also found the portraits of Henry James "fascinating and alarming…you have the sensation that at last you are really in the presence of a man capable of writing Henry James's novels." Gordon discovered that Coburn "had photographed any writer of any interest in the Edwardian period," and been "celebrated by the greatest poet, the greatest novelist and the greatest English playwright of his time."

Poring over Coburn's collection of books and manuscripts, over his notes, portraits, interpretations of cities, vortographs, Gordon began to shape another exhibition which should illuminate both a period and a man. Not just Coburn the photographer, but Coburn as a total personality, his interests, his friends, his times. It was the largest show Coburn had yet had, and "the first…I did not help to hang!" There were only fifty-eight photographs; among them appeared the strange form in a glimmering sea—"Reflections, 1961."

At the opening, at the University of Reading, on January 24, 1962, Coburn gave an amusing address on his "Photographic Adventures." Briefly he sketched the many people and ideas which had moved and excited him. Looking back on all this, he concluded:

…the perfect life of the mystic leads the soul out of the limitations of time and space into a beholding of the unity of the eternal *now.*

Friends have asked me why I have for many years ceased to devote my energies exclusively to photography, after having attained a certain proficiency in the subject through a life of dedication to its mysteries? The answer to this is that I think spiritual concerns are more important…religious mysticism is the peak of the range, from which even the vistas of photography may be beheld in an ever new, richer and more mysterious radiance. Photography teaches its devotees how to look lovingly and intelligently at the world, but religious mysticism introduces the soul to God.

From *A Portfolio of Sixteen Photographs by Alvin Langdon Coburn* (Rochester, New York: George Eastman House, 1962).

Emerson's Bombshell

PETER HENRY EMERSON was, to his enemies, a particularly infuriating man. Photographer, doctor, author, he was armed at all points. His energy was prodigious. To any opinion varying from his own, his mind was an impregnable blank wall; he was as dogmatic as a Calvinistic preacher, he wielded invective as it if were a sledgehammer, and he feared nobody. Believing with all his force that photography was an independent and potentially great art form, he set out to establish it as such down to the last detail, and in blowing up the abuses that stood in his way, he, like many another fanatic and reformer, started a war.

In the 1880s, the walls of photographic salons were crowded from floor to ceiling by huge frames containing all of each exhibitor's entries. Photographs pointed morals, related anecdotes, and jerked tears. Titles ran like this: *An Old-World Bit, End o' Day Crewel (Cruel) Work.* Combination printing (piecing together bits of two or more negatives) ran riot, and the aim was to imitate as closely as possible the genre painters who had flourished in bad artistic odor a generation before. In the universal sharpness and slickness, no picturesque detail—no spectacles on grandpa's nose, no patch on the seat of the pants—was spared the spectator. As one man remarked, a comment like "Its not a bit like a photograph," was to be taken as a compliment.

The "uncrowned king" of all of this, as he had been for nearly thirty years, was Henry Peach Robinson. Salons were scarce, yet Robinson, had he chosen, could have covered himself with the hundred medals or so that he had won. His combination print *Autumn,* 1863, was "the most bemedalled photograph in the world." The huge prints—usually about eighteen by twenty-four inches—that he issued annually to subscribers were each regarded as the photographic event of the year. His handbook, *Pictorial Effect in Photography,* which contained his recipes for making photographs look like art, ran through edition after edition. Before taking up photography, Robinson had been a painter, so precocious that the Royal Academy accepted his paintings for exhibition before he was twenty-one. And the confusion in photography in the 1880s, as well as earlier and later, was largely due to the misconceptions of painters.

Up to 1853, the photographic image was regarded with the awe and reverence due a miracle. It was still imperfect; red tended to record as black, and blue as

6. *Dr. P.H. Emerson to his nephew W.C. Emerson—The photo was taken in my study Feb. 11, 1925, where I am writing the History of Artistic Photography*
—PHE

white. Photographers called forth all their powers of lighting and composing to meet the problems of freckles, pale eyes, and white skies. To be sure, the great daguerreans tinted their best portraits so subtly that the colors seem almost in the eye of the beholder, and D. O. Hill occasionally enlivened a dull background by sketching in a craggy waterfall. And in 1845 an American daguerreotypist named Mayall caused a furor by exhibiting in his new London studio ten allegorical daguerreotypes illustrating the Lord's Prayer. But, generally speaking, those were, in Robinson's words, "the bad old days when it was considered fraudulent to improve your pircture in any way; when the fine old crusted purists would prefer to have a photographed face peppered over with black spots almost invisible in nature, or a blank sky also untrue to fact, rather than have the sacred virginity of the negative tampered with."

But in 1853 Sir William Newton stood up to address the inaugural meeting of the Photographic Society of Great Britain (hereinafter referred to by its present title of "the Royal"). Sir William was a miniature painter, and he found the studies he made with his camera too sharp, too detailed, and too lacking in atmospheric lost-and-found to help him with his painting. He proposed that such studies, made by artists for their own use, should be a little out of focus, "thereby giving a greater breadth of effect and consequently more suggestive of the true character of nature." He was "particularly desirous" of making this proposal "because it has recently been stated in this room that a Photograph should always remain as represented in the Camera, without any attempt to improve it by art. In this," he continued, "I by no means agree, and therefore I am desirous of removing such false and limited views as applying to the artist, or, indeed, to any person having the skill and judgment requisite." And stated that it was not only permissible but laudable to paint in skies and otherwise remedy the defects of the process.

This caused great excitement and protest in the Royal. The great corps of Victorian letter writers, whom we shall meet again, went into action. One man suggested imperfect lenses as a means of attaining soft-focus. At one memorable meeting, Sir William, who, as vice-president, happened to be in the chair, suggested differential focus—throwing various planes of the subject into sharper or softer focus, as desired—as an artistic control. At this, several simmering members boiled over and the meeting became disorderly. Sir William used his authority to quell it. He refused to argue, restating that he recommended soft-focus only to artists, and closing the discussion with this sage and liberal statement: "Photography is a wide field; each may take from photography what he requires; he is not bound or tied to any rule that I know of; let him take his own course, by which not only photography will be advanced but Art will be considerably improved."

The course taken was logical enough, but it is doubtful if either art or photography benefited to any extent. Sir William left photography at the mercy of the painters, and they were not slow to exercise their license. Mayall's allegories had been straight daguerreotypes of posed figures; now, with the advent of wet collodi-

on, the photopainters had negatives that could be masked out when printing. Why not add to the posed figures a nice bit of sky, or a glimpse of woods, just as in painting one combined many sketches—figures, backgrounds, details—into one enormous "machine"? A certain amount of handwork was necessary, of course, but after all, they were spared the labor of drawing and shading. The strained, theatrical effects thus achieved did not worry them unduly. They wanted photography to be an easy way of making pictures, not an independent medium and felt they were doing the gangling child a favor by subduing its harsh and terrible truthfulness into civilized aim and graces.

In 1857, the Swedish photographer O. G. Rejlander exhibited his moral allegory *The Two Ways of Life*. It was composed of thirty negatives, all of the same two or three models in different poses and resembled in stage management the Babylonian orgies of an early supercolossal movie. Queen Victoria bought a print of it. A year later, Robinson's *Fading Away* caused a storm. It was made up of only four negatives, but the subject, a young girl dying, was considered too painful to be represented.

Combination printing flattered the taste of the art-conscious public. It swept into popularity and carried Robinson, the most skillful and charming of its practitioners, along with it. In 1860 he was asked to lecture before the Royal on his methods: how most of his outdoor subjects were photographed right in his studio or backyard, how he had made a brook out of his darkroom drain, how he found real peasants and fisherfolk too awkward and stupid for genre work and enlisted graceful young ladies instead.

Two furors shook his growing "kingship" in the 1860s: Julia Margaret Cameron's powerful soft-focus close-ups of great men, and what Lamartine described as "the marvelous portraits caught in a burst of sunlight by Adam Salomon, the emotional sculptor who has given up painting." Robinson admitted Cameron's talent, but told her to learn not to make "smudges." To the Frenchman's "creative retouching" and "Rembrandt lighting," he bowed down, along with hundreds of English photographers and was in seventh heaven when this idol visited him at Tunbridge Wells.

By 1869 the clamor for his formulae for success was so great that he responded with *Pictorial Effect in Photography: being Hints on Composition and Chiaroscuro for Photographers, to which is added a Chapter on Combination Printing*. His chief ingredients were a few outworn theories from an 1830 treatise on academic painting, illustrated by diagrams, little scribbled etchings of popular paintings, and actual albumen prints of his own work. These he garnished with quotations from Sir Joshua Reynolds, Ruskin, and so on. He advised on the proper bedside manner for getting the best out of a sitter, and described his own studio methods, which distinctly foreshadow Hollywood and *Vogue:* movable platforms heaped with earth and ferns, "outdoor" lightings for indoor work, props like stumps and gates and *prie-dieus* and carefully painted backdrops.

However, his success stemmed from the imitation of academic painting. He went comfortably on, being elected to the Council of the Royal, receiving the gold medal of

the Paris Exhibition 1878. And *Pictorial Effect* went on, becoming through the years the sourcebook for that vast and ubiquitous class for whom photography is a means to something else. The aim may be, like Robinson's to imitate painting, or it may be to advertise a movie actress, a can of peas, or the photographer. Paraphrased and streamlined, Robinson's ideas and devices are overwhelmingly still with us.

By 1882, when Emerson joined the Royal, along with legions of amateurs enthralled by the ease and scope of the dry plate, the gorge of advanced thinkers was already rising aginst the Robinsonian gloss and glamour and the sentimentality to which his followers had sunk.

Born in Cuba in 1856 and brought up in Massachusetts, Emerson had come to England as a young man and acquired at Cambridge the degrees that caused one irate Victorian letter writer to dub him "Emerson A.B.C.D.E.F.G." His training as a physician exactly suited his temperament. Science was orderly and constructive. A thing was true or false. If true, it was added to the great architecture of science and other scientists might build upon it. Miracles were taking place in the dizzy upper heights of this structure, and all because of the solid supporting masonry of fact.

When Emerson took up photography and started reading about art, he was horrified. There was not a fact or a scientific first principle in all art. There was nothing more solid than *taste*. Art was a kind of quagmire in which various literary "experts" kept building literary palaces. The next generation of experts, evolving a new palace, condemned the old to sink out of sight. The third, likewise building and likewise condemning, dug up the ruins of the first and enshrined them, romantic and nostalgic ghosts, in the new holy of holies. Meanwhile, the untutored public, beholding these illusions across the bog, tried to reach them and were swallowed up. This phantasmagoria had been going on for thousands of years. It was deplorable.

With all this, thought Emerson, the artists had nothing to do. They simply went on working. It was the critics and historians, notably Ruskin, that were to blame. And here in photography was Robinson, basking in adulation with his hand-me-down literary fallacies. No dynamite was too strong for such a mess. He, Emerson, would personally clean up photography and establish it on scientific first principles.

What, then, was the scientific first principle of art? Nature, obviously. (Here Emerson fell into the bog up to his eyebrows, but failed to notice it for some years.) Naturalism, like the impressionism with which he and others confused it, was an offshoot of the nineteenth century obsession with science and reality. But unlike the pure or French impressionists, the naturalists did not throw out their dirty water when they got in their clean. Emerson, whose inexperienced mind approved their apparent logic, swallowed these impurities from the past along with the rest.

Nature, then, is the scientific first principle of art. But here enters Helmholtz, saying that the accurate rendition of nature is impossible, since the scale of pigments (or of a photographic negative) is infinitely less than the scale of light. Therefore the rendition can only be relative; it is an *impression*. This impression, said the naturalists, must be absolutely faithful. *Nothing must be changed, added, or removed.* Every nuance of light

and weather must be recorded. The painter, accordingly, becomes a kind of lens, more or less perfect, through which nature is transferred to a plane surface. In this, thought Emerson, with reason, the painter is inferior to a real lens and his canvas to the sensitive plate.

The idea of reproducing the effect of the human eye appealed particularly to Emerson's medical training. "To *look* at anything," said Helmholtz, "means to place the eye in such a position that the image of the object falls on the small area of perfectly clear vision." And Emerson commented, "The image which we receive by the eye is like a picture minutely and elaborately finished in the center, but only roughly sketched in at the borders." Coming across Sir William Newton's proposal, Emerson saw how this method of concentrating attention, then much in vogue among painters, could be achieved by a lens properly constructed and focused. "The principal object in the picture must be fairly sharp, *just as sharp as the eye sees it and no sharper,* but everything else, and all other planes of the picture must be subdued…slightly out of focus, not to the extent of producing *destruction of structure,* or fuzziness, but sufficient to keep them back and in place." Mrs. Cameron had gone farther than this; in her strongest portraits, nothing is sharp. But Emerson, though he discovered that her first apparatus was so ill-assorted that she could not have achieved sharp focus, realized that in her feminine contempt for technique she had brought into photography a new power, a sculptural use of light. He became her ardent champion.

In his own hands, differential focusing attained a remarkable quality peculiarly suited to the soft light and moist air of England. "Nothing in nature has a hard outline, but everything is seen against something else, often so subtly that you cannot quite tell where one ends and the other begins. In this mingled decision and indecision lies all the charm and mystery of nature." Had he tried to express this charm and mystery in the rich gloss of the still current albumen print, he might have found that it looked very much indeed like indecision. But platinum paper was newly on the market, and he pounced on it as the perfect expresion. Fine drawing paper, delicately tactile, with a long range of grays, from pale silver to charcoal, and absolutely permanent! At last, a photograph had in itself, as an object, the sensuous appeal of a drawing or etching.

It is unfortunate for photographic history that Emerson had forgotten the brilliant light and diamond-cut edges of the Americas, where extremely sharp focus, expressed on a glossy surface, has from the days of the earliest daguerreotype been equally logical and natural.

He speaks of having been in Norway, Germany, and Spain, as well as Cuba, Delaware, and Massachusetts, but the land he loved was East Anglia — half land, half water, its low towns and farmlands barely raised by dike and canal above the tides of the North Sea. Hunter, fisher, sailor as well as photographer, Emerson was profoundly in love with nature, but he felt keenly that neither painting nor poetry could adequately express nature. Early and late, in the misty sparkle of early summer and in the dark light of snow, Emerson was abroad, photographing when necessary from boats or enormous tripods sunk deep in the mud. Full of air and the moods of light and weather, his photographs often attain a breathtaking lyrical quality.

Increasingly, the peasants and fisherfolk fascinated him. Reapers with scythes and sickles, little boys fishing in the dikes, housewives in shawls, girls gathering waterlilies, hunters on the marshes, ploughmen, rope spinners, fishermen with gleaming nets—he induced them all, for a coin or two, or beer if preferred, to hold themselves still for a moment while he photographed them. He began to observe and record every detail about them—their fairs, songs, speech, their medieval superstitions and remedies, their queer amphibian trades and customs, their dealings with tourist and landlord and grocer. He respected their heroic qualities, and inveighed against the tyranny that caused their avarice, their evil-smelling cottages, and their hard and bitter destiny.

A far cry indeed, this documentary interpretation, at once lyric and accurate, from Robinson's fakes and Victorian sentimentalizing over humble virtue and rural charm!

Each of Emerson's six publications on East Anglia covers a different aspect; together they are not unworthy to rank beside Atget's France, the Farm Security Administration's America, and the U. S. Geological Survey's Far West. And while Emerson was photographing, compiling facts, writing, printing hundreds of platinum prints or haggling over the photogravure plates with the engravers, he was fighting one of the stormiest battles in photographic history.

His rise was brief and phenomenal. In 1885 he suddenly began appearing everywhere at once. His photographs struck the stuffy artificialities of the salons like a sea breeze. "Six views of the open sea, artistically printed in platinum" won the first medal offered by the new magazine, *The Amateur Photographer,* and his illustrated narrative, *A Cruise on the Norfolk Broads,* their Prize Tour Competition. Articles like trumpet calls aroused the photographic public. And early in 1886 he was elected to the Council of the Royal Photographic Society, to represent the amateurs.

In March 1886, he really opened fire. In a lecture, *Photography as a Pictorial Art,* before the Camera Club Conference, he fulminated against Ruskin and the "pernicious illogical literature" of previous art criticism, and called Robinson a "wiseacre" and his book "the quintessence of literary fallacies and art anachronisms." Skimming alarmingly through the history of art to prove that naturalism is the scientific first principle of art, he proclaimed photography second only to painting and direct photogravure a medium superior to any engraving. The Robinson group quaked; the letter writers began to view with concern.

As sole judge of the *Amateur Photographer's* Holiday Work Competition in 1887, he awarded the prize—two guineas and a silver medal—to the man who was to succeed him, a young American studying in Germany. Among the twelve photographs submitted by Alfred Stieglitz were some of his loveliest early work, such as the *Venetian Gamin* and the tender *Fruit Seller.* But Emerson's choice of the now deservedly forgotten *A Good Joke,* is significant; every child in that group around the fountain is a living breathing individual, caught in a wave of delight and laughter. Emerson himself had never captured such a moment. As he wrote in his heavy, almost illegible scrawl, of all the photographs he had seen Stieglitz's alone were truly spontaneous. (Stieglitz's reaction to this, his first prize, was characteristic—"How poor the other competitors must have

been!") To him, rather isolated in Germany, Emerson's writings were like a great voice uttering his own growing thought.

In 1889 Emerson brought out his handbook, *Naturalistic Photography,* aptly described by a contemporary as "a bombshell dropped in a tea party." In this he states, more completely and convincingly than anyone before him, the fundamental esthetics of photography:

1. That photography is an independent medium with its own inherent characteristics and potentially a great art form.

2. That the controls offered are sufficient to express vision.

3. That the effect of a photograph, emotionally and psychologically, lies in the untouched image of the lens as recorded by the sensitive material.

4. That this effect should never be spoiled by handwork or combination printing.

5. That composition has nothing to do with rules or formulae.

He also stated the tenets of classic photography — its simplicity of means and its straightforward approach. And for portraiture, he condemns Robinson's scenery as "incongruous lumber," and recommends the use of a plain background slightly out of focus.

If Emerson had confined himself to stating the tenets of classic photography his work would be valuable and probably little known. But he added much debatable matter, setting forth his theory of differential focusing, well bolstered by optical and scientific detail, and compressing the history of art into sixty-six pages.

To Emerson's contemporaries, all his ideas were heresy, and heresy compounded with such maddening pigheadedness that the real issues were often obscured. They longed to blast through his ridiculous prejudices and hurt him where it would do the most good. The photographic world blew up.

The least understood subjects, of course, were composition and focus. On these the Victorian letter writers trained their heaviest artillery. "Naturalistic focus, then, according to Emerson, means no focus at all, a blur, a smudge, a fog, a daub, a thing for the gods to weep over and photographers to shun," writes *Justice,* and draws replies like this, from the pen of George Davison, "It is not in man, even in f/64 man, to overlook the unnaturalness of joinings in photographic pictures, and the too visible drawing room drapery air about attractive ladies playing at haymaking and fishwives." — It is an ironic comment on Emerson that f/64, a term of opprobrium hurled by his fellow purists in one crusade, should become the sign and title of his direct descendants in another!

In the beginning, Robinson had tried to maintain an attitude of amused superiority, on the ground that "Even the young are not infallible." (Emerson was thirty-three; Robinson's career began before he was born.) Now he counterattacked, rehashing *Pictorial Effect* in book after book and article after article. "Naturalists pretend to represent what they see but healthy human eyes never saw any part of a scene out of focus." He defined the chief characteristic of naturalism as "an utter lack of imagination," and discovered with glee that naturalists "compose their pictures with the precision and formality of Dutchmen," even hinting that perhaps, after all, they owed something to

himself. This drew fire from Emerson: "I *never* ignored or lost sight of the fundamental and vital importance of composition and challenge anyone to show that I have done so. But I did, and still do condemn all arbitrary 'rules and laws.'… Finally, I have yet to learn that any one statement or photograph of Mr. H. P. Robinson has ever had the slightest effect upon me except as a warning what not to do."

Thanks to all this, the first edition of *Naturalistic Photography* sold out immediately, and a second was rushed into print. In vain, editors tried to close their columns to the controversy; it broke out in fresh directions and had to be readmitted. During an occasional lull, some letter writer would gleefully regret the passing of naturalistic photography, and Robinson would preach over its supposed grave: "Naturalistic photography may now be taken as a negligible quantity. The good of it will be absorbed into serious art and the sound and fury which signifies nothing, not finding a congenial home here, has crossed the Atlantic and blown itself out in fitful gusts in America.…It was a case, if not of temper, then certainly of temperament." Robinson proved but a partial prophet; in this same year, 1890, Alfred Stieglitz crossed the Atlantic, and it would be seen, in due time, that the fitful gusts might be more properly described as a tornado.

In the fall of 1890, a terrible revelation, like that of Saul at Tarsus, broke upon Emerson. It was threefold: a conversation with a great painter (Whistler?), the prints of the Japanese Hokusai, and Hurter and Driffield's discovery of the mathematical relation between exposure and development. Nature was not the scientific first principle of art; photography was a mechanical process! His world darkened, his scientific structure crashed down about him. He too, had built in the quagmire. He retired into his houseboat for three and a half months.

January 1891 brought the most violent explosion of all. The editors of all photographic magazines received a letter from Emerson, begging them to give publicity to the enclosed, addressed "TO ALL PHOTOGRAPHERS." Asking forgiveness of those who had followed him and those whom he had mistakenly attacked, he proceeded to renounce in toto the claims of photography to be an art.

> To you, then, who ask an explanation for my conduct, art—as Whistler said—*is not* nature, is not necessarily the reproduction or translation of it; much, so very much, some of the very best, is not nature at all, nor even based upon it.…If there can be no scientific basis for art, as some have asserted, Meissonier can claim to be as artistic as Monet and Monet as Meissonier. The sharp photographer can assert his artistic rights alongside the veriest "blottist." So all opinions and writings upon art are as the crackling of thorns beneath the pot.

Expanding his renunciation into a black-bordered pamphlet, *The Death of Naturalistic Photography,* he wrote:

> The limitations of photography are so great that, though the results may, and sometimes do give a certain esthetic pleasure, the medium must rank the lowest of all arts, *lower than* any graphic art, for the individuality of the artist is cramped, in short, it can hardly show itself. Control of the picture is possible to a *slight* degree.…But the all-vital powers of selection and rejection are fatally limited.…I thought once (Hurter and Driffield have

taught me differently) that true values could be obtained and that values could be *altered at will* by *development*. They cannot; therefore, to talk of getting values in any subject whatever as you wish and of getting them true to nature is to talk nonsense.

In short, I throw my lot in with those who say that photography is a very limited art. I regret deeply that I have come to this conclusion.

(That this is an erroneous conclusion from the experiments of Hurter and Driffield is proved by such integrations of exposure and development as that taught and practiced by Ansel Adams, who, by using their findings and those of their successors, is able to pre-visualize and control exactly the tone of his negative, expanding or contracting the scale of values, or placing any one given tone higher or lower at will.)

It took great moral courage, in the face of the certain triumph of his enemies, to make so dramatic and public a confession and it is the measure of Emerson's sincerity that, once thoroughly convinced, he rushed to prevent others from being engulfed. He withdrew all remaining copies of *Naturalistic Photography* and resigned from the Camera Club.

The experience left so deep a scar that to the day of his death his second opinion remained essentially unchanged, Perhaps the violent publicity and the glee of his enemies, perhaps his own intense, Calvinist temperament, forbidding him to chop and change any more, prevented him from understanding that such changes are part of the growing pains most mortals endure in trying to approach art.

He was, however, by no means so humbled as his enemies would have liked to see him. He continued to write articles, sit on juries, publish albums and pamphlets. And, realizing the importance of what he had done, whether he disowned it or not, the Royal Photographic Society in 1895 awarded him its Progress Medal for his work in the advancement of artistic photography. In 1899 he brought out a third edition of *Naturalistic Photography,* at once expurgated and augmented. In the retrospective exhibition of his photographs held at the Royal in 1900, his remarks in the catalog retain something of the old fire and brio, but only one photograph, an experimental portrait with Dallmeyer's telephoto lens, had been taken after 1891.

What he had started was beyond his power of that or anyone else to stop. In 1892, the international society known as the Linked Ring was founded among four or five others, by Robinson, who acknowledged the good Emerson had done. And in 1902 Stieglitz founded the Photo-Secession, the stormy brilliance of whose crusade for photography as an art eclipsed even Emerson's. Meanwhile, differential focus became extreme soft-focus, the delicate surface of the platinotype was replaced by rough papers and its silver tones by the red, green, blue, and viscid black of gum-bichromate. All Robinson's "dodges, tricks, and conjurations" returned, plus imitations, by hand, of drawing and etching. Photographers became stagestruck with their importance as artists. By 1910 the most creative workers had realized the error of these manipulations, but inferior workers, missing the spirit and message and imitating merely the bad mannerisms, kept on sinking into worse and worse morasses — and again the crusaders rose.

Emerson and Stieglitz met only once, under strange circumstances, in 1904. Stieglitz was in London, and he wanted to talk at, not with, Emerson. He felt very ill, with so

high a temperature that he was forbidden to talk. Through the fever he remembered dimly that a man came and stood beside him, and then went quietly away.

Many years later, Emerson wrote Stieglitz that he was undertaking a history of photography and asked that a hundred of the Equivalents be sent him. He had heard many people say that in these semiabstractions photography reached the heights of great art. He did not believe it, but he wanted to see for himself. To Stieglitz the request seemed both futile and arbitrary. He was grateful to Emerson for his own first recognition; he fully realized how much photography owed to the great principles Emerson laid down. But he himself had taken up the battle where Emerson abandoned it, and the battle had been lifelong. He felt entitled to refuse.

In 1936 Emerson died, leaving his history still unfinished.

Photography, Winter 1947.

Helen Levitt

PHOTOGRAPHS OF CHILDREN

HELEN LEVITT seems to walk invisible among the children. She is young, she has the eye of a poet, and she has not forgotten the strange world that tunnels back through thousands of years to the dim beginnings of the human race. With her camera to her eye, she watches a group playing; she seizes the split second when the dark world rises visible into the light. She understands the magic of metamorphosis —how a mask invests the wearer with the power of the enigma, how a discarded mirror or an empty house may engender a hundred improvisations full of danger and destruction. Reverently she records the occult symbols drawn on walls and sidewalks.

The children of the poor are not starched and supervised. Roaming in tribes through the streets and empty lots, they inherit to the full the magic and terror of the inscrutable world. Joyous, vicious, remote, or sad, these photographs arouse in adults a swift and poignant succession of emotions.

Helen Levitt was born in New York City. She started photographing children in 1936. Harlem, with its mixture of races—Negroes, gypsies, Latins—is where she finds the most vivid action. Nearly always she uses a Leica with a right angle sight that enables her to avoid pointing directly at her subject. In 1941, when she went to Mexico for a few months, she found most of her material in Tacubaya, a suburb of Mexico City. The majority of the New York series were taken during the last four years.

Bulletin of the Museum of Modern Art, vol. 10, no. 4, 1943.

The Photo League

THE PHOTO LEAGUE is more than a school, a gallery, or a club. For eleven years, in spite of cramped quarters and limited funds, it has been a vital center for photographers in all stages of development.

In its darkrooms, more than 1,500 young photographers have been taught a direct and clean technique. In the streets of New York, which are the league's most important studios, they have learned to approach and interpret the life around them. Within whatever loft or brownstone "floor-through" the league inhabited at the time, audiences ranging from small informal groups of members to hundreds of photographers, both professional and amateur, have heard and seen and been able to ask about the scope and meaning of their medium as revealed by the exhibitions hanging there, by the programs of unusual films, and by the outstanding photographers and writers who came to talk to them.

These leaders, too, found something they were looking for—one of the liveliest and hungriest audiences they ever faced. In the work submitted to them for criticism, these audiences found no superficial imitations, compositions, nor commercialisms; always, whatever its faults, the work sprang from a genuine attempt to realize *photographically* the living world. And their respect increased on learning that all the league's activities—from teaching, organizing programs, hanging shows, and editing *Photo Notes,* down to licking postage stamps and scrubbing out the darkrooms—are and always have been carried on voluntarily by a group of young photographers on whatever nights, holidays, and spare hours they can snatch from earning a living.

In the beginning, in 1928, there was the Film and Photo League. Among the cinematographers, there were Irving Lerner, Lionel Berman, Sidney Myers, and Ralph Steiner, who also taught in the photography classes. During the difficult days of the early 1930s, the vision of the league photograhers was limited to tragic symbols—breadlines, ashcan pickers, strikes, pickets. In 1936, the film section split off, some of its members going into Frontier Films, and two young photographers, Sid Grossman and Sol Libsohn, took it upon themselves to carry on the Photo League.

They had little except their zeal to help them. There was no active center for photography in those days. Stieglitz was in his seventies. The great fire that had

7. *Photo Notes*, Spring 1950

blazed across the world forty years earlier, founding the Camera Club, *Camera Notes, Camera Work,* The Photo-Secession, "291," still glowed for those who came as to a goal or a shrine, but the quiet walls of An American Place were not for the turbulent energies of the League. At the Museum of Modern Art, photography was confined to the unofficial devotion of one man, the librarian; the occasional shows were no substitute for the force of an integrated program. Most of the schools in New York were and are commercial, and even the Clarence White School, excellent as it was, could not answer the searching hungers of these young photographers. They needed more than a school.

Sid and Sol went forth and assembled a board of advisers—Paul Strand, Berenice Abbott, Margaret Bourke-White, Leo Hurwitz, Elizabeth McCausland, Lionel Berman, and Beaumont Newhall. With such guidance, they began to discover new horizons—the depth, the scope, and the traditions of photography. They hired space in an old loft building on Twenty-first Street and, with other league members, hammered and sawed until they had built a gallery and meeting room, a schoolroom, and a darkroom. By day they eked out what sometimes could only by courtesy be called a livelihood by such jobs as photographing mattresses and shoes for catalogs. By night, they worked for the league. They wheedled every outstanding photographer within range into talking or exhibiting at the league. There was something exciting in those shows and discussions; the public came and came again, in increasing numbers.

Photo Notes, which first appeared as a wall newspaper in 1935, became a mimeographed bulletin sent to all members. It reprinted valuable and sometimes inaccessible articles such as Paul Strand's much discussed antipictorial lecture before the Clarence White School in 1923 and Elizabeth McCausland's series of critical essays from the *Springfield Republican.* It began to instigate original articles, interviews, and reviews of exhibitions, films, and books. Today it is sent free to all leading photographers, museums, galleries, and camera clubs and is welcomed as, in the words of Edward Weston, "the best photo magazine in America today."

The development of young photographers has always been the league's main purpose. Membership dues were and are kept low—$1 for initiation, $7 a year. For another twenty-five cents—to cover the cost of chemicals—members may use the darkroom. Fees for classes are equally low: $30 to $50 per semester of twelve sessions. No one has ever been turned away from the league for lack of funds.

Sid and Sol geared both the course and their cost to the growth and needs of young students such as they themselves had been. Basic technique, advanced technique, workshop—horizons expanding as one progressed, not into commercial problems, but into a fuller integration with the city and the world. It was in Sid's workshop class that many students discovered the meaning of photography and their own relationship to it. They went out into the streets, into the neighborhoods

that make up a vast metropolis, trying not only to meet the difficult photographic problems involved but also to understand the people and the famous *Harlem Document,* which has been widely circulated and reproduced. The *Chelsea Document* followed, and *Park Avenue,* and others.

Personal creative problems came next—and here young photograhers hardly out of their teens, produced amazing work: Walter Rosenblum, expressing the warmth and richness of the crowded East side where he was born; Morris Engel, finding at Coney Island not vulgarities and satires but humor and affection, grace and pathos. Courses in special techniques were also given, such as instruction by Eliot Elisofon and Mary Morris in synchroflash and Robert Disraeli in the miniature camera.

Recognition of the Photo League soon appeared in magazines and newspapers. Individual members were presented in one-man and group shows at various museums and galleries. At the *Pageant of Photography,* held at the San Francisco World's Fair in 1940, the Photo League exhibition was voted the second most popular. In the Museum of Modern Art's *Image of Freedom* competition in 1941, 13 of the 100 photographs purchased were by league members. For *New Workers I,* a group of six small one-man shows held at the Museum of Modern Art's Photography Center in 1944, Morris Engel and Walter Rosenblum were chosen. Both are represented in the museum's collections, together with other former students, instructors, and officials of the league: Eliot Elisofon, Arnold Eagle, Sid Grossman, Arthur Leipzig, Sol Libsohn and Elizabeth Timberman.

When Lewis Hine died, the Photo-League was appointed guardian of his work. The task of cataloging and preserving, duplicating negatives and making prints for distribution, is carried on by a league committee. Two portfolios of fine contact prints from his negatives have already been published.

It is a comment on the youth of the league that World War II swept its most active members into service on every major front. Many enlisted in the Signal Corps. Sid Grossman was a member of the Joint Army-Navy Photography Group; Walter Rosenblum received the Bronze Star for films he made in Normandy. Those who stayed home carried on faithfully, and the documentation they did for the Red Cross and the Service Canteens was publicly commended by Captain Edward Steichen as an example for other photographic organizations.

Introduction to *This Is the Photo-League* (New York: The Photo League, 1948).

Alfred Stieglitz

"AS A KID I WAS PROMISED an America—An America I believed in—and I insist on living—and dying—in that America, even if I have to create it myself."

On the evening of Saturday, July 7, 1946, Alfred Stieglitz, suffering from a heart attack, was helped home from An American Place. A week later, at 1:30 in the morning of July 13, he died. So ended a magnificent battle.

In 1890 a young photographer with an international reputation returned to New York after nine years of student life in Germany. He found the America of which he had been proud abroad betrayed and corrupted. He was so lonely—in the midst of friends and family—that he cried at night. One thing only kept him from fleeing back to Europe, as so many of his contemporaries were doing—the then-despised hand camera, so light, so mobile, and so quick, that he could express through it the life he found in the obscure and humble people moving through the streets and the unchanging reality of storms.

His instinct was always for life—electric, potent, mysterious. His feeling for people was extraordinary; his medium was people; and his photographs—"When I make a photograph, I make love."

His own life thenceforth was a succession of defeats that became victories. He left the photoengraving business because, for him, it was not worthwhile to do business with a lawyer on one side and a policeman on the other. He lived on a tiny income that fluctuated between a few thousand and a few hundred a year; even at its lowest, he was still able to give much of it to others. He had already been building the *American Amateur Photographer,* which was as somnolent and provincial as the photography it represented, into a lively magazine with contributors all over America and Europe; he resigned the editorship because the publisher's business attitude was that of caution, compromise, and misrepresentation. He then welded two desultory amateur societies into the Camera Club of New York. In an impatient country where "time is money" and "that's good enough; don't waste any more time on it" were stifling the creative impulse, he went among the users of an instrument miscalled a machine and insisted that they bring forth through it their deepest and most personal emotions, and perfect what they made down to the last detail of its presentation to the public. He, himself, with his laboratory training under a famous photo-

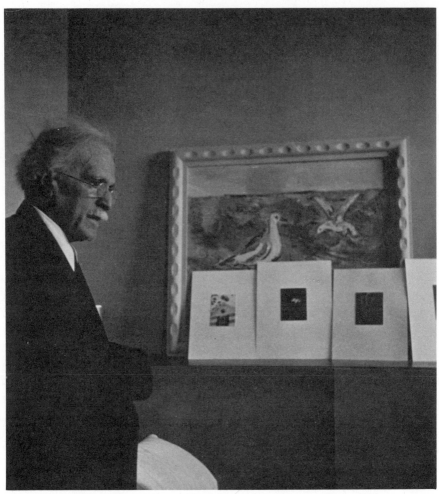

8. Nancy Newhall, *Alfred Steiglitz and* Equivalents *at an American Place*, 1943

chemist, would make twenty, fifty, if necessary a hundred prints from a negative until it balanced all the subtle factors of time, chemicals, and himself into a print so alive that it really expressed what he wanted to say.

All day and often into the night he was at the Camera Club, encouraging, demonstrating, making it one of the vital photographic centers of the world. He exhibited the work of the most talented Americans he could find and published it, together with the most stimulating writing he could borrow or provoke, in *Camera Notes*, the little magazine he founded for the Club. Certain members of the Camera Club felt they were not getting enough of this publicity and accused Stieglitz of perverting the club's facilities and magazine to furthering his own "clique." Stieglitz withdrew. With the same maligned "clique" of brilliant photographers, he founded: One, the Photo-Secession; Two,—after the speedy collapse of *Camera Notes* —his great quarterly, *Camera Work;* Three—incited by Steichen to find an exhibition outlet—the Little Galleries of the Photo-Secession at 291 Fifth Avenue.

At "291" he came closest to realizing his ideal of the free group—each creating, each contributing—spontaneously working together without laws or penalties. Everyone worked—fighting the stormy battles of the Photo-Secession, bringing in the unknown and talented, helping to hang the exhibitions, which were demonstrating the richness and variety of photography as an art; helping to pack them for shipment to museums and organizations even as far away as India; helping tip in the gravures in each of the thousand copies of each issue of *Camera Work* in whose manufacture Stieglitz was employing a firm considered by other publishers impossibly bad and calling forth from them work of the highest quality.

His own photography at this time was regarded by his co-workers as old-fashioned. Apart from a few collaborations, he persisted in following his instinctive feeling that the photographic image was more beautiful than anything the human hand could do to it. In the middle of his activities, he still found time to greet the new century with the penetrating tenderness that characterizes his work—photographs of a locomotive, an airplane, of the rising, changing city, and *The Steerage*, that strange picture of immigrants returning to Europe, with his prophetic split organization of form.

When jealousy and delusions of grandeur began to destroy the Photo-Secession, Stieglitz quietly enlarged the sphere of "291" by starting to show and publish the blazing work of unknown and revolutionary painters, sculptors, and writers—work that acted on the beholders like a catalyst, shocking, revealing, coalescing. Each exhibition was a demonstration, as were the stimulating, free-for-all discussions that happened in those two little rooms. They were part of Stieglitz's fierce attack on the false glosses and inner corruptions threatening America. Anyone who put love into whatever he or she did was welcome at "291," but anyone who came uttering the current cant, insincere and skeptical, was apt to feel as stunned as if run into by a precipice. Stieglitz had no patience with superficialities and patent formulas, whether intellectual, social, or political.

Even more ardent was his protection of the innocent and true and creative (it is a
symptom of decay that these words and what they symbolize are suspect) of which
the artist was the clearest example. Stieglitz's sense of responsibility toward the
artists became steadily deeper. It was not enough to show and defend their work;
they themselves had to be given the freedom and security to develop to their full
stature. To the question, "How much?" Stieglitz's invariable answer was, "How
much are you willing to give the artist?" For him a work of art was beyond value.
Neither "291" nor its successors were ever a business. The money went directly to
the artist. The rent and the framer were paid by voluntary contributions—sometimes
by the artist, if his living for a few years was assured, more often by others whose
giving must be itself a true thing, lest it hurt or distort the spirit of the place.

Yet even "291" was killed by the hysteria of World War I and its destructive
offspring in the arts, dada. From this black defeat, alone and almost penniless,
Stieglitz rose to make his greatest photographs, the portrait of Georgia O'Keeffe,
composed of hundreds of searching and passionate images, first of several portrait
series. Then the Equivalents, that series of cloud and sun, of dew and grass and tree,
through which he expressed thoughts and emotions usually considered too subtle
for the "literal" photograph. And beside these, as always, his forty-year-long biogra-
phy of New York City in its tragic final phase.

After a few years, the needs of his co-workers again impelled him to continue
the work of "291" in The Intimate Gallery and later in An American Place. About
the middle of the thirties, the condition of his heart became so critical that the
tremendous energy and concentration of photographing were forbidden him. Day
in and day out, from ten in the morning to six at night, he was at the Place, resting
on a cot, still welcoming all comers with the incomparable wit and wisdom of his
talk, still rising to expose, shame, and convict the shoddy and corrupt, still trying to
free and protect, in every individual he could reach, the noble America of the
promise.

The walls of the Place were still immaculate. There was still not even the first
cobweb of compromise with the huge forces outside. At eighty-two, Stieglitz was
still a refuge and a tower of strength, still a conscience, a goad, and a goal, to whom
thousands of people took their deepest, purest, and most intimate expressions for a
word of understanding or illuminating disapproval.

In his black hours, ruthlessly examining the past, he said that he had failed. It was
his fault. Of the vast company launched and strengthened by his strength, so few
remained to act and to share. Even among those few, there were jealousies and
denials. There was no one, no place, strong enough, vital enough, pure enough, to
carry on.

He thought of the photographs he might have made—longing to photograph, to
print again. Always he was impatient with the younger men; why work in fields
already explored, when so much life and its meaning, its force and mystery,
remained expressed? He often shifted relentlessly, saying, "If only I were younger,

I'd show them how to use the miniature camera—" or the movies, as he had done with the hand camera, magazines and reproduction processes, galleries, lantern slides, prints, as he had done with everything to which he devoted himself.

He had already become a legend, approached with terror or shunned as difficult, despotic, and exasperating. Some laughed, and said he was a charlatan and a superb salesman. Some said he was a fool to be baying after lost causes. Some said he was a great man—actual or potential—who went off the track into mysticism in his later years. For some of us who loved him, he was the most real and passionate human being we have ever known, and from that lightning-fact it was natural that he should be a fighter and a force and an artist beside whom many of today's acknowledged great look pallid and quibbling.

His photographs have also become a legend. For more than twenty years only fragments of his work have been exhibited. He refused to show them, once canceling a retrospective at the Museum of Modern Art after months of work; he was too old and weary to put that amount of energy into a lifetime statement of his own. And it hurt him to look at the photographs. When finally they are shown, in cyclical growth from the first joyous exuberance to the last profound and majestic meditation, they will constitute a revelation, not merely in photography nor art, but reaching beyond such confines to something in each of us.

"I am an American. Photography is my passion. The search for truth my obsession."

Photo Notes, August 1946.

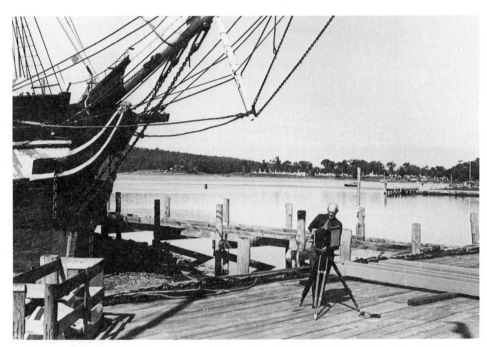

9. Beaumont Newhall, *Paul Strand photographing whale ship for* Time in New England *(p. 128), Mystic, Connecticut, 1946*

Paul Strand

PHOTOGRAPHS, 1915–1945

THE WORK OF PAUL STRAND has become a legend. Rarely exhibited, its influence has nevertheless spread through the last thirty years of photography. Time and again photographers coming in brief contact with its force and its extraordinary beauty have felt the shock of a catalyst. Strand has been a discoverer of photographic forms and concepts for our time, penetrating with unswerving logic and passion through each succeeding phase of his problem.

Seen as a whole, his work has remarkable unity. The abstract impressions of the speed and terror of New York in 1915 triumphantly announce his themes. The increasingly majestic and tender interpretations of lands and peoples, from Gaspé 1929 through Vermont 1944, are their latest resolutions.

He was born in New York City in 1890, of Bohemian descent, and grew up in a brownstone on the Upper West Side. In 1904 he started attending the Ethical Culture School. The gift of a Brownie camera had started him photographing when he was twelve, and when in 1907, a young biology instructor named Lewis Hine persuaded the school to build a darkroom and start a course in photography, Strand eagerly joined the four or five students learning to develop and print and set up their cameras in Central Park. Hine was just starting himself, photographing the immigrants at Ellis Island and their degradation in slums and sweatshops.

One winter afternoon Hine took his group of students down to the Little Galleries of the Photo-Secession at 291 Fifth Avenue. To the seventeen-year-old Paul Strand, that afternoon opened a new world. Here were photographs with the exhilarating impact of music, poetry, painting. These photographers were expressing vital things. Every print bore the individuality of its maker. The range of color and surface seemed unlimited—the powerful chiaroscuro and rich blacks of Steichen's gum prints, the simmering tone-patterns of Clarence White's platinums, the dynamic portraits by Gertrude Käsebier and Frank Eugene, printed on surfaces ranging from thistledown Japanese tissue to linenlike charcoal papers. There were rich carbon prints of Hill's noble portraits, Stieglitz's penetrating images of the rising, changing city. Strand felt that here was a medium to which one could devote a lifetime.

He joined the Camera Club of New York—only once or twice in his life was he to have a darkroom of his own—and settled down, at eighteen, to become a photographer. The control of camera, chemicals, and paper came first. With characteristic determination and a capacity for taking unlimited pains, he worked his way through the current enthusiasms: soft-focus lenses, gum prints, carbon prints, manipulations, all highly regarded then for their "artistic"effect. Feeling the need for genuine criticism, he went to see White and Käsebier, who were cordial but not cogent. He went to see Alfred Stieglitz, the extraordinary force guiding the two little rooms at 291 Fifth Avenue. Here was a man without prejudice or preconceptions, with an instinctive feeling and passion for photography. It was his energy and devotion that had evoked the Photo-Secession and brought forth its magnificent quarterly, *Camera Work* (1902–1917). Already the walls of "291" were beginning to blaze with strange revolutionaries— Cézanne, Picasso, Matisse, Rousseau, Brancusi—Weber, Hartley, Marin, Dove…

Here Strand received his first real illumination: Stieglitz pointed out that photography in its incredible detail and subtle chiaroscuro has powers beyond the range of the human hand. To destroy this miraculous image, as some members of the Photo-Secession, and Strand himself at the time, were doing, was to deny photography. To realize the full resources of his medium, the photographer must accept the great challenge of the objective world: to see, profoundly, instantly, completely. After that, during the slow, painful years of groping toward what he had to say, Strand went back to Stieglitz whenever he felt he had some advance to show.

Meanwhile, he faced the problem of making a living. Graduating from the Ethical Culture School in 1909, he began a dismal series of first contacts with the business world—an enameled ware business, a slaughterhouse, an insurance office. In 1911 he took his childhood savings and went to Europe for two months. With his usual thoroughness, he landed in Africa and worked his way up through Italy, Switzerland, Germany, Holland, Belgium, France. All alone, knowing nobody, traveling at night, he crossed to England, went up to Scotland, and came home, having enjoyed himself immensely. Shortly after this, he set up for himself as a commercial photographer, doing portraits and hand-tinted platinums of college campuses.

Dropping in now and then to see the exhibitions at "291," he found in Picasso, Braque, Matisse some thing that at first puzzled him and then became a great generative force. He began to understand their need to reexamine reality in the light of the twentieth century, their search for the elements—form, line, tone, rhythm—whose counterpoint underlies all art. He found the same structural sense in Picasso and El Greco, in Stieglitz and Hill. "In 1915," he wrote, "I really became a photographer…Suddenly there came that strange leap into greater knowledge and sureness…"[1]

When, in 1915, he went to see Stieglitz with his platinums under his arm, he was totally unprepared for what happened. Stieglitz was very much moved,

particularly by the photograph of Wall Street, with the little figures hurrying under the ominous rectangles of the Morgan building. Here was the city, now entering its climactic period of structure and thrust, dwarfing its inhabitants, engulfing them in speed, terror, and frustration. Other photographers had looked down from the city's towers before, but not with this formidable realization of abstracted form. Here too were the hurt, eroded people in the streets and parks. These huge, astonishing close-ups are the first true "candids." To catch these people unawares in the split second of self-revelation, Strand had diverted their attention by fixing a glittering false lens on the side of his quarter-plate reflex camera. Coming so close to things as to destroy identification, he created new classic structures from ordinary kitchen bowls, fruit, and later, machines. With a white picket fence and a dark barn he stated a rectangular theme that has obsessed a generation of photographers.

This was a new vision. Stieglitz himself, since his epoch-making *The Steerage* of 1907, had been realizing its formal and emotional implications with quiet, searching portraits, architectonic records of exhibitions, and images seen from the back windows of "291," which served as metaphors for his thought. In Pennsylvania, Charles Sheeler was making abstractions from native barns and buildings. In California, Edward Weston, still winning prizes in pictorial salons, had not yet begun his true evolution. Man Ray and Moholy-Nagy were still painting and would not for six years take up the camera. These dynamic forms and concepts of Strand's proclaim the new approach to photography.

Stieglitz said these things must be shown at "291" and in *Camera Work.* He called in Steichen and others who were in the little backroom, introduced them, and said to Strand, "This is your place. you belong here. Come here whenever you like." That was the beginning of a close relationship that lasted for fifteen years.

The show took place March 13 to 28, 1916. Six plates appeared in *Camera Work,* No. 48; the last number, 49-50, was devoted to Strand. Stieglitz wrote:

> His work is rooted in the best traditions of photography. His vision is potential. His work is pure. It is direct. It does not rely upon tricks of process. In whatever he does, there is applied intelligence…[These gravures] represent the real Strand. The man who has actually done something from within. The photographer who has added something to what has gone before. The work is brutally direct…These photographs are the direct expression of today. [2]

Strand's concepts have been endlessly repeated by the European experiments of the 1920s and their American imitators in the 1930s. Few of the photographers who filled photographic magazines, annuals, and exhibitions with patterns from above and portraits from too close realized that these forms were not an end but a beginning. To Strand, Stieglitz, Sheeler, Weston, and all the major American photographers, abstraction was a discipline and a starting point.

In 1918-1919 Strand served in the army as an X-ray technician; on his release he found himself slow to regain his momentum. The photographs Stieglitz had

been making, the passionate and searching portrait series of Georgia O'Keeffe, moved him profoundly and stimulated him to renewed activity. A sharper sensitivity to texture and light begins to characterize his work. In Nova Scotia in 1919 he made his first landscapes. In the New York landscapes of this period the raw chaos of the city's growth becomes a minutely organized vertical plane. A buggy in slanting sunlight becomes a skeleton of steely elegance, framed in weathered wood. A mullen, dark as sleep, prefigures his Maine sequence of six years later.

A beautiful new movie camera owned by Charles Sheeler inspired the two men to make a movie together. The result was *Manahatta,* released in New York in July 1921 as *New York the Magnificent.* With its captions from Whitman, its strange angles up and down on crowds pouring from a ferry and going to work, this film was hailed both here and Europe as the first to explore documentary material with an abstract and poetic approach.

Soon after this Strand was persuaded to become a free-lance motion-picture cameraman. His purchase of an Akeley camera eventually resulted in a fairly comfortable living making newsreels for Fox and Pathé, background shots for Famous Players and Metro-Goldwyn, and short films for Princeton commencements. Its more immediate results, however, were a series of photographs of the machine. In the camera he saw the black sculpture of its case, the interlocking climb of its gears, and the glimmering abstraction of its film movement. Through these and the lathes in the Akeley shop he "tried to photograph the power and marvellous precision which the very functional forms, surfaces, and lines of a machine reflect. I barely touched this field; it is still to be explored." [3] His preoccupation at this time with the relation of the machine to the artist appears in several articles.[4]

This was Strand's most polemic literary period. Intimately part of the brilliant, changing group around Stieglitz, he not only helped hang exhibitions, found galleries, and support projects, but fought battles in the press with articles and letters on Marin, O'Keeffe, Lachaise. A lecture he gave at the Clarence White School of Photography, attacking pictorialism and stating the creed of pure photography, caused much discussion here and in England.

By 1926 his income had reached the point where he was able to take a month or two each summer and concentrate on photography. That first summer, in the Rockies, he found two significant new themes: the uncanny sculpture of blasted trees and the ghostly ruins left by dead races. In Maine, 1927-1928, he made a series of intense close-ups that have been called the essentials of poetry.[5] In these photographs he rises to his full stature: the velocity of line developed in slanting grasses, curling ferns, vivid spear thrusts of young iris; the rising counterpoint of dark forest, etched across with dead lichened branches. A fugal development of motifs runs through the series: rain and dew appear as jets of light on a fern frond, as a shower of jewels in a cobweb. Driftwood changes from bosses of splintered silver to passages of Dantean incandescence. These rock forms, to quote Henry McBride, "...have been bitten by rain and wind into hieroglyphics that seem to mean everything." [6]

Beginning with this series, Strand's prints attain a depth and richness that Elizabeth McCausland, the most comprehensive of his commentators, called "superlative purity pushed beyond logic into passion."[7] Preferring platinum paper because of its permanence and long scale of values, Strand was not satisfied with the pale and uniform results usually obtained and experimented ceaselessly until he found ways to deepen and vary its tones. The rich black of his platinums he obtained by adding to the prepared paper a platinum emulsion he made himself. Goldtoning this enriched surface produced intense violet blacks. For silver tones, he used blue-black platinum paper; for a cold brilliance, as in the Machine and early Gaspé series, he used ordinary chloride papers. Working in the intervals between movie assignments, he seldom had time to make more than one superb print. Those on platinum paper, now unobtainable, are truly unique.

In 1929 Strand went to the Gaspé for a month. Working with a 4 x 5 Graflex instead of his heavy 8 x 10 Korona view camera, he began composing with all landscape elements, developing an exquisite sense for the moment when the moving forces of clouds, people, boats are in perfect relation with the static forms of houses and headlands. In this little series, where the whites blaze in the cold light of the North, that sense of the spirit of place which is implicit in the New York and Maine series emerges as the dominant theme of Strand's work.

This search for the fundamentals that shape the character of all that rises from a land and its people reaches symphonic proportions in the New Mexico series, 1930-1932. This is by far his most prolific and varied period. Of its first year, the poetess Lola Ridge wrote: "Earth is here a strange and terrible foreground in which the dark forces of nature seem to be raised to the nth power. There is a triumphant movement in the skies that alone rivals the else omnipotent earth. . . . Paul Strand has apprehended and made manifest the fierce rhythms of this earth. . . ."[8]

Among the shouldering adobe forms, the buttressed apse of the Ranchos de Taos church appears again and again in magically changing lights. In the ghost towns, Aspen, St. Elmo, Red River, Strand saw the last vestiges of the frontier. The boards of these moldering buildings seemed to him still permeated with the violence of the lives that had been lived in them.

From New Mexico Strand drove down to Mexico. Here it was the spirit of the people—their grace, their pride, and their enduring strength—that moved him. Returning to the "candid" theme of nearly twenty years earlier, he fitted a prism on the lens of his 5 x 7 Graflex (always masked to 5 x 6$^{1}/4$) and went into the streets and marketplaces of the little towns. Photographed against walls under the open sky, sometimes gently revealed, sometimes struck with vivid sunlight, these portraits attain a massive solidity and intensity that recall the work of Hill. In the dark churches, Strand found the *bultos,* strange images of Christ and the Virgin, which seem to symbolize, like the brief glimpses of the land and the architecture in this series, the emotional preoccupations of the people. The Mexicans themselves acknowledge the depth of Strand's realization.

The composer and conductor, Carlos Chavez, then chief of the Department of
Fine Arts in the Secretariat of Education, appointed Strand chief of photography
and cinematography and asked him to make a film on Mexico. The result was
Redes, released in the United States in 1936 as *The Wave,* the simple story of
fishermen in the bay of Vera Cruz, and photographically one of the most beautiful
films ever made. For Strand it was a focusing of his two media and his experience
in Gaspé and Mexico. From then on, for nearly ten years, he concentrated on
films. The pressures that were mounting into World War II impelled him, like
many other artists, to devote all his energies to awakening in the public an aware-
ness of threatening dangers. In 1935 he photographed with Ralph Steiner and Leo
Hurwitz *The Plow that Broke the Plains,* under the direction of Pare Lorentz. In
1937 Frontier Films was formed, with Strand as president. This non-profit organi-
zation produced *China Strikes Back, Heart of Spain, People of the Cumberland,*
and Cartier-Bresson's *Return to Life. Native Land,* the only Frontier film actually
photographed by Strand, was released in 1942.

Two interludes only break these years in film. The first was a two weeks' return
to the Gaspé, in 1936. Brief as this second series is, it is incomparably warmer and
more powerful than the first. The Gaspé is no longer remote, under huge skies:
children smile, a hardy old fisherman stands behind chicken wire in his barn door-
way. The white picket fence, no longer a challenging abstraction, recurs among the
clapboarded, gabled houses "like a musical figure."[9]

The second interlude was the production in 1940 of the magnificent portfolio,
20 Photographs of Mexico. This was Strand's attempt to solve the photographer's
problem of distribution. After considerable research, he decided on gravure, hand-
wiped and hand-printed, and worked out a lacquer that intensified the blacks. The
fine paper, the close cooperation with the skilled craftsmen making the plates, even
the assembly line of friends organized to coat the gravures with the special lacquer,
are characteristic of his own craftsmanship. Sold by subscription only, the edition
of 250 copies has long been exhausted.

After the release of *Native Land* and various short films made for government
agencies, it was with joy that Strand returned to photography. In the fall and winter
of 1943–1944, he went to Vermont. Here, as in the Gaspé, in Mexico, and in New
Mexico, where generations of painters and photographers have found only the
superficial and the picturesque, Strand reached into the essence of New England.
The shuttered white church stands on patches of snow like the terrifying grip of an
ideal. In the worn doorlatch, the tar paper patch, the crazy window among rotting
clapboards, appear the ancient precision and mordant decay of New England. In
the glimpse of delicate woods in snow through the side of a shed he expresses its
frail and stubborn loveliness. The portrait of the old farmer, Mr. Bennett is one of
the most eloquent and poignant in photography.

Strand himself has never worked symbolically. "His photograph is his best
effort to render the emotional significance of the object."[10] In the past thirty years

his work has been called brutal, cruel, tender, selfless, precious, static, timeless, tumultuous, wonderfully alive. The final verdict, as with all artists, rests with the future.

1. Paul Strand, "Photography to Me," *Minicam Photograph,* May 1945.
2. Alfred Stieglitz, "Our Illustrations," *Camera Work,* no. 49–50, June 1917, p.36.
3. Paul Strand, "Photography to Me."
4. Paul Strand, "Alfred Stieglitz and a Machine," (New York: privately printed, February 1921); Paul Strand, "Photography and the New God." *Broom,* November 1922, pp. 252–258, ill.
5. Henry McBride, "The Paul Strand Photographs," *N.Y. Evening Sun,* March 23, 1929. Review of one-man show at the Intimate Gallery.
6. Henry McBride, "The Paul Strand Photographs."
7. Elizabeth McCausland, "Paul Strand, the Photographer and His Work," *U.S. Camera,* Feb.–Mar., 1940, pp. 20–25, 64, ill.
8. Lola Ridge, "Paul Strand," *Creative Art,* Oct. 1931, 9, no. 4, pp. 312–316, ill.
9. Elizabeth McCausland, "Paul Strand."
10. Leo Hurwitz foreword, *Paul Strand: 20 Photographs of Mexico.* New York: Virginia Stevens, 1940.

Essay for the catalogue *Paul Strand: Photographs, 1915-1945* (New York: Museum of Modern Art, 1945).

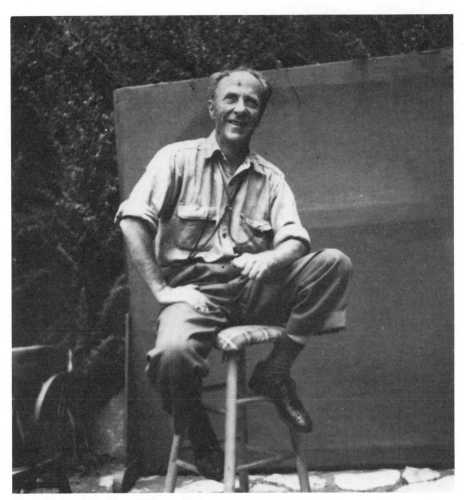

10. Nancy Newhall, Edward Weston, 1940

Edward Weston

IN 1902 TWO LETTERS passed between Dr. Edward Burbank Weston and his sixteen-year-old son Edward Henry, who was spending the summer on a farm. The first, from Dr. Weston, accompanied a Bullseye camera and contained instructions on loading, standing with the light over one shoulder, and so on. The second, full of Edward's thanks, excitedly discussed his failures and a first success— a photograph of the chickens.

From then on photography absorbed young Edward; his interest in school dwindled. When a magazine reproduced one of his sensitive little landscapes, such ambitions as wanting to be a painter or prizefighter vanished; he was definitely a photographer.

A livelihood, however, was something else. He came of generations of New England professional men. Edward, born in Highland Park, Illinois, in 1886, and his beloved sister Mary, were the first children born out of Maine for more than two centuries. His grandfather taught at Bowdoin College before moving to the Midwest to head a female seminary. His father, a general practitioner, found time during his rounds to teach in a local college. His mother, rebelling at the family tradition, left it as her dying wish that Edward should escape and become a businessman.

After three dull years as an errand boy in Chicago, Edward went on a two-week holiday to visit Mary, now married and living in Tropico, California. Enchanted by the place, he decided to stay, and immediately got a job with some surveyors, punching stakes in orange groves for a boomtown railroad nobody intended to build. Later, carrying the level rod on the Old Salt Lake Railroad, he found mathematics in the hot desert sun overpowering. Returning to Tropico he set up as a photographer. With a postcard camera he went from house to house, photographing babies, pets, family groups, funerals, anything for a dollar a dozen. He fell in love and, full of responsibility, began seriously studying his profession. He attended a "college of photography," learning a solid darkroom technique and how *not* to pose a sitter. For a year or two he held jobs with commercial portraitists, learning to make exact duplicate prints even from the poorly exposed and lighted negatives of his bosses.

In 1909 he married. Four sons were born: Chandler, 1910; Brett, 1911; Neil, 1914; and Cole, 1919.

In 1911 Weston built his own studio at Tropico. The customers who drifted in were delighted; even with his 11 x 14 studio camera, he was often able to make several exposures before they were aware of it. Posing by suggestion, he hid ungainly shapes in chiffon scarves or vignetted them away. The soft-focus Verito lens helped, and he retouched so deftly and with such regard for actual modeling that his patrons, unconscious of any change, were convinced they looked that well.

He was particularly successful with children. Trying to capture their activity, he bought, around 1912, a $3^1/4$ x $4^1/4$ Graflex. The curtains obscuring his skylight and sunny windows came down; the subtleties of natural light absorbed him. "I have a room full of corners—bright corners, dark corners, alcoves! An endless change takes place daily as the sun shifts from one window to another.... All backgrounds have been discarded except those for special decorative effects, which are brought out when needed."

He worked outdoors as well—his baby sons in the garden, Ruth St. Denis in Japanese costume standing in a shimmer of light and space with one spot of brilliant sun slanting across her cheek. From 1914 to 1917 he received a shower of honors. Commercial and professional societies awarded him trophies and asked him to demonstrate. Pictorial salons in New York, London, Toronto, Boston, Philadelphia, elected him to membership. Many one-man shows at schools and clubs brought him further acclaim.

But he was not content. Something was wrong—with himself, with his hazy Whistlerian and Japanese approach. At the 1915 San Francisco Fair he first saw modern painting; radical new friends introduced him to contemporary thought, music, literature. His conservative friends and in-laws frowned; instead of settling down as a successful man and father he began to sport a velvet jacket and a cape. He ceased to send to pictorial exhibitions. His work was changing.

By 1920 the Japanese arrangements were violently asymmetrical. An attic provided semiabstract themes of angular lights and shadows. By accident he discovered the extreme close-up; focusing on a nude, he saw, in the ground glass, forms of breast and shoulder so exciting that he forgot his customers. Groping, with occasional flashes of insight, he was still trying to impose his "artistic" personality on his subject matter.

Then, in 1922, the dark and exciting Tina Modotti took some of Weston's personal work to Mexico and exhibited it at the Academia de Bellas Artes. Her friends—Rivera, Siqueiros, the artists of the surging Mexican Renaissance—were enthusiastic. What is more they bought—a new experience for Weston. He decided he would go to live in Mexico.

In November he went East to say good-bye to Mary, whose husband was now with the steel industry in Ohio. The Armco plant, with its rows of giant smoke stacks, excited Weston to a series of photographs in which his own vision emerges unmistakably. Mary urged him to go to New York and see the legendary masters there. In New York, with his mind full of the forms and rhythms of industrial America, he haunted the bridges and

rode endlessly on the buses, looking up at the towering city. Articles on Stieglitz by Paul Rosenfeld and Herbert Seligmann had helped him discover why he was dissatisfied with his own work; actual contact with Stieglitz left him rather bewildered, though much moved by the photographs of O'Keeffe. His greatest enthusiasm was evoked by the clear structure of Charles Sheeler's architectural photographs.

In August, 1923, he sailed for Mexico. With Tina, whom he had taught to photograph, he opened a portrait studio in Mexico City. His exhibition at "The Aztec Land" in October contained palladiotypes of industrial themes, sculptural fragments of nudes, highly individual portraits, people in contemporary life. The Mexican artists immediately accepted him. "I have never before had such intense and understanding appreciation. . . . The intensity with which Latins express themselves has keyed me to high pitch, yet viewing my work on the wall day after day has depressed me. I see too clearly that I have often failed."

The three years in Mexico were years of ruthless self-scrutiny and growth. Unable in his halting Spanish to control his sitters by conversation, he took them out into the strong sunlight and watched in his Graflex for the spontaneous moment. A startlingly vivid series of heroic heads against the sky resulted— the keen-squinting Senator Galván at target practice, Rose Covarrubias smiling, with the sun in her downcast lashes. Commenting on the head of Guadalupe de Rivera, Weston wrote (1924): "I am only now reaching an attainment in photography that in my ego of several years ago I thought I had reached long ago. It will be necessary to destroy, unlearn, and rebuild."

Between sittings— desperately poor, he was much confined to the studio for fear of losing a customer— he worked searchingly with still life— Mexican toys, painted gourds, jugs— arranging them again and again in new lights, new relations. Within the courtyard, from the rooftop, whenever he could get away, he was at work with a more powerful and articulate clarity on the massive forms of Mexico; the vast landscapes, the huge pyramids, the people-sprinkled patterns of the little towns.

More even than to the mental stimulation of such friends as Diego Rivera, Weston responded to "the proximity to a primitive race. I had known nothing of simple peasant people. I have been refreshed by their elemental expression. I have felt the soil." Close to them, confusions fell away. Eliminating every illusion, convention, process, or device that impeded creation, he concentrated on vital essentials. "Give me peace and an hour's time and I create. Emotional heights are easily obtained, peace and time are not. ... One should be able to produce significant work 365 days a year. To create should be as simple as to breathe."

In 1925 he went to California for six months. Contact with his native land produced sharper rhythms, more complex motifs— industrials again, and unposed 8 x 10 portraits. Returning to Mexico with his son Brett, he photographed with a stronger feeling for light and texture the markets, the wall paintings outside native bars, Dr. Atl standing beside a scribbled wall. Reviewing the Weston-Modotti show at Guadalajara, 1925, Siqueiros wrote, "In Weston's photographs, the texture— the physical quality— of things is rendered with the utmost exactness: the rough is rough, the smooth is smooth,

flesh is alive, stone is hard. The things have a definite proportion and weight and are placed in a clearly defined distance one from the other.... In a word, the beauty which these photographs of Weston's possess is *photographic beauty!*"

With Tina and Brett, Weston traveled through almost unknown regions photographing sculpture for Anita Brenner's *Idols Behind Altars* and bold details of cloud and maguey for himself. But he was not and never could be Mexican; the time had come for him to return home.

His friends grieved. He had brought them an important stimulus and vision. Jean Charlot, in an as yet unpublished history of the Mexican Renaissance, wrote recently:

> It was the good fortune of Mexico to be visited, at the time when the plastic vocabulary of the Renaissance was still tender and amenable to suggestions, by Edward Weston, one of the authentic masters that the United States has bred.... Weston photographs illustrated in terms of today the belief in the validity of representational art ...cleansed...of its Victorian connotations....He dealt with problems of substance, weight, tactile surface and biological thrusts that laid bare the roots of Mexican culture. When Rivera was painting *The Day of the Dead in the City* in the second court of the Ministry we talked about Weston. I advanced the opinion that his work was precious for us in that it delineated the limitations of our craft and staked optical plots forbidden forever to the brush. But Rivera, busily imitating the wood graining on the back of a chair, answered that in his opinion Weston blazed a path to a better way of seeing, and, as a result, of painting.

Back in Glendale, Weston missed Mexico and was at first unable to work. Then, in the studio of the painter Henrietta Shore, he picked up some shells of which she had been making some semiabstract studies. His mind was suddenly filled with the dynamic forces of growth, the vital forms and lucent surfaces of shells, fruits, vegetables. Often he worked for days on a single form in various nuances of natural light, seeking "to express clearly my feeling for life with photographic beauty — present objectively the texture, rhythm, form in nature without subterfuge or evasion in spirit or technique — to record the quintessence of the object or element before my lens, rather than an interpretation, a superficial phase or passing mood...." He began to free the forms in space. One superb pepper came most thoroughly alive within the shimmering darkness of a tin funnel. At the same time, with the same feeling: "I am also photographing a dancer in the nude....I find myself invariably making exposures during the transition from one position to the next — the strongest moment."

With Brett, already at seventeen a remarkable photographer, he opened a studio in San Francisco. Cities increasingly oppressed him; in 1929 he welcomed a chance to move to Carmel among the Monterey coast mountains. Here he discovered what his friend Robinson Jeffers has described as "the strange, introverted, and storm-twisted beauty of Point Lobos." He photographed the writhing silver roots of cypresses and the strangling kelp, the starred succulents and monumental eroded

rocks, incandescent salt pools and winged skeletons of pelicans. Orozco, passing through Carmel in 1930, was so moved by these transcendent images that he arranged Weston's first New York one-man show that fall.

In 1927 the reaction to the first shells was surprise and dismay. Many people, including Rivera, thought them phallic. As the close-ups grew more subtle and powerful, they struck beholders with the force of a revelation. Sober reviewers from Seattle to Boston discovered they were "art" and prattled of "miracles," "lowly things that yield strange, stark beauty." They declared Weston one of the most significant artists in America, in the twentieth century. They found him the peer of Picasso, Matisse, Brancusi, and Frank Lloyd Wright. In 1932 Merle Armitage brought out a handsome book of thirty-nine reproductions, *The Art of Edward Weston*. One-man shows swept spontaneously from Berlin to Shanghai, from Mexico to Vancouver. Unaided, with neither agent, group, nor institution to back him, Weston responded to innumerable requests with more than seventy different shows between 1921 and 1945.

With his first New York show, composed entirely of glossy prints—the shells and rocks demanded a brilliance and clarity beyond the bronze tones and matte surface of the palladiotype—Weston's concept stood forth clear and mature. "This is the approach: one must prevision and feel, *before exposure,* the finished print....The creative force is released coincident with the shutter's release. There is no substitute for amazement felt, significance realized, at the *time of exposure.* Developing and printing become but a careful carrying on of the original conception...." He had, and has, two cameras: an 8 x 10 view camera and a Graflex for portraits. There is one background, occasionally used behind a sitter. Settling his friends or clients somewhere, indoors or out, where the light is favorable, he lets them become themselves while he watches fleeting expressions and gestures. He uses one film, one paper. He tray-develops his negatives in pyro-soda, by inspection, bringing each one to the exact degree of delicacy or density he wants. Working under an overhead bulb with a printing frame, he makes only contact prints, dodging in areas beyond the scale of paper so deftly that the balance of light is never upset. Developed in amidol, scrupulously fixed and washed, more than half of the first prints from his negatives are exhibition quality. These prints are then dry-mounted on white boards and spotted. This is technique at its most basic and direct; the result of decades of experience, its emphasis is entirely on vision.

In his professional work he was still compelled to use evasions, enlarging the Graflex negatives onto 8 x 10 film with the old Verito lens stopped down just short of sharp. Printing the results on matte paper either eliminated retouching or hid the last traces of his almost invisible pencil work. This division between personal and professional standards bothered him. He campaigned among his sitters. More and more people discovered that the reality of one's own face, worn into character, quick with thought and feeling, the composition completed by mobile hands, has a curiously exciting quality. Friends liked the little prints and the unostentatious way

they fitted into contemporary living. By 1934 he could at last hang out a sign: *Unretouched Portraits.*

To thousands of photographers Weston was becoming a challenge; to his friends a sanctuary as well. To live more freely and simply than Thoreau, to work with a bare technique and produce brilliantly, to walk free, without help or com-promise — these things are not easily achieved in the cluttered and frantic twentieth century.

His isolation was ending. Brett was changing from a prodigy to a co-worker and others were coming to share the stimulating companionship: Ansel Adams, whom they met as a pianist with some promising but immature photographs; Willard Van Dyke, who left his filling station for two weeks to study with Weston. These young photographers, wrestling with creative problems, discovering new subject matter, groping for their own approaches, began to form a group around Weston. The more they grew away from pictorialism the more intolerable they found it that there should exist a system which put a premium on the obvious and the sentimental and consistently squeezed any honest or original thought into decadent impressionistic formulae.

The idea of organizing occurred to them. One night in 1932 Willard Van Dyke called a meeting and proposed *Group f/64* — f/64 being one of the smaller shutter stops and therefore associated with sharp focus. The charter members of Group f/64 were Ansel Adams, Imogen Cunningham, John Paul Edwards, Sonia Noskowiak, Henry Swift, Willard Van Dyke, Edward Weston. Later members included Dorothea Lange, William Simpson, Peter Stackpole. Preston Holder, Consuela Kanaga, Alma Lavenson, Brett Weston were associates. Lloyd Rollins, the new director of the M.H. de Young Museum in San Francisco, strongly encouraged the nascent group and held its inaugural exhibition in the fall of 1932. The most ardent protagonists, Adams and Van Dyke, both opened galleries, wrote vigorously for the press, and started a salon of "pure photography." With some of their pronouncements Weston could not agree. Gently, he withdrew. As an active spearhead, Group f/64 lasted only a year or two; as the violent peak of a great contemporary movement, its influ-ence still persists.

In the early 1930s Weston was alarming his friends by breaking away from the extreme close-up, doing clouds and villages in New Mexico, perspectives of a lettuce ranch in Salinas, the massive naked hills of the Big Sur. Then came, in 1936, a classic and majestic series. From their new studio in Santa Monica, Edward and Brett worked together among the vast, wind-rippled sand dunes at Oceano, which rose from deep swirls of morning shadow to stand dazzling and sculptural at noon, and sank again, bright-crested, into darkness. Photographing across from one bank to another, with the sun along the same axis as his camera, Weston made a series of nudes in which a subtle line of shadow outlines the figure, rounding the living skin away from the harsh brilliance of the sand.

The old longing to be free of clients led Weston to apply for a Guggenheim

Fellowship "to make a series of photographic documents of the West." In 1937 he became the first photographer to receive this award. After twenty-six years he was at last able to concentrate on his personal work alone. He wanted to see if he could now meet what he considered photography's greatest challenge: "mass production seeing." In most mediums, he felt, the artist is retarded by his process. He may not in a lifetime bring to birth a fraction of what he conceives. The photographer, realizing and executing in almost the same spontaneous instant, is limited only by his own ability to see and to create.

In *California and the West* his second wife, Charis, has written the log of that journey—the planning of the $2,000 grant down to the last cent for a maximum of photography and travel, the canned foods stewed together over campfires, the slow drives through desert heat, mountain snow, and coastal fogs. During those 35,000 miles, deep-rooted thoughts and emotions began to coalesce into an image of the American West. It concerns the span of geological ages and the enormous savage earth momentarily littered with a brittle civilization. Elemental forces are the true protagonists in Weston's vision—forces that irresistibly produce a flower or a human being, erode granite, and make strange beauty not alone of skeletons but even of the decay of man's works.

In 1938 the Guggenheim Fellowship was extended. In the bare and simple darkroom of the little redwood house, built by Neil on a mountainside looking down over Point Lobos and the Pacific, Weston spent most of the year printing the fifteen hundred negatives made on his travels. The only duplicates were of unpredictable moving objects such as waves or cattle. Very few were discarded because they did not meet Weston's severe technical or esthetic standards. The series constitutes an astonishing achievement in variety of vision. Weston felt he had learned a great deal; he longed to go on.

Returning rather reluctantly to Lobos, he discovered new themes—surf and tide pools, fog among the headlands starred with succulents and dark with cypresses. The stream of visitors began again. Weston photographed them more and more with the 8 x 10, sunning on the rocks, against his house, among the ferns and flowers of his garden.

In 1941 he was asked to photograph through America for an edition of Walt Whitman's *Leaves of Grass*. His aim was not to illustrate but to create a counterpoint to Whitman's vision. During the journey through the South and up the East Coast he found the land and the people weary, the civilization more strongly rooted in a quieter earth; he saw blatant power in industry everywhere, strength still standing in old barns and houses. In Louisiana he worked intensely on the decay and beauty of swamps, sepulchers, ruins of plantation houses. A miasma of gray light and smoke obscures the cities. In New York it seemed to wall him in.

The trip was cut short by Pearl Harbor. The Westons returned to Carmel, joined civilian watchers on the headlands. All Edward's sons were swept into the war. Lobos was occupied by the army. Security regulations and gas rationing confined

Weston to his backyard. Here he began photographing a beloved tribe of cats. Capturing their sinuous independence with an 8 x 10 produced an amusing series —and a formidable photographic achievement. With the robust humor and love of the grotesque that have always characterized his work, he also began producing a series of startling combinations— old shoes, nudes, flowers, gas masks, toothbrushes, houses—with satiric titles such as *What We Fight For, Civilian Defense,* and *Exposition of Dynamic Symmetry.*

On March 24, 1946, Weston will be sixty. For him, the long vista of growth focuses on today; in a recent letter he wrote, "I am a prolific, mass-production, omnivorous seeker." His latest work surges with new themes. All the signs point toward fresh horizons.

Essay for the catalogue *The Photographs of Edward Weston* (New York: Museum of Modern Art, 1946).

Brett Weston

BRETT WESTON IS AN ARTIST and a craftsman born. Everything he makes or owns must have the same forthright simplicity and deep feeling for materials. His wood sculpture has the lift and sweep of yacht hulls; his approach to his chief medium, light, is sculptural. His tools — his chisels, cameras, tripods — are not just tools to him but objects of his love and respect. His cameras must be flexible as his hand and his lenses cover the image to the last millimeter with microscopic clarity. He cannot abide shoddy workmanship, mushy definition in a photograph, or a life cluttered with unessentials. Blue-eyed, blond-maned, full of gusto and vitality, he moves about his living and working like a benign and unexpectedly gentle lion.

He became a photographer as naturally as breathing. The second of Edward Weston's four sons, he was born in Los Angeles in 1911, and he was thirteen when he went to Mexico with his father and found the pursuit of images through a camera even more absorbing than the pursuit of butterflies. What he learned was photography at its most direct, powerful, and flexible. A year later, just before they left Mexico, Edward wrote in his daybook: "Nov. 5, 1926…With the greatest satisfaction I note Brett's interest in photography. He is doing better work at fourteen than I did at thirty. To have someone close to me, working so excellently, with an assured future, is a happiness hardly expected."

Back in California, they held several joint one-man shows, and Brett, at fifteen, began to be published and acclaimed. They shared a succession of portrait studios, first in San Francisco, 1928, then in Carmel, 1929, and later in Santa Monica, 1935. Brett became more and more the stimulating co-worker for whom Edward had longed, learning meanwhile from his father still another important technique— that of living a life cleared of superfluities and concentrated on creative work. By 1929 his photographs were being exhibited as far away as Stuttgart, Germany, and his first major one-man show was held at the M. H. de Young Memorial Museum in San Francisco in 1932.

Abstract form dominates his early work—the black explosion of a broken window, swirls of wet emery on glass, the dunes at Oceano rippled and hollowed by the wind. Already his love of intense blacks and whites is evident—black as space in which forms move, black as active force or repeating rhythm; white as pure continuous line, an accent like a chisel cut, or frost on darkness. Equally strong is his

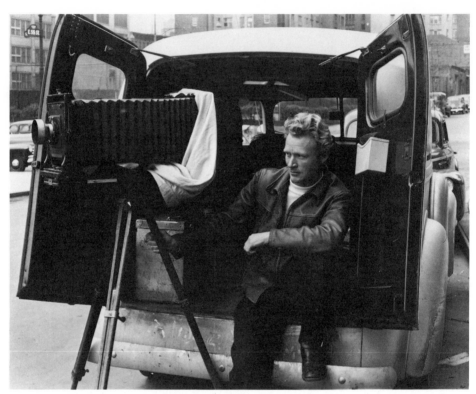

11. Nancy Newhall, *Brett Weston*, New York, 1948

feeling for dynamics. Force and rhythm are as important to him as form—the sweep of the great bridge across the Golden Gate, the brilliant surge of the Pacific leaving huge twisted ropes of seaweed behind it. In his first portfolio of original prints, *San Francisco, 1939,* the city marches over the hills to the sea. Content and mood are there too—the strange magic of the moment when fog advances toward the roofs and steeples over the dark islands and the gleaming bay.

For a few months in 1943, he worked as movie cameraman for Twentieth Century Fox. In the early years of World War II, he had been photographing everything from machine parts to accidents for North American Aircraft. Then the army swept him away from his home in Santa Monica and his little daughter Erica and plunged him three separate times into basic training. Finally connected with the Signal Corps in 1944, he came East to undergo a fourth dose of basic training—as a photographer! After twenty years, such assignments as the Signal Corps could think up were child's play. Brett tossed them off in half an hour or so each morning and then disappeared quietly on his own concerns.

As a buck private he still had more freedom than most of us ever achieve, and he spent it wandering around New York City, often with his 8 x 10 inch camera and tripod over one shoulder and a canvas bag containing a few holders over the other. It was his first view of the East, and the ballet of city forms obsessed him—door and alley and rooftop, the thrust and stress of tower and bridge, the shadow of fire escapes, the million windows, and the face of walls.

The tremendous city scale that reduced all human measurements to minutiae led him to acquire an 11 x 14 camera. Few men these effete days will tote such a load about the landscape; they prefer making enlargements comfortably at home. But Brett senses a loss of clarity and brilliance in the most skillful enlargement. And for his grand volumes and contrapuntal motions he likes a big ground glass and a massive image he can examine minutely.

Perhaps by contrast to the city, his curious sympathy for plants increased—the dark majesty of palms in the Botanical Gardens as well as the crowding of suburban weeds toward the light. When he met an ivy on a city wall, his photograph is full of its tenacious clinging, creeping, exploring through crisp new shoots a strange inimical world.

Around Christmas, 1945, he was ordered to El Paso, Texas, where he became a sergeant, somewhat to his surprise, and spent his Sundays exploring with his cameras the dazzling gypsum dunes of White Sands National Monument. Instead of abstract sculpture, he saw a magic play of light: grasses, ghostly in their winter death, shadowing the massive, luminous dunes with silver, the spikes and bells of yucca black as jet against them. He saw the delicate aerial structure of eerie plants reaching into the skies, the dunes gray with storm or gleaming with snow against dark distant mountains—endless absorbing variations!

While still in uniform he was awarded a post-service Guggenheim Fellowship. In the spring of 1947, he set forth on his journey—back to White Sands, on through

the South, and up the East Coast. His solution to the problems of transportation, food, and shelter was as self-contained as the mules, tents, beans and bacon of Jackson and O'Sullivan in the 1870s: a panel truck painted aluminum against desert heat, with a jerry can for extra gas on the running board and a railed platform, for extra height when photographing, on the roof. He fitted up the interior like a ship's cabin, with folding bunks, lockers for food and clothes, racks for pipes and shoes, a brassbound keg for water, an insulated case for films, a Primus stove, and spaces for cameras and tripods—the 5 x 7 Linhof (his "minicam"), the 8 x 10, and the 11 x 14.

In this camera car, he was independent of towns and darkrooms for days, even weeks, at a time. To load or unload his film, he sealed the windows with blinds, let down a seven-foot shelf, and went to work with more elbowroom than at home. His housekeeping, like all Westons', was simple as an Arab's. A handful of figs or dates, an avocado, a hunk of cheese and crusty bread—on these he flourished during working hours. If he came at night to an enchanting swamp, he had no need to hunt up supper and a bed in the nearest town; he cooked and slept right where he was, brewed black coffee in the earliest gray, and had cameras all set up for the first sunlight and the morning stillness. If he came at noon—usually the least interesting light—to a beach or a brook, he jumped in for a swim and took a nap in the sun afterward. In New York City itself he was equally at home. Nightly he bivouacked in Sutton Place, and belligerent policemen, hammering on the doors, found themselves cordially invited inside and sitting meekly on the bunks with cups of coffee in their hands.

The work of those three years—New York, the East Coast, White Sands—was received with enthusiasm by his friends and collectors. A portfolio reproducing the White Sands series was proposed. Smoking a few pipes over the idea one morning in Sutton Place, Brett came to the conclusion that since no reproduction yet known could convey the full scale and impact of the original—why not originals? As he had done with *San Francisco,* he could buy in quantity, gear himself to mass production, and achieve a publication somewhat limited perhaps in number, since it meant months devoted to the darkroom, the trimmer and the dry-mounting press, but unlimited in quality.

It was the answer of a true photographer. Printing, to Brett as to most creative photographers, is the climactic test—the moment of truth—in one's work. One may rush to proof the latest exciting negatives, but serious printing, in mass, is approached with rituals of preparation and almost with prayer. Brett did a great deal of it in the late 1940s and early 1950s: the exquisite *White Sands* portfolio, 1949, the Special Edition of 1951, the vigorous *New York: Twelve Photographs,* 1953—and not only his own negatives but his father's. Edward, stricken with Parkinson's disease, could no longer photograph. Under his supervision, however, Brett, long so close to him in vision and feeling, could make prints from his negatives that he considered equal to his own. Morning after morning Brett brought from the darkroom damp prints for Edward to examine under the skylight. Edward

would indicate "more luminous" or "sharper black," and Brett would vanish back into the darkroom to try for the model print to which he would match all subsequent prints from the same negative. In this way he printed Edward's *50th Anniversary* portfolio and then tackled the formidable job of making eight sets from nearly a thousand negatives Edward had selected as the finest of his life's work. Often, Edward maintained, Brett achieved a finer interpretation than he had himself. But he felt strongly that this filial duty must not be allowed to confine Brett nor usurp his own creative life.

Often, as a contrast to the darkroom during those years, Brett was helping his brothers and friends build houses, including an adobe studio for himself at Garapata Creek and later the distinguished contemporary house and studio in the Carmel Highlands where he now lives. And now and then, as necessary to him as air and light, he went forth with the 8 x 10 or the 11 x 14, for a morning on Point Lobos, an afternoon down the Big Sur, an expedition of several days to the desert, a trek across the continent, in his camera car.

In 1930 Merle Armitage, impresario, book designer, and old friend, had hailed his first little one-man show at a San Francisco gallery and proclaimed, "Brett is more than a chip off the old block....This 19-year-old and lusty fellow is one of the great photographers of America." Two years later, in the midst of the Great Depression, he brought out Edward's first book, the spectacular *The Art of Edward Weston,* now, in 1956, with the same massive and lavish splendor, he brought out *Brett Weston Photographer.* In his introduction, Merle commented:

> The rising sun of Brett Weston has been apparent to critics and collectors for many years, and he has achieved a body of work so sound and advanced as to represent a great achievement in the ever widening world of photography....He ranges without limit in the subject matter, from the most evanescent subtleties through every nuance to the powerful mutations of nature and the monuments of man. One of the most distinguished contributions is his mastery of non-objective results, which of course are based on the myriad forms of nature, the greatest designer. Here his seeing takes on the quality of miraculous perception and produces photographic prints of new esthetic dimension...presented with the brilliance and the pristine quality which only photography can command.

Ice, mud cracks, foam, the towering rock walls of Glen Canyon before it was submerged behind a dam, raindrops on metal, crags dark against the shining Pacific—the common underfoot and within hand's reach, the unusual and the overpowering, Brett transforms them all, unaltered, into forms both bold and subtle. It did not seem to matter where he went; his subjects drew him to them like magnets.

In 1960 he realized a long-cherished project: he sailed for Europe, with a thousand sheets of film, intending to stay a year. In a Volkswagen bus, he drove from Scotland to Greece, from Austria to Portugal, bivouacking as he had on his journeys through the United States. But, jolting through narrow cobblestoned alleys,

grinding up the switchbacks of mountain roads, laboring down the autobahns, always monotonous and often billboard-infested, he found himself setting up camera where suddenly Europe seemed to prevision, as it often does, the America it spawned. "Am I homesick!" he scribbled on postcards. "Many good negs...twelve countries—three more to go!" He was enthusiastically received, he made many friends, but the moment came when he could no longer wait to get back to the space, power, and beauty of his own country. In New York he debated whether to visit friends in the East or "roar home." He roared home. "Erica, mother, darkroom and house won out!"

Two more portfolios appeared; one, *Fifteen Photographs,* 1961, contains some of his European work; the other is entirely his work with the 11 x 14.

Then expeditions to Baja, California, wild, remote, rough and beautiful, led him back to Mexico and south to Guatemala. In Mexico City he held, in memory of his father, a joint show: Edward's work in Mexico in the 1920s and his own recent work there in the 1960s. This *Exposición Fotográfica de Dos Generaciones* was attended by the same passionate excitement his father's shows had received forty years ago. A copy of Edward's *Daybooks: Mexico* was actually worn out during the exhibition. "Hundreds came to the opening," Brett wrote. "My best reception ever."

Now he dreams of Alaska, of Japan, of new worlds to discover through his cameras.

Essay for the catalogue *Brett Weston, Photographs* (Fort Worth, Tex.: Amon Carter Museum, 1966). Revised from the introduction to *White Sands,* Portfolio of 10 Original Photographers, by Brett Weston (San Francisco: Grabhorn Press, 1950).

Minor White

"MINOR WHITE!" WE SAID. "What a curiously appropriate name for a photographer!" It was a hot August afternoon in 1942, and we were in the library of the Museum of Modern Art. Ansel Adams, Alfred Barr, David McAlpin, James Thrall Soby, Beaumont, and I had just finished judging a competition called *Image of Freedom,* and we were now finding out who made the one hundred photographs we had chosen. Each photographer had been asked to submit four prints. We discovered we had chosen all four of Minor's. Mostly Oregon landscapes, with farmhouses and barns, seen with integrity, nostalgia, and a beautiful feeling for structure and light.

After World War II, we heard the name again; the then director of the Portland, Oregon Art Museum, a friend of ours, was hoping to set up a department of photography like that at the Museum of Modern Art. Would we help train, for a year, Minor White, the photographer he had chosen as its future curator? So Beaumont took him in at the museum as an intern in museum processes and procedures and sent him to Meyer Schapiro at New York University for grounding in art history, and we both took him to Stieglitz. Of course, we took him with us whenever something or somebody interesting came along. He became quietly a part of our lives, this tall, pale, and very strong man, with his deep voice and his background of science and poetry. At our parties, whether large or small, he watched and listened, with humor and sympathy, to what went on around him, and you could feel him grow.

Equal perhaps to his conversations with Stieglitz was his meeting with Edward Weston, when, pushed on his first plane by his sons, he came East for his great retrospective at the museum, which I directed. He could study Edward's work with Edward, who was on duty everyday, and then come back to our place and see Edward the man.

In the spring of 1946, the Portland project died, and we had decided to leave the museum, but Ansel, who had founded a department of photography as art and profession at the California School of Fine Arts, was yelling for an assistant, so we shipped Minor out to him. Minor, riding in a daycoach day and night, reported he felt better every mile he came nearer the West Coast. Ansel reported, "He fits in like a glove fits on!"

The San Francisco period was a time of tremendous interior development for Minor. Living next door to Ansel, in the old Adams house, where he found himself

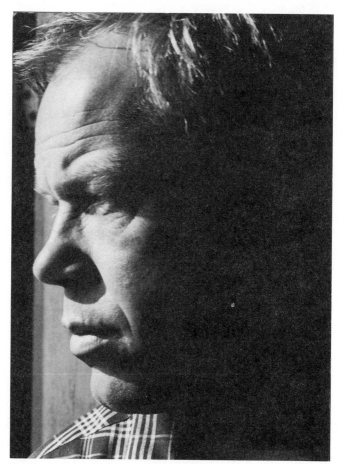

12. Nancy Newhall, *Minor White*, 1950

running a kind of hostel for students, learning from Ansel as well as teaching, going down the coast to see Edward and to lose himself, dreaming over Point Lobos, wandering through San Francisco, working with the students on a project involving a vast power company, and becoming aware of the anthropomorphic aspects of machines —all these, combining with Schapiro's Freudian iconography and Stieglitz's theory of the Equivalent, became a continuing revelation to Minor, who had always inclined to mysticism. He began to work out the system he calls "space analysis" and to write about it.

For years, Ansel, Beau, and I had talked about and written reams about founding a journal, or a quarterly, of a quality as nearly equal to *Camera Work* as might be possible today. But we never found the time or extra energy required. Minor did it. The first *Aperture*— title suggested by Adams—contained two essays, one by Minor on miniature camera photography, and one by me on the caption. On the cover was a photograph by Dorothea Lange of a signpost pointing in all directions.

Aperture steadily increased in the quality of its reproductions. In the early years, we all helped but, getting swamped again, came to leave it mostly to Minor. When we protested some issues, he would say, "If you don't like it, for God's sake do it yourself."

Then Minor came to Rochester, New York, to assist Beaumont at the George Eastman House, making shows, getting out *Image*, working with the vast collection. Again he dreamed through the countryside, often with students who had come to be with him.

A poetic series: tree peonies on the estate of a friend, barns in winter stubble and after snow, waterfalls ethereal in storm, miracles of light in his rooftop apartment or of frost on its windowpanes. His mysticism, fed by Zen, increased. He wanted to teach and to photograph, left Eastman House, and taught at the Rochester Institute of Technology for some years.

Every summer he got into his Volkswagen bus and headed West, giving workshops along the way and, of course, photographing. In many of these photographs the viewer feels like a disembodied spirit, floating with love and compassion above the earth, and stabbed now and then by strange discovery.

Then he went to the Massachusetts Institute of Technology to teach. He seems happy there, with his office on the third floor of a vast old building and his tall old house in Arlington, where he holds frequent workshops.

His strange personal vision unfolds through depths and distances in very beautiful photographs. Through *Aperture* and his teaching, he has developed and led a new direction in creative photography.

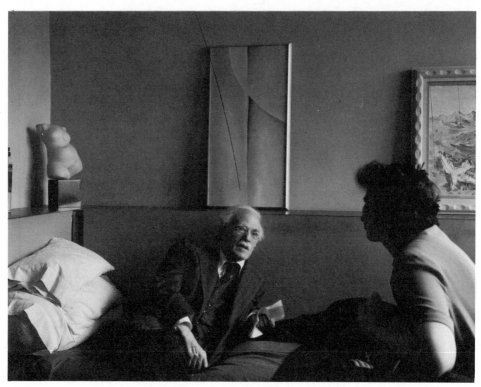

13. Ansel Adams, *Alfred Stieglitz and Nancy Newhall, An American Place*, New York City, 1944

Alfred Stieglitz
NOTES FOR A BIBLIOGRAPHY

INTRODUCTION "NO!" I said. "I don't ever want to meet Alfred Stieglitz! I think he's a sadist, a Svengali, and possibly a charlatan. He has bewitched and tortured you both, and from the few specimens I've seen, I don't think he is the great, *great* , GREAT photographer you two seem to think he is!"

We were discussing my maiden piece of research in photography, "Emerson's Bombshell," and both Ansel and Beau thought highly of it.

"You will have to tackle Stieglitz next," said Beau.

"I know," I said, and sighed.

Ansel, who had been helping Beau with the new little Department of Photography they had founded with the help of David McAlpin at the Museum of Modern Art, was having a farewell drink with us in front of the fire before he took the streamliner back to San Francisco. He looked at me over the top of his drink.

"I'm going to say goodbye to Stieglitz right now, on my way to the train. Why don't you come with me?"

Between them, they marched me, much like a reluctant puppy, down 53rd Street, to Stieglitz.

I had tiptoed in and out of An American Place for years. Where else could a young painter, as then I thought I was, see enough Marins and O'Keeffes? Or Dove's marvelous collages when they were shown? But fellow students back in Art Students' League days had warned me: "Go quiet as a mouse. Look, for as long as you can. But the second the voices in the open office cease, or if you catch sight of a little old man with wild white hair who always wears a black cape, beat it. That's Stieglitz, and if he catches you, you're lost for an hour in his mystique, his stories, and possibly some very searching questions about your personal life." So we sillies never went without company, tried to avoid being seen in the little gallery, which was visible from the office while the main gallery was not, and at first swing of a black cape, fled in infantile terror and pushed the down button for the elevator.

Now here I was, face to face with the ogre. Everything about him was black and white, the white hair and moustache, the immaculate white linen, the deep black eyes, the black clothes and the cape. He was almost dazzling. He was in his late seventies, and frail, and yet you felt within him what Ansel once described as "continuous transformer hum of God knows what voltages." That he was beautiful,

as beautiful as the Place which had emanated from him, should not have surprised me, but that he was really charming, warm, wise, and witty, certainly did. Ansel told him about the Emerson article and that I wished to continue in this theme by working with him. "You're welcome any time," he said. "I'm always here and I'll help all I can."

A day or so later I brought him the Emerson article, which he chuckled over. Yes, he remembered much of the controversy. "Did you ever meet Emerson, Mr. Stieglitz?"—"Not really."—"How was that?"—"Well, as you know, he wanted me to translate his book, *Naturalistic Photography,* into German, and I refused. Partly because I didn't want to take the time from my own work—it was a very exciting period for me—and partly because I didn't like his views on the other arts. And I never went to England in those years. Stayed on the Continent—Berlin, Munich, Vienna, the Tyrol, Venice. I was furious with Emerson when *The Death of Naturalistic Photography* came out. A betrayal, from ignorance, of his pure aesthetic. Then one summer I did get to London; I had written him that I wanted to see him. Not to talk with him but *at* him! But then I fell ill, with a very high fever. I remember dimly that a man came into the room, looked down at me, and went away. They told me later that it was Emerson. So you see how we never really met."

Then we discussed my working with him. He was very gracious. He said he would answer my questions, that I was welcome to everything, that I would be shown all the photographs, the scrapbooks and clippings—everything except the correspondence files, which he had long ago promised to Dorothy Norman when she began planning to do a definitive biography of him. I said I didn't think what I wanted to would in any way conflict with that monumental project, but I would check with her. All I wanted, I said in my incredible naiveté, was to do "a simple, connected story" centering about photography; no one else seemed to have done it, and there was much confusion and misunderstanding about his successive roles in history. And if I could find the materials about Emerson in books, albums, and periodicals—really a fairly meagre amount compressed into less than a decade—how much more I could learn about Stieglitz, the center of controversy for half a century, who had both written and inspired enough to fill a library. He smiled, I thought a little wryly and secretly, but he did not laugh at me.

By the time I found out how difficult it was to write "a simple, connected story" about Stieglitz, one of the most complex geniuses who ever lived and one of the most passionately eloquent of leaders in all the causes he worked for or espoused, it was far too late to back out.

And so I went to Stieglitz, but not with my notebook on my knee. For one thing, I felt that jotting down notes would break that vital circuit necessary for true communication, and also, since everything at the Place was a happening, the intrusive notebook might make others wary and divert or inhibit what might naturally occur. Of course the notebook was always with me, in case of need for an address, a

telephone number, something specific. And Stieglitz had evolved a series of almost imperceptible signals: If something interesting or really wonderful was going on, a smile, a nod, a slight beckon; something boring, which he hoped would be brief, a finger from the black cape pointed to the open storeroom of whose rich contents he had soon given me free rein and of which I was making copious notes. Only twice did he ever make that little shunting turn of the hand which meant, "Come back later."

I had learned from Ansel and others that he disliked telephones, using them only when absolutely necessary (An American Place was not listed in the telephone directory), and that he could conceive a violent dislike of people who just popped in to say hello and then popped out again. Such haste, he felt, was part of the madness that was killing America. "If God were American," he said, "no babies would be born—He couldn't wait nine months." So I never went to Stieglitz unless I had at least an hour to spare, and of course came away if I saw he was beginning to tire. Nor did I come more than two or three times a week. Always I wrote down immediately afterward what had occurred and what, while alone or in congenial company, he had told me. So these notes are filtered through two memories, his and mine. He disliked typewriters clacking as much as he disliked telephones ringing.

I sat through many of Stieglitz's astonishing early gambits with the unbelievers, the unenlightened people who wanted to buy a painting or a photograph. "What are you willing to give the artist?" he would ask those who asked a price. He believed that by the sale of the best of his work an artist should earn at least the wage of a plumber. He also believed that art is not a matter of mediums: why should a sculpture by Lachaise, or an oil by O'Keeffe, or a collage by Dove, bring more than a watercolor by Marin or a photograph by Strand, Adams, Eliot Porter, or himself? For his own work he asked a donation of $1,000 to An American Place. The most puzzling aspect of all this to the would-be buyers was that often Stieglitz refused to sell, no matter how much money they offered. That meant he distrusted the buyer. What, one of these beautiful things to be used merely for decor and prestige? Not to be lived with, day in and day out, a source of solace and meditation, speaking in its many different voices to your own many different moods and needs?

He distrusted museums and galleries, because so very few, especially during traveling shows, knew how to keep the artwork as immaculate as when it left the Place. An O'Keeffe without a frame—she had a period when she believed in no frames, and painted around the edges of the canvas instead—dumped on the floor by ignorant unpackers, would come back chipped or abraded. Photographs would come back looking as if cows had been on them: laid on dirty floors, their mats trampled by dirty shoes, stuck up under uncleaned thumb-printed glass, of the wrong size. And under bad lighting at that.

Stieglitz knew, none better, what went into making a print and insisted there was always only ONE print. Then he would bring out three prints from the same negative—darker, lighter, differently shaded or toned. He learned a lot about people

from the differing reactions, and God knows, anyone sensitive to photography learned from him how differently the same image could speak. As he said, the Place, like the gallery named 291 and the Intimate Gallery, was really a laboratory. Of course I did my "home work"—much of it at the New York Public Library which is one of the greatest in the world, and whose special collections and rare book rooms are superb, where I read the English *Amateur Photographer* and the *American Amateur Photographer,* which Stieglitz edited for a few years, and other publications I could endure. For *291, MSS,* show announcements and the like, I went to the immaculate new Museum of Modern Art, where Beaumont was still librarian as well as curator of photography, and was gathering the incunabula and the ephemera of all the arts of the twentieth century. For the collections of Stieglitz's own and other photographs, I went to the Metropolitan in New York, and the Museum of Fine Arts in Boston. Thanks to Beaumont, I was able to go through the very rare *Camera Notes* and almost all of *Camera* Work at home; that perceptive bibliophile and far-sighted historian had acquired them at prices so low they would make a present-day auctioneer faint.

For several reasons it seemed easier to keep my notes in ink, in a series of narrow loose-leaf little leather books which could be stuffed into purse or pocket. Stieglitz didn't like typewriters and they certainly did resound and echo in the bare, pure space of the Place. Much better to work silently with the lantern slides, the scrapbooks and the huge whole pages of, say, the *New York Times,* which he had dry-mounted on good card, and where, with an uncanny historical perception, he included everything simultaneously appearing with critics' reviews of his galleries, news of other galleries and art forms, right down to the advertisements. These were cumbersome—but what a portrait of the moment! We should do more such recording.

I always intended to type out these notes, and got as far as a fairly integrated chronology up to about 1910—but then events swept me away. They have been seen by Dorothy Norman, Peter Bunnell and others, but every secretary gives up on my handwriting, with an English calligraphic pen too thick for the small pages, and so sometimes have I. "(?)" means I can't read it myself; the delicate associations of three decades ago have vanished from my memory. (?) in an interview means *check later*—a spelling, a date, a source I intended to hunt down before I began to write. Some of these I have left standing, for others to pursue.

Also of course I went to see Dorothy Norman, whom I knew and liked. She welcomed me and my idea with the same warmth and understanding she must have shown to the many brilliant contributors to the book she edited, *America and Alfred Stieglitz.* I did not tell her that my reason for tackling my project was because that magnificent "collective portrait" celebrating Stieglitz's 70th birthday, a Literary Guild Selection in 1934, seemed to me like a hall of mirrors in which writers such as

William Carlos Williams, Lewis Mumford, Sherwood Anderson, John Marin, and even

herself, reflected themselves. Stieglitz passed among these reflections now and then like a gleam of light or a haunting shadow. But you could not look on Stieglitz plain, nor, in spite of articles by Paul Strand, Herbert Seligman, R. Child Bayley, and Paul Rosenfeld, could you really follow his growth as a photographer, or his enormous catalytic influence as it spread, reacted, reformed, died and was reborn. I wanted to make a simple book through which photographers—and also museum people as well as the public could see Stieglitz plain.

I did not realize at the time how difficult it is to keep one's self far in the background when writing about someone with whom one has worked day in and day out, year in and year out. The reader can judge how far I succeeded with that problem! As cool, impartial observer, I lasted possibly a visit and a half; after that I was involved. I remained the observer, of course, and any value these notes may have is probably due to their immediacy.

I find it hard to define my personal relation to Stieglitz; it falls into no category I know of. It was more than friendship, especially when he and I became fighters in the same cause. But it was never master and disciple, though he taught me more than Smith College, the Art Students' League, the Museum of Modern Art, and various artists in various media all combined. Nor was it sexual, though I am sure he welcomed me to the Place partly because I was a woman. He was moved and touched when I became pregnant in 1941—"You with the child in you"—and then distressed when late in the eighth month a severe hemorrhage drowned the baby and my life was saved only by an emergency cesarean.

Stieglitz was never cruel to me, as he had been to Beaumont in the early years when he treated "that young man from the Museum of Modern Art" as a whipping boy for all he disliked and distrusted about that institution. Nor, so far as I know, was he ambivalent, as he was about Edward Steichen and Adams. He did once remark to Beau that I had "some curious blindspots," but it appears he spoke with affection and amusement. If the blindspots have now disappeared, which I hope they have, his was definitely the crucial initial therapy. Nor did he ever get furious with me, as he did with Georgia O'Keeffe and Dorothy Norman. I was very careful to keep out of that triangle, not that I could ever rank with them in beauty or power, nor desired to, I just sought to be merely an intimate of the Place. I saw him in all kinds of moods and reactions. Sarcastic, as he often was about Strand and Hartley; bored, as he often was, with the writers and critics who could not keep away from him; annoyed by museum people and their lack of care and their perennial complaint, "The museum has no money." He, who gave penniless youngsters a work of art they loved in exchange for some small repayment in installments.

I think his happiest relation was probably with John Marin. Marin did not often come to the Place—or at least seldom when I happened to be there. But when he stuck that puckered, puckish countenance and, for the time, absurd hairdo through the doorway of the open office, Stieglitz began to smile. A curious, joyous radiance came with Marin. And, even in shabby clothes, Marin had a thin elegance, a style of his own. He and Stieglitz could communicate in a few, to the rest of us almost cryptic, words. Yet

somehow the fun got through to us listeners. Everyone, I think, loved Marin. Stieglitz could certainly get mad with him when he did something Stieglitz considered foolish, such as buying a Maine island where there was no potable water. Yet Stieglitz later acknowledged that the island paid for itself many times over in the paintings Marin made there.

As for my conversations with Stieglitz and many other people, here they come at you just as they came at me.

ANSEL ADAMS On a very rainy morning in March 1933, Adams, with his portfolio under his arm, came to An American Place, past the breadlines, where the men, many thin and with only newspapers for shoes, shivered and huddled in doorways or any other shelter. He brought an introductory letter from Mrs. Sigmund Stern, a sister of Agnes Ernst Meyer. Stieglitz looked at it. "Oh, yes, I know her, that woman. She has nothing but money, that woman, and if this Depression keeps on she won't even have that." What an insult to the kind and generous Rosalie! Adams could have knocked him down, but he was so frail, so old, and then there were those steel-rimmed glasses. "Come back at 2:30, I'm busy now," said Stieglitz, and turned on his heel.

Adams pounded the wet streets in a fury. Damned if he'd go back! But he did. Stieglitz, who associated him with the West Coast Purists, with Group f/64, and with Edward Weston, whose work he had never been able to accept, took his portfolio in silence, opened it and spent quite a time absorbing the depth and meaning of each photograph. He replaced each tissue exactly, came to the end, and tied the bows neatly. Adams, who was now well waffled by the radiator, on which he sat, the only other chair in the room being the camp chair occupied by Stieglitz, started to descend from his grill. But Stieglitz untied the bows again, went back over every photograph, replaced the tissues, tied the bows, and, looking up with those deep black eyes said, "Some of the most beautiful photographs I've ever seen."

So Adams became the first photographer since Paul Strand to whom Stieglitz gave his supreme accolade, a show. A number of prints were sold, at prices higher than Adams had ever dreamed of, and the presentation, precise installation in that beautiful light, against that marvellous, mysterious pale gray—O'Keeffe's mixture of doubtless many colors—made other shows, as Adams said later, seem poor and tacky.

Stieglitz began to think, as he had about Steichen so many years ago, that perhaps he had found his man, the man who could carry on for him. O'Keeffe, Marin, and Strand, who had all met Adams in Taos, testified to what Stieglitz could clearly perceive for himself: here was a fighter who would never be conquered, indomitable, yet who always fought with wit and grace, without animosity. Here too was a poet, a musician, a lover of beauty, of laughter, and of his fellow man. Adams the musician he never heard; it is one of Ansel's deepest regrets that he was never able to get Stieglitz and a piano together. "Then I could really have said things to him."

Then Adams wrote the finest short manual of straight photography ever produced up to that time, *Making a Photograph,* published in 1935, by *The Studio* in London and

New York simultaneously. The halftone illustrations looked like actual, tipped-in photographs. And his "big white book," *Sierra-Nevada: The John Muir Trail,* 1938, seemed to Stieglitz one of the most beautiful and poetic things ever produced in America —in the scorned, depressed America of the late 1930s, when skilled printers and engravers were scarce, good paper almost unobtainable, and standards much debased. So even in publications and the art of making engravers produce finer reproductions than they ever dreamed they could, Adams was carrying on in Stieglitz's own tradition. Inspired by his first encounter with Stieglitz and the Place, Adams went back to San Francisco and started a gallery himself, humbly, in the same spirit, where he too showed paintings, sculpture, prints and photographs. Stieglitz was moved, and bestowed his blessing, but fell short of sending his own photographs in their fragile white metal frames, and O'Keeffe's paintings—was that the no-frame period?—all the way to San Francisco. To this request he said no, though he knew Adams would handle them with reverence once they arrived. But 1933 was no year for starting galleries; anybody in San Francisco who still had money was desperately hanging on to it. Adams gave courses, lectured, wrote, but essentially it was no go. The inactivity for him was worse than the finances. He was temperamentally incapable of Stieglitz's heroic sacrifices of time, energy, and his own photography. Also he did not have even a tiny income; he had to earn a living for three old people, a wife and, soon, two children. To get something moderately resembling a living took a lot of scrambling in 1933. Virginia Best, his wife, inherited her father's studio concession in Yosemite Valley, but the Depression wasn't helping there either.

Yet Adams refused to leave the West. He would not leave his native San Francisco, then still one of the most beautiful and beloved cities in the world, where his studio overlooked the Golden Gate; nor his adored Yosemite valley, even more beautiful; nor the Sierra Nevada, John Muir's "Range of Light"; nor the Pacific; nor the Sierra Club, of which he was a director, and which was already a potent force in the battle for conservation. All Adams liked about New York City apart from Stieglitz and The Place were quite a lot of the people he knew, the jobs he was able to get, and the explosive Museum of Modern Art. No. He wouldn't and couldn't come take up Stieglitz's cross and follow him.

Stieglitz was profoundly disappointed. Here really was the Man who could have helped. The Man, an even more superb technician than he himself had been, who could have carried on his explorations into the human condition and its Equivalents. So there were days, weeks, months when, if David McAlpin or I were around, he growled about Adams. All those commercial jobs! All this about rocks and peaks and flowers and trees, while the cities were dying! Stieglitz never saw the interrelation. And Adams didn't photograph Woman, at least not in his own spirit of a passionate love. (The only near nude Adams made, that I have seen, was a beautiful girl sunbathing, with a towel over her breasts. Her fiancé was distressed, and that distressed Adams.) Stieglitz often said, "What Adams needs is a real relation with a woman." Hearing of this Adams wanted to know just what Stieglitz could know of his own sex life?

ADAMS AND THE NEWHALLS One noon in the spring of 1939, Beaumont came charging up the three flights to our apartment. "Come—we're having lunch with Ansel Adams!" So I brushed up and we rushed down Fifty-third Street to where, under the aluminum cove of the new Museum of Modern Art entrance, a tall, very thin man, with a few wisps of baby-fine black hair blowing over his dome, was flashing a new tripod through its paces. Even Ansel Adams had a new gadget! He saw our grins, put on a real display of antic pyrotechnics, and, then with Adams clunking the tripod along the sidewalk like a walking cane, we crossed Fifth Avenue and had a delightful lunch, of which I remember nothing except that he was charming and we laughed a lot. Then he and Beau went back to the Museum and I went back to my never-to-be published book on the American sources of modern architecture.

Around four o'clock, the phone rang. "Mrs. Newhall?—This is Georgia O'Keeffe." O'Keeffe, whose painting meant more to me than any one else's, even Marin's! My heart skipped a beat or two, and I must have sounded out of breath, which indeed I was. "Yes, Miss O'Keeffe?"—"Can you get hold of your husband and Ansel Adams and tell them to be at the penthouse at five o'clock?"—"I think I can find them. I will certainly try."—"David McAlpin too, if he's with them. I'm not inviting you, you understand. I think wives are irrelevant, don't you?" Since she had never met me, this seemed a hasty judgment. It hurt, but I dutifully called around and collected Ansel, Beau, and Dave, and then went back to the balloon frame and its relation to skyscrapers.

Beau called me later to say he would not be home for dinner, and possibly not before midnight. He did not tell me for twenty years what really went on: Dave had proposed that everybody—Ansel, Dave, Stieglitz, and O'Keeffe—grab a bite to eat at River House, where, since his estrangement from his wife, he had been living, and hire from its dock a motorboat to take them all up the East River to the newly opened World's Fair. Beau leaped up and said, "I'll call Nancy. She'll love it." He was laughed at. O'Keeffe: "Are you tied to your wife's apron strings?" Dave had met me a few times and Ansel just that day at lunch. They joined Stieglitz—all three having wife trouble at the time—and Stieglitz joined in ridiculing Beaumont for loving his wife and wanting her to share all wonderful experiences. Beau gave in, under the attack of such powerful voices (I don't blame him—there was much more at stake than me, as he knew I would understand), but he had a bad conscience about it. As I had not yet demonstrated that I was "relevant," as all of them later acknowledged, he could not yet defend me.

When he did come back, around midnight, he told me of the thrilling ride up the dark East river, under the bridges, past the lighted towers, past the tugs and tankers, and then of the still more exciting discovery that Ansel was even more of a clown than himself. They both had looked so solemn to each other—Beau the scholar, Ansel the great photographer—but that evening dissolved any such illusions. At first they walked sedately beside the rolling chair Dave had hired for Georgia and himself—Stieglitz had refused, in favor of bed—and then something set them off. It could have been one of the absurd collosal statues or an unfinished pavilion, of which there were many. Whatever it was, they capered and clowned and made noises and chased each other around the

illuminated fountains and through the pavilions, with Dave and Georgia laughing in their wake. It was the beginning of a very important relationship. Adams keeps saying "What would life be without the Newhalls?" And we can say the same of him.
May 1939

ALBRIGHT SHOW—1910 Started by Dr. Kurtz asking for a show. He thought it an easy matter. Stieglitz said he didn't know what he was asking; would decide, and let him know. Kurtz died before Stieglitz wrote. Cornelia Sage wrote asking about the show as if it were already decided. A long correspondence ensued. Eventually all was settled. A week before the opening, Stieglitz, Haviland, Weber and White arrived to find the galleries unusable. However, they had complete charge. They hung blue cloth as a frieze at the top to bring the eyelevel down, and hung the rest of the dusty burlap with cheese-cloth, which gave a pleasant gayish tone.

Weber's installation marvellous—spent two days hanging the David Octavius Hills alone. He had however completely dominated White into sharing his hate for Steichen and others. Haviland and Stieglitz hung Steichen. Stieglitz hung his own—not a very good job he says. He learned a lot about installation from watching Weber.

Stieglitz once said to Weber why is it both your heroes—Rousseau and Cézanne—are dead? Weber was a violent partisan; he wished to exclude—anti-291.
Undated

AMERICAN AMATEUR PHOTOGRAPHERS Stieglitz insisted both on absolute control of the magazine and on the appearance of other editors on the masthead: F. C. Beach and Catharine Barnes Ward, English correspondent. Announced as editor in chief July 1893; resignation announced February 1896.

Reason for resignation: Beach (?) made a vignette from a copyrighted yacht picture by a man named Bowles. This picture had already appeared in their pages, duly paid for and credited "copyright Bowles" by Stieglitz. Bowles sued under the existing copyright law: $1.00 per subscription. Beach solicited advertising on a basis of 50,000 subscriptions, hence $50,000 would be due to Bowles. Beach proved his own claim false; there were actually only some 19,000 subscriptions. Still, that was quite a lot of money in those days. Stieglitz, disgusted with the whole mess, nevertheless pointed out that Bowles' copyright was incorrect and inadequate, bearing neither his full name nor the date. The suit therefore failed, but Stieglitz resigned anyway. He was already uniting the Camera Club with the Society of Amateur Photographers and planning the periodical *Camera Notes*. As a result of this suit, the copyright law was changed.
Undated

AN AMERICAN PLACE In 1928 or 1929 the owner of the Anderson galleries sold the building and went to Paris. Stieglitz felt that at his age and since O'Keeffe and Marin both had something to go on, they could find another outlet perhaps and let him go back to photography. Then he heard that Lillie P. Bliss and the Rockefellers were starting a

Museum of Modern Art. The crash came. Stieglitz said to himself that the Rockefellers —their fortunes unshakable—would get the same stranglehold on art that they had gotten on finance, the church, and to some extent, education. He felt also that they would center their interest on the older and more famous European names: Cézanne, Van Gogh, Seurat, and so on, and that whatever they did in American art would be half-hearted.

O'Keeffe felt that in that case she would back a new gallery for herself, and they found a place—no walls, just space. Stieglitz would have no carpets, not even linoleum, nor covers for the radiators, nor anything that smacked of mechanization or functionalism. Nor would he have any doors, or so much as a curtain to his "private" office. He wanted everyone who came in to see all there was to see, although O'Keeffe and others felt it was too great a strain on him. He said there were to be no chairs in the galleries because his friends, the painters, would sit in them all day long to the exclusion of everyone else. He called it simply *an* American Place. The first year Marin made $22,000 and gave $3,000 to cover the rent of the Place. O'Keeffe one year made $35,000 and gave $1300 ($13,000?) to artists—Marin, Strand, Enters, and others. Stieglitz's idea was that artists should help each other. He keeps no accounts. Later, there grew a stabilizing group for the Place.

March 1941

CHARLES H. CAFFIN, critic for the New York Times, wrote in 1898 a scathing criticism of Stieglitz, who was then approached by the editor of *Everybody's,* the house organ of Wanamaker's department store, for a series of articles on photography. Stieglitz said he was no writer and recommended Caffin. Having written the criticism of Stieglitz, Caffin came to him, bewildered. Stieglitz said he himself would give him any information except about the photographs themselves. Caffin then really looked at them, and the articles he wrote began to show it. Caffin became one of Stieglitz's closest friends. Seven years later he praised some of Stieglitz's photographs highly. Stieglitz pointed out that these same wonderful photographs were the ones Caffin had once condemned as old hat. The artists and photographers both objected to Caffin and demanded why Stieglitz tolerated such an old fogy. Stieglitz replied that he was the only art critic who was utterly honest, who took the trouble to sit down and look at every picture before making up his mind. Stieglitz adds that he never influenced any critic, never explained or complained.

16 May 1941

THE EQUIVALENTS I had heard Stieglitz tell of reactions to the photographs he called "Equivalents": how, for example Madame Lachaise, looking at one of the series of dying poplars—the one that rises intricate as the human nerve system and is silver in its contorted death—cried out, "That is the Blood of Christ," and fainted. It seemed to me quite unlikely, Madame Lachaise being actually a good solid New Englander and the inspiration for many of her husband's most massive and delicately balance sculptures.

I could understand why Stieglitz called the first series of Equivalents "Songs of the Sky" and why in looking at it the composer Ernest Bloch, as Stieglitz had expected, pointed to violins, horns, and other instruments. But I still took most of the reactions with more than one grain of salt; frankly, I thought they were mostly humbug, and Stieglitz at his romantic worst.

Then, one afternoon he turned me loose, alone, among the several boxes of Equivalents. He had learned to trust me with that most fragile and delicate of all forms of art, the photograph: never touch them without freshly washed hands, and wash again if you feel faintly hot or grimy. Always replace the tissues; never slide another mat across the easily abraded surface, nor ever pick up a mat or print by one corner. You can handle work prints without such meticulous care, but never a fine print.

A couple of hours later I came out in tears. I had been through a tremendous experience. It was like the thunderstorm I felt in my head once in Paris when I groped my way out of the Louvre and sat on a bench in the Tuileries; the sun itself could not compare to this blinding brilliance within. Music has done this to me many times, but though I already deeply loved photographs, nothing like this had happened to me before, not even with Strand, Weston and Adams.

Stieglitz, amused and compassionate, waited until I could speak. "Oh Stieglitz," I said. "There must be a way to lead those who don't yet understand into those things. The dramatic anecdotes don't do it—at least not for me." He said, "You will have to make your own Equivalents." This must be seen against Stieglitz's dislike even of titles, and his fifty years of reprinting all criticism, much of which he considered either inordinate praise or equally stupid blame. In the Place, there were no titles on the walls, just numbers on the sides of frames. Sometimes there was some publication, resting on the radiator, say, a book of Marin's remarkable poem-letters, or some announcement like the famous:

AN AMERICAN PLACE
No formal press views
No cocktail parties
No special invitations
No advertising
No institution
No isms
No theories
No game being played
Nothing asked of anyone who comes
No anything on the walls except what *you see there*
The doors of An American Place are ever open to all

Make your own Equivalent. That still rings in me. It has been the guiding principle of almost all of the books and shows I have done

Never to be literal or descriptive. Sometimes, as in *Time in New England,* the photographs do not need even a title. In that book Paul Strand and I worked out something like a chorale: the voices expand and elaborate the themes suggested by the great chords

of the photographs. Either medium can carry the melody alone; they are both independent and interdependent. Ansel Adams and I took this even further in some of our exhibitions and books, especially in *This Is the American Earth,* where the photographs are the eloquent core symbols of the text. I have done it also, more literally, with Edward Weston's photographs and daybooks, where his writing describes his feeling and experience with the actual image he has made.

It is an extraordinary experience to observe how a different text or sequence of general context can change what people see and feel in the same photograph. And how a poor reproduction can block response from the viewer. The shapes and the subject usually come through, but the intimate loveliness, the evocative poetry, do not. Many others have worked in this dual medium, notably Minor White.

Behind all of us stands Stieglitz: without the Equivalents and the sequence concept, both of which are beyond journalism, we might never have done what we have—perhaps we would have had to invent it ourselves. Whether he, who didn't like words and photographs together and always kept them in separate sections, would approve, I don't know. But I think I see him smiling.

Equivalents for the Museum of Modern Art Collection Nine, thanks to McAlpin's gift of $1,000 and Stieglitz's generosity. Stieglitz showed them to me in a special sequence, propped up against Marin's.

1. *Apples and Gable of the Farm, in Rain*
 "My mother was dying. She was sitting on the porch that day. O'Keeffe was around. I'd been watching this thing for years, wondering, 'Could I do it?' I did, and it said something I was feeling."
2. "This, as you know, is the Immaculate Conception. I can tell you that because you understand—you don't misinterpret me."
3. "And Dorothy's hands—what is it that they are? It's related to the other two. She didn't have any idea what I saw, just sitting there. That's the one Charlie Chaplin sat half an hour in front of, and said, 'Stieglitz, what you've gotten in that!' I didn't ask him what he saw."
 Later: "That—that's a prayer."
4. "And that—that's death riding high in the sky. All these things have death in them." "Ever since the middle Twenties," I said. "Exactly," he said, "ever since I realized O'Keeffe couldn't stay with me."
5. "And that's reaching up beyond the sun, the living point, into darkness, which is also light."
6. "And that's related to the other—see the same forms."
7. *Rainbow* "And that's something I never thought I'd get. Never been done before. Oh, they've made pictures of rainbows, yes—but not that."
8. "And that's when Georgia's sister was nursing me. A very powerful woman."
 5 May 1943

FILM In the 1890s a fat man named Simpson who possessed a fireman's badge and tried to persuade Stieglitz to rush off to fires with him, came to Stieglitz with a small movie camera, saying that Stieglitz's street-scenes, etc., really needed this medium. Stieglitz replied, "I know it! But I should make a series of stills now." Regrets deeply his not having tried, but feels that the urge was never deep enough or he would have. Feels that his cherished, never-undertaken projects—women, children, horses—might have been best in movies.

 7 July 1941

DALETT FUGETT Introduced by Joseph Turner Keiley during *Camera Notes,* Fugett was an editor and anxious to help. Stieglitz gave him mss to read. Sadakichi Hartmann was his bane. Crazy style, no spelling, no punctuation—he could not read such stuff. Stieglitz said he was not publishing literature but ideas and kept the poor man on a diet of Hartmann—or worse. No use, so Stieglitz gave him the galleys and all that end of the job, where he was not only happy but indispensable. Stieglitz said the magazine would have been impossible without him. A tall man with a beard, a poet, of French extraction, who wrote English well.

 16 May 1941

MARSDEN HARTLEY Came in bearing a small Indian sculptured head, c.200 A.D., which he could not wait to show Stieglitz, who looked at it intensely, said it was beautiful, and glanced away. I took it and fondled it. Hartley tickled; felt he was given this because he had been kind to someone. Stieglitz told him to be careful not to drop it on his big toe.

 Then Hartley told about how he visited Steichen at Voulangis—the flowers blooming, the children, the clematis outside his window, the nightingales that sang all night and the larks that sang all day—and remarked how right Stieglitz was when he said Steichen was a peasant and a farmer at heart.

 Told too how unkind Carles, Katharine Rhoades, and Marion Beckett (both six feet, beautiful and always together) were to him. How they would talk against him in the backroom and then come out front and be very nice, and how they left him out of a party they were arranging to see Havemeyer's (?) Cézannes until the last minute, when he refused to go, saying he was nobody's bather. Arthur Bowen Davies took him later.

 2 July 1942

THE INTIMATE GALLERY With the passing of 291, Stieglitz felt that part of his life—the public one—was over, and he could now go back to photography. The wonderful life with O'Keeffe and the greatest photographs of his life—the Equivalents, the crown of his career, were sufficient. Later, O'Keeffe left him to go Southwest and he let her go because he felt their lives were basically different—she from Wisconsin and he from Hoboken, Europe and New York—and should remain so. But still his friends came, for encouragement and help, and dumped their stuff with him. The accumulation

was pushing him out of house and home; the spiritual accumulation forced him to see that they still needed him and the outlet he gave them, the focal point in the world. So there had to be another gallery.

16 May 1941

LAKE GEORGE HOUSE "Oaklawn" newly built, offered for rent or sale because of private scandal. Stieglitz père rented it one season with option; liked it, bought it. Meadow for cow across the road. Stieglitz père very sensitive to smells; couldn't bear odor of farmer's pigsty at top of hill. Bought house, sixty-three acres of land, barn, dancehall, and house where farmer's daughter lived. Allowed her to live there all her life. At first he used farmhouse as studio and hermitage. O'Keeffe and Stieglitz lived by the lake at first; spent part of one winter there, at the farm. O'Keeffe, when very sick, once spent all year at farm. Then Stieglitz gave his opinion that the Lake should be sold, and sold it was, under protest by the rest of the family. Had ideas for making a community of artists; it didn't work. Farmhouse still used by all the family—sons, ex-wives, etc. Is going to pieces. Only O'Keeffe knew what should be done in way of repairs. Nobody else cares—or else there's a feeling that Alfred should do it all. Section of porch roof removed by O'Keeffe to let light into room where she painted.

MUSEUM OF MODERN ART When Adams came on in the spring of 1944, he brought with him the eloquent appeal, in words and photographs, he had made at his own expense for the loyal Japanese-Americans interned at Manzanar, who were trying to relocate and desperately needed a better understanding by the American public. So Adams brought his cameras repeatedly down from Yosemite, whenever the Tioga Pass was reasonably open. He photographed the charming children in their pigtails, the delightful mothers, the tailors, chemists, X-ray technicians, agricultural workers, secretaries, nurses, the hospital, the chapel, the newspaper office, the pleasure garden, the baseball games, the interiors of the shacks, with portraits of sons in the U.S. Armed Services—everything. Tom Maloney, of *U.S.Camera,* would bring out a book as cheaply as possible, so that it would easily be available to all. It would be called *Born Free and Equal,* for nearly all at Manzanar were American born, Nesei, and longed to get back to being Americans. Their wholesale incarceration, in the hysteria after Pearl Harbor, was one of the most tragic wrongs ever committed by the U.S. government.

Adams, of course, had words and images so well organized that he and I put the show in sequence in two hours. The Museum Exhibition Committee were much moved and wished that such shows could be made for all racial minorities in America. So the dates were set. Then, ten days or so before the opening, the wartime hatred and hysteria blew up in our faces. The Museum considered canceling the show. I pleaded that it was a great show, by a great artist, and very much needed. Jim Soby gave his opinion that the Museum should not be used for propaganda. I retorted that what else could Steichen's "Road to Victory" and "Power in the Pacific" be called—to say nothing of several inferior shows the Trustees had thrust upon the Photography Department? We argued all

through lunchtime, our secretaries canceling our engagements — often important ones, since lunch was when you really did business. Two men from Washington had come to help me. But what could they do in such an intramural fight? Finally, I broke up the meeting, thanked the government men, and fled for the Place. Where else?

But Stieglitz was involved in some transaction with the Whitney Museum, and well I knew what that might mean to Marin, or O'Keeffe, or Dove. He met me in the entry, saw I was in great trouble, heard me try to summarize it, realized he couldn't help me through such a crisis without dismissing the Whitney Museum. We both knew that was impossible. I had probably bent down to lay my head on his shoulder for otherwise he couldn't have given me the hug and the kiss which made me cry.

I could not go back to the Museum with tears running uncontrollably down my face, so I went home. After several agonizing hours full of phone calls, ending with one to Ansel at midnight, a compromise was achieved. And what was cut out from the show, so it shouldn't be "propaganda"? A quotation from Lincoln, another from Whitman, and the title itself, adapted from the U. S. Constitution.

Had Stieglitz been able to help me stiffen my spine, I might have been able to find a better way out. As it was, we had a bitter laugh together over it; it was no surprise to him.

Autumn 1944

Two Thunderstorms I had just come back from California, where Ansel had insisted on taking me for more reasons than I had not had a vacation for years. There was a lot I wanted to tell Stieglitz: the wonderful experience at Manzanar in the magnificent Owens Valley. Many of the loyal Japanese-Americans did not want to leave what had been a concentration camp, but to stay, sharing their music, their garden, and the community center they had built with the other inhabitants of the Valley. The old wanted to stay until they died, the young to come back to be married. It had become a sacred place to them. And with what cries of joy Adams had been greeted by the old gatekeeper, the office staff, and how, when he knocked on the door of a tar paper shack and scowled horribly when it opened, he had been nearly knocked down by some fifteen cheering people, all ages and stages, down to a baby, the children jumping for joy. There were lots of other things I thought Stieglitz would be interested to hear.

I love thunderstorms, and there was a magnificent one going on when I set out for the Place. When I got there, I found there was a worse thunderstorm going on inside. Stieglitz was on the phone, talking to Dorothy Norman in Woods Hole, and from the tone of his voice, it was a furious, tragic conversation. He motioned me out of earshot. So I went into the little gallery, let down the shade — rollers at the Place were at the bottom, so that light always came from the top and was reflected by the pure white ceiling — opened the window, not enough to let the rain in, and stuck my head out into the storm.

There is probably no safer place in a thunderstorm than New York City. Lightning was striking the skyscrapers, and thunder boomed and echoed through the canyons.

Then I looked down, me with my fear of heights and urge to throw myself out and down into the dizzying perspectives.

In California, Ansel, only he and God know how, had been persuading me to try a little rock climbing. He would go first, showing me how to use the rope, how to find handholds and footholds in the prismatic fissures of the granite on what, he wrote Beaumont, were "safe, practice climbs," only six hundred feet or so. All the way up I would curse myself for a fool. Then the ledge at the top was always a little Paradise and the view therefrom almost beyond belief. Rapture! But if Ansel had explained to me about rapelling down—winding a rope over and under you and then, belayed to a man or rock or a tree, walking out *backwards,* at right angles to the cliff, down into the abyss —he would never have coaxed me up. Safe on the valley floor again, among the grinning mountaineers, exhilaration and euphoria again!

Now I looked down the seventeen stories of 509 Madison below and thought, How much simpler than the Sierra Nevada. Look at all those handholds and footholds! What fun, if only I had a rope and a belay!

Finally Stieglitz put down the phone, and after a few moments, said, "Nancy." He was huddled in his cape in the corner of the cot, looking as if he wished death would take him. I hastily combed my hair, repaired my rain-washed makeup, but forgot to blot my lipstick. So when I kissed him, I left what looked like a wound on that white forehead. "Oh, Stieglitz," I said, horrified, advancing with a handkerchief, "I've left lipstick on you!" "My dear," he said, "it is an honor." Of course I scrubbed him up, and my mouth too, and then kissed him again, very delicately, above the white hairs that sprouted from his ears. He began to look better.

So I told him of my fantasy about climbing down 509 Madison, which amused him. I doubt if he had done rope work in the Alps back in the 1880s, but his niece, Georgia Engelhart, already a famous climber, must have told him about it. Then I told him about Ansel and the Japanese, then about Edward Weston, Imogen Cunningham, Dorothea Lange, and others on the West Coast, with some stories which made him chuckle. And then of the demise of the Photography Center. The giant Willard Morgan, editor and publisher, had been appointed director of the Center, but his attempts to raise money from Eastman Kodak and the Pictorialists, the two wealthiest sources, by insipid shows had sickened the Museum to the point where Willard had left and the Museum decided to close the Center. I told of the Museum's refusal to send me the usual painters and installers, and how the photographers themselves, plus such unexpected hands as the publisher Albert Boni, were helping me paint the walls and install the last show. It was a new version of an old story to him. Nor was he surprised when I said I thought it a good thing that the Collection, the Library and me were being folded back into the Museum. Photographers might be crying, but nothing had been lost but space. Things seemed to me clearer and cleaner, and great retrospectives, with publications, were being planned.

One of the reasons I always came back to Stieglitz was that, once he knew me and had come to trust me, I never had to explain. Not anything.

Summer 1944

World War II was catching up with Beaumont; he was to be drafted soon if he didn't enlist immediately. He decided, rightly, that he would be more useful in some specialized service, possibly having something to do with photography, than in the infantry. So he applied to the Marines and the Navy, was finally accepted by the Army Air Force, commissioned a first lieutenant, and slated for photo-interpretation.

And then there was the problem about me—and the Department of Photography at the Museum of Modern Art. One thing I was not going to do was to go back to live with my family in Massachusetts. A stately uncle came down to see Beaumont off in a uniform for which we had popped some family diamonds and which he, had he known, could have bought at the PX for half the price, better cut of better materials. Uncle then escorted me back to family for two or three weeks.

Finally word came from the Museum of Modern Art that I was to be appointed "assistant in charge" of the Department of Photography, salary $50 a week, with a part-time secretary and an office, soon half filled by the cabinet I had built to house the collection, whether framed or in solander cases.

So when Stieglitz came back from Lake George in the fall, "the simple, connected story" could not continue. We became old fighter and young fighter, a relation most precious to me. Of course I went to the Place often out of sheer affection and delight, but I also came now with questions such as: "How do you manage a committee?" Stieglitz said, "Think it all through yourself, in all its possible permutations. Esthetic, financial, and so on. At that point, you propose your solution, which is often accepted out of pure relief."

I couldn't always achieve such a goal, but neither had Stieglitz himself. He was *there,* thank God, and sometimes he could laugh me out of my problems, and send me, with courage and sense of humor restored, back to the battle. Without him around the corner, without Paul Strand, who came almost daily, without Ansel Adams, constant correspondent, and when he came to New York, the most eloquent and energetic colleague of all, I don't think I could have done what I actually did achieve at the Museum—making it the liveliest center since 291 for photographers of all different persuasions and collaborating with Paul Strand and Edward Weston to create the first major retrospectives given by a museum to photographers.

 Undated

DOROTHY NORMAN Conscious always of two urges—art and action. A rebel against the wealthy Philadelphia society in which she grew up. After graduating from Smith, took a course in art appreciation at the Barnes Foundation. Found the paintings part of her life; the instruction in line, mass, color, absurd. On arriving students were supposed to stand before the picture of the day and look. So people scampered in as early as possible and pretended not to know what they were intended to admire.

Dorothy met Ed Norman at parties, and each found the other the kind of rebel necessary. So they married, using their money for worthwhile purposes and devoting their energies to civil liberties. In the winter of 1927 (?) Dorothy became pregnant and was forbidden to work, so she spent her time absorbing art, which up till then she had

more or less shelved, except for looking of the most innocent sort and for conversations with Bertram Hartman, whose painting did not ring true for her.

She came to the Intimate Gallery (called by intimates simply "the Room") and discovered Marin, later O'Keeffe, to whose work, with exceptions, she has never really been devoted. These discoveries reassured her that art was not entirely dead or French, and she kept returning. Stieglitz, whose name she had never heard, forbade her to touch or ramble through the stacks; she found him a nuisance and abominable.

After Nancy was born, in November, Dorothy begged to be allowed out to see a Marin show. While there she heard Stieglitz tell an ignorant and opinionated female art student that everyone must experience art for himself; in talking about art one learns only about the other person. Light seemed to break for Dorothy.

At an O'Keeffe show, she fell in love with a waterlily and asked Stieglitz the price. He said she probably couldn't afford it, but began asking her about herself. Dorothy felt that for the first time she was really saying what she felt.

Dorothy began spending her time learning about Stieglitz and his ideals, with the purpose of writing a real interpretation. She felt, like all the others, that nobody had grasped or told the whole truth She spent a year in the files and letters and old clippings, reading the publications and so on.

Then the Intimate Gallery closed and she and Strand went about collecting subscriptions to support An American Place. The general idea was that subscribers might receive a Stieglitz photograph. Dorothy, being used to collecting subscriptions, got hers without any strings. Strand sold Stieglitz photographs. He also made the deal for a three year lease with the manager of 509 Madison, a "friend" of his, at an extraordinarily high rate. Later, when the time came for renewal, Dorothy got the rent much reduced, from the same man, and still later got it for even less from new management who were complete strangers.

She also took over the financial and business end of the Place (exclusive of sales, which only Stieglitz could conduct) such as water, lights, paint, repairs, etc. Stieglitz never asked her about them, so she never had to bother him with the details. Proceeds of sales, of course, went directly and entirely to the artist, except for costs of framing and Andrew Droth, the assistant. If the artist had a remarkably good year, he made a contribution toward the rent of the Place.

Dorothy felt that Strand's great weakness lay in his being by nature a follower rather than a leader. He was, both Stieglitz and she agree, the first to pursue the technically perfect — as distinct from Stieglitz's search for the most expressive — print. Many of Strand's more ridiculous performances were due to his following the letter, not the spirit, of Stieglitz's fight for workmanship and the respect of photography. His print shows negated natural and healthy criticism, so that people would ask Stieglitz to tell Strand not to make such absurd and theatrical pictures of Becky, his wife, and Stieglitz would beg them to say it themselves, since Strand kept feeling increasingly that only Stieglitz was adversely critical and therefore captious and difficult. Becky, brought up in

vaudeville, coarse, vigorous, ambitious, did not help matters by imitating O'Keeffe in dress and mannerisms, and setting up herself and Strand as the logical reincarnations of O'Keeffe and Stieglitz. Dorothy said that the Strands were her best teachers and therefore her best friends: they showed her exactly what *not* to do. Dorothy also felt that Stieglitz was diabolical in presenting the show of both Strand's photographs and Becky's paintings on glass in 1932. Apparently, however, the Strands were unaware of any irony or of how clearly their weaknesses were exhibited.

Stieglitz's attempt to show Strand new fields to conquer—instead of reworking what Stieglitz had already done—by photographing Becky underwater (nude in Lake George) takes on more meaning in such a setting. It becomes understandable why Strand, in the early 1930s, found the Party Line easier to accept than the kind of thinking and living demanded by Stieglitz, and found the uncritical Communists, who accepted him with joy as a great tool, more satisfying company than Stieglitz and his former friends. The journeys to the Southwest and Mexico widened the separation.

Meanwhile Dorothy herself became more and more in touch with the writers, poets and others who found inspiration in Stieglitz's way of thought—Waldo Frank, Harold Clurman, and so on. The Group Theater was being born. Dorothy's poems, *Dualities,* were published by An American Place. Stieglitz's seventieth birthday was approaching; some sort of testimonial was in the air. In a meeting at Dorothy's house, the general shape of the book *America and Alfred Stieglitz* was decided on—a group or collective portrait being felt the most appropriate. Dorothy naturally became the mainspring, both because of her love for Stieglitz and her research into the past. Stieglitz fought the whole idea because, he said, it would absorb so much of his time. He also forbade any portrait of himself to appear in the book. People were already throwing mud at Dorothy for climbing through Stieglitz's influence, and her portraits of him would merely cause more mud. Also he felt that publishing or exhibiting the many other portraits of him would make his friends ridiculous.

Soon after his death, Norman hired a battery of secretaries, and began asking people for their letters from him, had them copied, and of course returned. And thus she founded the great archive now at Yale. Her original idea of devoting an issue of *Twice a Year* to whatever people felt about Stieglitz, as an outlet for all our emotions, finally turned into a portfolio, with fine reproductions, and a long introduction in which she printed our letters, articles, and statements.

Then she started on her enormous task of a definitive biography. Her interest centering on Stieglitz as philosopher and fighter, she tended, in all this multiplicity, to underplay the great photographer. Stieglitz was right about her, yet the only time when she was hurting during the years I came so often to the Place was when Stieglitz gave me the freedom to go through all his prints, which he had never granted her. He had given her a hundred or more of them and they hung on the walls of her high white living room, along with the Marins, O'Keeffes, and other artists, which today, as her gift, form the basis of the Alfred Stieglitz Center at the Philadelphia Museum. Since

she was herself a photographer who made fine prints, I still do not understand why Stieglitz had denied her that freedom.

Undated

GEORGIA O'KEEFFE After the passing of 291 in 1917, O'Keeffe, who had no money, expected to go back to teaching. Stieglitz still had a little money, so he helped her, and they shared a studio together, she painting, and he, without a family, putting all he had into photography. Without premeditation or desire on either side, this common spirit overpowered them, and, as he puts it, it happened. The wonderful photographs of O'Keeffe and some of her best paintings were the result.

Naturally the couple were not understood. A banker friend came to Stieglitz saying he must not throw himself away; there was much more to his life than a beautiful woman. For answer, Stieglitz took him to the studio and showed him the paintings and the photographs. The banker was overcome: "I never dreamed there could be anything like this." Stieglitz said, "I never thought at all."

16 May 1941

Stieglitz agrees, more or less, with my theory that his photographs of O'Keeffe and the Equivalents are the best part of O'Keeffe—something that in her own work she has never quite accomplished. He says, first, that he was riper, and second, that O'Keeffe, like most women, is not the seeker, the completer, that a man can be. Starts ideas and does not carry them through. Believes, however, that a great show of O'Keeffe would be a revelation.

22 May 1941

Went to see Stieglitz in the morning and found the new O'Keeffe show up. Stieglitz still very depressed. Does not walk; spends all his time indoors—the Place, the penthouse, taxis—and feels cramped. After a while he began to get hoarse. So I went out and looked at the O'Keeffes. He told me O'Keeffe was in the open storeroom, cleaning and sorting, but I had dreaded meeting her too long to rush in blithely. Memories of all the barbed things she had said to Beau, Ansel and Dave, and of her behavior at the dinner party, deterred me.

Finally Stieglitz, on what pretext I do not remember, took me to meet her. She was in fine fettle, grimy handed but happy. She went on sorting, asking me if I liked Arthur Dove. I said I realized his importance, but did not yet feel his quality, although I was trying to. Whereupon she told me that Dove, years before she came to 291, had seemed to her a very great and honest artist, and hauled out a series of little animal watercolors and then recent sketches for paintings, and told me of her experiences with them. How one sketch, supposedly of a cow, had hung at the foot of her bed for years before one morning she actually saw the cow. She recommended that I buy one of these little watercolors and live with it. (Would that I could!) And then brought out three magnificent Doves—a pattern of gulls in flight, very linear against clouds, a

marvellous, huge pastel with the richness of stained glass, and a strange and wonderful painting of leaf forms on metal.

Then she said she had found a lot of Stieglitz's lantern slides, none of which she had ever seen. Was there some place over at "my Museum" where she and I might look at them together? I immediately called Beau, who was elated at the prospect, and he secured the little projection room for four o'clock. He and I lunched together, I feeling as if a burden had tumbled off my shoulders, but still dreading some thunderbolt, and went downstairs to get a slide carrier to fit the English—$3^1/4$ x $3^1/4$—slides.

Zoler helped O'Keeffe bring over the three heavy boxes at four, and we hied us to the projection room. O'Keeffe and I sat with our feet up in the deep leather chairs while poor Beau did all the work. It was a great experience. No photograph ever looks so wonderful as when projected, and many of these things made in the nineties were made especially for lantern slides. Many exist only in that form—the three hansom cabs beneath snow-covered trees, another—unknown—"Icy night," trees and bridges in Central Park heavy with snow. Three pictures of a fire, with falling walls, and fire engines belching smoke, and many informal snapshots. The "Car Horses" and the "Glow of Night" and "Katyjk" never seemed so luminous. They were of course frequently toned, and sometimes enhanced by second printings of weak parts.

O'Keeffe bubbled away, identifying people and telling about them. After an hour and a half—many were duplicates—we helped her take them back to the Place. We opened the door on Dorothy and Stieglitz. Dorothy looked aghast. I thanked her for checking my outline and supplying some dates, and she looked better, squeezed my hand and left.

We told Stieglitz how delighted we were with the slides. He did not want to see them —too close to a bitter past—but he became happier listening to us, and we finally left him looking gayer than for a long time. It was high time, too, for it was dark and nearly seven o'clock and O'Keeffe and Zoler were patiently waiting in the office.

6 February 1942

Came in and found O'Keeffe happily trotting about carrying pictures for Dan Rich of the Chicago Art Institute to look at. She is to have a show there this January with illustrated catalog. I begged Stieglitz to be allowed to stay—not that anyone is ever kicked out—but to make him understand what a joy an O'Keeffe retrospective—hundreds of pictures, unselected—would be to me. So I sat on the very hot radiator or occasionally an obscure stool, and watched, and sometimes asked Rich if he had seen some favorite or other of mine. He has excellent taste; Stieglitz highly approved, and O'Keeffe's dimple—unsuspected in so strange and spare a face—was coming and going. She wore a long, full, beautiful black dress, with a filmy white scarf pinned around her throat. It appears she had met Rich in the Southwest. As soon as the choice is final, all the paintings are to go to Chicago, which, O'Keeffe thinks, may save something from the bombings.

(Note: Since Pearl Harbor, December 7, 1941, New York had been more or less blacked out, knowing it shared with Washington and San Francisco the most important target for enemy planes.)

As always, I tried to disappear whenever serious business came up, and have at present no idea whether Stieglitz got the usual insurance or if O'Keeffe waived it.

16 March 1942

THE PHOTO-SECESSION The Photo-Secession neither started nor dissolved formally. No dues. The first office was in the basement of George Of's shop, where prints were packed and shipped. Stieglitz always insisted that the institution pay expressage to and from, and that prints be returned in perfect condition, which they invariably were. Even passepartout traveled safely to England and Germany. Of course the institutions were carefully picked. All the other work he did himself, just as for *Camera Work,* at home in the evenings, in the dining room.

Up to about 1908 he had a fair amount of money and could meet deficits himself when necessary, but always he has tried to make things self-supporting, and never did he draw on his wife's money for them.

Undated

REPRODUCTIONS More and more he came to depend on Goetz at Berlin Verlag. He did not need to stand over them, after he had once worked with them and suggested what might be done. Goetz was photographer, retoucher and crayon portraitist. Also photographed the paintings for the American Artist something; was very skillful in retouching the false tones of the photographs of paintings.

One reason why Stieglitz feels reproduction of his later work is difficult is that the sense of touch, which came through O'Keeffe and his work with her, became so important in them. In the *Camera Work* plates, touch was confined to the paper—the Japan tissue on which he taught Goetz to print. Later, touch was integral in the photograph itself. If he were to reproduce the Equivalents now he would work with the negatives and try to interpret their spirit through the best contemporary process—not imitate the prints.

Undated

EDUARD J. STEICHEN First came to Stieglitz in 1901, en route from Milwaukee, his home, to Paris. Said his mother and sister (later Mrs. Carl Sandburg) had saved their pennies that he might have the opportunity of studying in Paris. Stieglitz picked out five prints and asked if he would accept $5.00 each? Steichen, overcome by such a fortune, said he had never gotten more than fifty cents before.

Among the paintings there was one very Whistlerian study. Stieglitz asked about it. Steichen said he couldn't part with that. He wanted to show it to his masters in Paris. Stieglitz asked him to write for *Camera Notes,* offering always 100 francs, that he might not be short of money. General impression of rather touching faith and youth. Stieglitz

asked him if, should he become a great painter, he would cease to photograph. Steichen said "Never! They were two very different things." This tall and very young man shouted this as he was going down in the elevator. When Stieglitz went home, he said to his wife, "I think I've found my man," and told her the story. She said he was foolish.

Steichen *was* recognized and praised abroad by Auguste Rodin, Franz von Lenbach, and others. Stieglitz in the meantime was shunted out of *Camera Notes*, and thought that was the end of his labors. Keiley, unbeknownst to him, sent around letters asking his followers to petition Stieglitz not to leave American photography in the lurch. So the idea of *Camera Work* grew, and Stieglitz planned the dummy. For the first, Gertrude Käsebier. Stieglitz thought of Steichen being his co-worker when he should return. Käsebier, in Europe with her daughter, recognized Steichen's ability, helped him, took him on trips, got him commissions, and hoped he might be her son-in-law.

Käsebier appeared one day with Steichen—a very different Steichen, long-haired, cloaked, full of gestures. Stieglitz told him about the Photo-Secession. Steichen said it was all wrong, with all those inferior workers. There should be only Käsebier, Day, White, Stieglitz and himself. Stieglitz said he would not let his helpers down like that. Steichen then said he wouldn't have anything to do with it.

Käsebier begged Stieglitz to show Steichen the dummy of *Camera Work*. Stieglitz demurred, but finally gave in. Steichen, very much impressed, said that if this was the organ of the Photo-Secession then he would join.

Next morning, they all took the train for Newark. Käsebier, who was deaf, sat alone in front, Steichen and Stieglitz behind. Steichen proposed that the first issue should be devoted to himself, and the second to "Granny." Stieglitz refused. Steichen went on about how he wanted to get married and the publicity would help him. Stieglitz was adamant.

They arrived at Käsebier's studio, 231 Fifth. Steichen announced that he was going to Milwaukee to see his mother. Käsebier did not speak. After he had gone, she burst out. She had heard. She called Steichen an ingrate and warned Stieglitz that Steichen would do the same to him. Steichen had already been scheduled for the second issue, and been offered the job of designing the cover and marque of *Camera Work*.

Note also that Stieglitz finally and convincingly maintains that in spite of his occasionally unfortunate temperament, Steichen was not only a great photographer but a great co-worker in the fullest sense.

16 May 1941

Says Steichen wanted to be an actor.

Note, 1970. There is a space after this in my notebooks, for two reasons. One was that, pursuing research on Steichen as I did everyone else of any importance in Stieglitz's life, I found myself completely puzzled. Why was he such a turncoat? Hailed by Stieglitz and others as the greatest photographer alive, almost a son to Rodin, friend of Matisse, Picasso, and the rest of the avant-garde in Paris, he suddenly gives up photography as an

art — at least, his magnificent multiple gum prints — does a little fashion on the side, goes with Isadora Duncan and her troupe to Greece, but really concentrates on painting and plant breeding at Voulangis. Then around 1915, his gardener brought him paintings in his own style, which he thought were better than his own. So, with the gardener's help, he made a bonfire of all this "expensive wallpaper," and then, when the Germans swept through his little paradise, went back to America, enlisted, was commissioned first lieutenant assigned to aerial photo-intelligence.

When he came back after the War, he shut himself up and performed countless experiments, often with just one subject, such as a teacup, until he felt that command of lighting, depth of field exposure and development had become automatic. When he saw what Stieglitz had been doing, especially in the great, multi-faceted portrait of O'Keeffe, he was much moved. But instead of joining in this new direction, he said he was tired of starving and went into commercial photography — advertising, fashion, portraits of celebrities of *Vanity Fair* and *Vogue*. He transformed these fields, raising both standards and prices. He did not go to see Stieglitz for more than twenty years.

So when I asked him, Stieglitz thought a moment, and then said, "If you will remember Steichen was born a peasant and wanted to be an actor, perhaps it will be clear to you."

I didn't like that remark. It seemed snide, even envious, and unworthy of Stieglitz. Of course Steichen was the son of Luxembourg peasants with a deep desire to grow things, but what peasant ever worked so scientifically on plant-breeding and developing extraordinary new strains, especially in delphiniums — six feet tall, very strong, and of the most beautiful blues. And, I thought, if Steichen had really wanted to be an actor, he would have been, with his height and his vital presence.

It took me years to perceive how accurate and penetrating an insight into the dynamics of Steichen that remark really was.

To resume these notes:

Steichen's brother, Julius, took up photography in later life and went at it with true scientific zeal. His work utterly lacking in aesthetic intent, or, indeed, interest. Came to Stieglitz once and inquired where Stieglitz kept his negatives. Stieglitz replied, "Oh, anywhere." Julius, horrified, asked if he made duplicates. Stieglitz said there wasn't time. Julius virtuously stated that he made duplicates of all his negatives and kept them in the safe deposit vaults of a college building. Again he asked Stieglitz if he had seen color photographs, and Stieglitz said some. Julius said he'd seen one of a sunrise that was just as real as a sunrise. Stieglitz said then he could never have seen a sunrise. Julius in despair complained, "There you are. Once never knows where to have you. One day you say, 'White,' and the next you say 'Black.' "

Stieglitz asked him to look through *Camera Notes* and *Camera Work* and other publications to see what he had said and why, throughout the years.

1 January 1942

Steichen's married life Wife 1 was Clara, a singer studying in Paris, who posed for the nudes-moods in *Camera Work*. Probably an intimacy; she insisted on marriage.

Stieglitz's mother, when they came up to Lake George for a few weeks, also said he should certainly marry the girl. Stieglitz said, "Clara was a terror," and, left to himself, Steichen would probably not have married her. Even so, her family put up a protest at her marrying an impecunious artist. They even got married at Trinity (the old church at the head of Wall Street) and the Stieglitzes asked them to Lake George for their honeymoon, which they spent on "the Hill." Mary arrived promptly nine months later (Dr. Mary Calderone, distinguished pioneer in sex education). Clara began upbraiding Steichen. Of course *he* could paint; she did all the scrubbing and washed all the dishes; if it weren't for him, she'd have been a great singer. Stieglitz of opinion she never would, but would have married somebody anyway.

9 June 1942

Stieglitz and O'Keeffe were working in the same studio, in the brownstone on 59th Street between Lexington and Park, where they had a room and shared a bath with the landlady and her family. They had been together in Lake George the summer of 1918, he photographing her furiously, and the results were now around the walls.

Footsteps heard on the stairs—Steichen appeared in uniform of a major. O'Keeffe and he had never met. Steichen: "God damn it all, ever since I've returned I've heard nothing but money. Did we fellows fight so that America could get rich? This seems the first clean place I've seen since my return." (Note: Steichen had entered the service and been appointed head of aerial reconnaissance at the recommendation of Stieglitz and Eugene Meyer.)

Stieglitz: "Steichen, tell me something. When did you receive the first photographic goods in France?"—"Some days after the Armistice was signed. What a mess. If I hadn't known the ropes in England and in France, what would have happened? I wanted you in Washington to attend to this end while I was in France, but as the powers that be wouldn't listen to my suggestion, I forced nothing." Stieglitz laughed. "Of course they didn't want me. Eastman Kodak and the rest would have had to toe the mark, but you would have received what you needed in time, certainly long before the Armistice. I asked you this not because of myself—I don't count—but because of Eastman's 'We helped Win the War.' Those ads made my blood boil, and I told O'Keeffe that I didn't believe that any American photographic goods reached France—or the lines, at least—before the Armistice."

Steichen: "What have you two people been doing?" Stieglitz showed him O'Keeffe's paintings; he grew pale. "Steichen at his best," said Stieglitz, "when he is true to himself, is as sensitive as a fine woman, and he *sees*." On seeing Stieglitz's photographs of O'Keeffe, tears rolled down his cheeks. He got up and paced the floor. "What are you going to do with these photographs? The world ought to know about them—see them—you must show them. You must find a way."

Stieglitz thought of his fight for the young Steichen years earlier. Now he himself was down and out. What would Steichen do for him?

Undated

ALFRED STIEGLITZ He spoke of how few people had come to see the new Marins
—the most beautiful Beau and I have ever seen— of how slow even O'Keeffe had
been to realize their importance. He discussed the war in relation to his own
fight—bringing up how, in the first issue of *Camera Notes,* he included a fine gravure
of Alfred Horsley Hinton, whose work he especially disliked. He told the story that,
when all his friends were congratulating him on the Holiday Work prize and the praise
from Emerson, he said, "I'm very glad for my father; it's a tangible proof for him that I
am not wasting my time—but for myself, I can only think how bad my competitors
must be."

Finally Beau said that the Museum had $1,000 and had in mind some of his work.
Stieglitz laughed and said, "Where is the $1,000? In your mind?" Beau said "No, in a
promise." Stieglitz said, "Somebody told me about it, but I never think about such
things. Well, what have you in mind?" Beau said he felt there should be no duplication
of what the Met had or what had appeared in *Camera Work.* Stieglitz emphatically
agreed. Beau said he felt there should be something of the Equivalents and something of
Lake George. Stieglitz broke in and asked if we would leave the selection to him. We
immediately and enthusiastically agreed. He said he would select what the Museum
needed "for a start," and if he felt like throwing in a few more, that was his own
concern.

We never realized more clearly what a really great and simple man he is—in the
middle of such a tangle, universal and particular, with all his long-rooted disappointment
with the Museum—to make such a great gesture.

 23 January 1942

Stieglitz upset about things—profoundly. Apparently wants to make some stipulation
about the prints for the Museum, but Ralph Flint came in, and Stieglitz's mind being
hazy, he never quite finished the circuit of his talk. Then Dorothy came, and Beau made
three photographs of the Marin show.

Stieglitz feels that An American Place is coming to an end, just as 291 did. He feels
alone, although surrounded still by friends. "If I have the misfortune to live a year or two
longer, I shall find myself where I was in 1917." Feels, and rightly, that the place of
photography in the average mind is rather worse than when he began—and that people
like Steichen, whatever their intentions, have helped muddle it.

 27 January 1942

Found Dorothy Norman sitting in dark corner going through flimsies from a bookcase.
Stieglitz, more depressed than ever, was saying: The Place is and must be an open place.
Why cannot people—even remarkable people—live together decently? It's just like
291, only then he could take a ten mile walk in the Park and stop for coffee and cinna-
mon bun in a cafe on 110th Street. Now he is confined. He wants to walk out and leave
it. Its spirit is dead. The beautiful living things no longer mean anything real to
people—he is tempted to destroy them all. The artists want to destroy each other.

O'Keeffe will probably destroy his intimate pictures of her and the paintings of hers which people misinterpret. He would like to photograph again—he does not know what and suspects that materials are already adulterated—he no longer knows contemporary equipment. He wants to make certain prints and give them away. He should have died three years ago. I said that then I and so many others would never have known him, it meant a great deal to us; no doubt we were selfish. He said it was not selfish. Still, for the first time, he was envious—of the dead. His brother should have let him go then.

I asked him when O'Keeffe went to the Southwest? In 1929; except for a few weeks in Maine, it was the first time she had left him. It nearly killed him, because he knew something had come to an end. She returned a different O'Keeffe—determined not to leave him again. But she did. She had to—the paintings prove it.

Said he'd been thinking about the prints for the Museum, but the present situation made it almost impossible to look at his prints and see his whole feeling for life at the same time.

What will happen to Marin and O'Keeffe when the small backlogs he got for them last year are gone? Phillips is interested in Dove. But O'Keeffe, when he is gone, will have to face so many problems.

18 February 1942

The Collapse of 291 After the Armory show in 1913, Stieglitz felt that the excitement went out of showing modern art. The dealers scented money—of course the article needed to sell. Marius DeZayas caught the infection, hence the Modern Gallery which opened in 1915 with DeZayas as director, but would show only abstract art. Stieglitz felt he could not leave Marin, who was producing much of his best work not in the abstract form, in the lurch, so kept on with 291. The war—and the Dada spirit—began breaking up the group. Emil Zoler and Abraham Walkowitz sat around and blasted the rich. Agnes Meyer's husband began making millions out of the war. Stieglitz's wife, Emmeline, lost $600,000 in the brewery with prohibition. In 1917 they separated. Stieglitz maintains that he never spent her money on artists, and proves it by continuing to help them without her. And Stieglitz could not join in the anti-German hysteria. Steichen went to France. His friends were gone. Why should he keep up 291 when its meaning was dead? The last show was O'Keeffe in April 1917. It began clean, he said, and it ended clean.

16 May 1941

291 The decoration of the original gallery was entirely Steichen's. He feels Steichen's painting essentially decorative and nothing more. Stieglitz made the later gallery as much a facsimile as possible. Coming out of the tiny elevator you faced a tiny hall, with one lovely thing in it. To the right, the decorator's large room. To the left a little passage into a tiny gallery, made by a partition, then the room, 15 feet square, and the backroom, shared by the decorator as a waiting-room, where people sat and talked. O'Keeffe says it was the loveliest place she ever saw. The idea of non-photographic exhibitions was

Steichen's, since he was also a painter. The photographers came to take Stieglitz for granted.

20 February 1942

Asked him about Berlin days: Went to Karlsruhe to learn classroom German and German attitudes to study and so on. Did not fit in. Was always lonely as a child, and always unashamedly in love, perhaps with the ladies who came to see his mother. After he started photography in Berlin, father asked him about it, and Stieglitz said he felt he had no right to be here—ought he not to go home and earn his living? Father said his living would always be taken care of—would leave him $60,000 now and $400,000 when he died. Stieglitz cheered up at that and began to enjoy himself.

Always felt that any women he adored must never be touched. Never intended to marry, feeling that he could not provide. Would not have married Emmy if she had not had enough money to provide for herself. Never took any of her money, unless a bed in a small room and his meals could be called that. States emphatically that none of Emmy's money ever went into *Camera Work* or 291. O'Keeffe is independent and he touches none of her money. Regards the penthouse as putting him in a false position.

His first simple camera dry plate. His first photographs copies of photographs Ernst Encke made of him. Encke trying to win some contest or other dressed him in a shepherd costume and tried to get every hair sharp. Litfassäule—column covered with posters—his first independent photograph. Plaster cast of Venus—Vogel explained it was a compromise. Stieglitz incidentally mentions that he never used H and D or any of those things. Always after the feeling. Did not feel photography was his medium. "I'll tell you a secret. It'll surprise you. *Woman is my medium.*"

I asked him if Katharine Rhoades was proto-O'Keeffe and he said yes, emphatically. Otherwise he would never have been ready for O'Keeffe. Told how an old man came in to see O'Keeffe's tree series—then saw in office a portrait of Rhoades by Stieglitz—and said, "My niece might have painted these things out there if she had not been distracted and had too many big ideas." Stieglitz asked him if the niece was Rhoades and he looked at the tree series and said, yes, that's Katharine.

Stieglitz said that if he had been a real man, which, he said, he wasn't—if he had been six feet tall, all strength and sinew, he would have carried Rhoades off to some mountain top, built them a little house, given her children, and let her paint.

She asked him for a photograph once, he gave it to her, she gave him a check, at which he said she didn't need to do that and put it in his pocket. Looked at it later—$1,000.

Stieglitz's mother's family cultured; father a rabbi. More English than German spoken at home. Mother came here when she was 8.

His sister Flora's death from blood-poisoning after childbirth shocked his mother badly, and father thought Alfred had better come home. Gave him $600 a year. (In Berlin it had been $1,300, $700 of which he didn't need.) Saved $150 every year and

sent it to the little prostitute in Berlin (Paula) so that he could feel she was not on the streets. Later some man set her up in a café. People asked him how, feeling as he did about women, he could live with a prostitute, and he said he could not have done it had he not felt she was as clean as his mother. They were, of course, shocked, but his mother understood, years later, when he told her. He never saw how or why any woman could love him.

12 March 1942

Began photographing facade of Polytechnic and noted that as the light and weather varied there were innumerable different facades. Knew nothing of impressionism, never read catalogs, programs, histories; ran through galleries and stopped only when he found what meant something to him. Loved Rubens and Tintoretto. Rubens because his women were real women — Helena Fourment, portrait of second wife with fur coat — to him one of the best things ever done of a woman. Far ahead of Renoir, who felt only the sweet flesh.

At about 17 his mother remarked that since he was always in love, he'd probably be getting married soon. Replied that he would never marry because he was unworthy of any woman he would feel like marrying. Feels he was absolutely right; he is unworthy — cannot really protect and provide either for women and their children or artists and their paintings. Feels he has really failed. Has been in search of clarity — his own most of all — yet even his most beloved friends try to obscure his search — Marin about six years ago did some magnificent things of New York which Stieglitz saw only yesterday. So now O'Keeffe is pushing him to seize this opportunity, now that the *New Yorker* profile (on Marin) is out, to put up these things and postpone Dove's show for a few weeks. Dove still a sick man.

Jennings Tofel came in, a little humpbacked, pigeon-breasted dwarf with a squashed nose in a good, broad, sensitive face. He wrote something for *America and Alfred Stieglitz,* which I was criticizing. Stieglitz still stoutly maintains that the book has done real good, especially in the Middle and Far Wests. But he does not like being God plus. He rejected the idea when it was proposed to him, and had really nothing to do with it. It was all Dorothy, though Waldo Frank had had the idea for years. Stieglitz feels you can find out about 291 in the *Camera Work* number, and the Place in *America and Alfred Stieglitz.* I don't.

Says Hartley is an acrobat — denied he had seen Giovanni Segantini, which was literal truth, because he had seen only the colored reproduction in *Jugend* magazine. Stieglitz showed his things only because of his willingness to live on $200 a year.

Stieglitz had put up some photographs, against the Marin oils, to help his choice for the Museum. The decaying snowy window he said was a portrait of the Stieglitz family (and he says the disintegration of the family is due partly to there being such uncompromising individuals as Stieglitzes in it). Katharine Rhoades wanted this to go with her Chinese things, and it was for this she gave him the thousand. Two prints of the

dead poplar, the young street boy, and a beautiful 1887 of a flight of stairs in Italy
and the shapes of people living in the blaze. Bought some grapes (from the fruit-
seller) and stayed there most of the day. Says this was one of the twelve he sent to the
Amateur Photographer; "The Good Joke" was just a moment, this was what he really
felt.

 13 March 1942

Bellagio 1887 First of the Italian lake tours. Stieglitz so fascinated he stayed three
days and let his friends wait for him. Found Maria the fruitseller early in the morning,
when she had just set up her stall, and bought 5 pounds of grapes from her. When she
said she could not change his 10 lira note, he told her to keep it. She was about sixteen,
and beautiful; took her portrait and her mother's in the stall with the flight of stairs going
up. Got to know all the children and laughed with them—could not speak Italian well,
just enough to get the drift. Took "The Good Joke." Met Leone (Maria's brother) a
handsome boy, and took his portrait. Maria's mother said she had a relative living in the
States—Denver or somewhere—and perhaps Stieglitz would like to take Maria to him?
Stieglitz longed to be rich enough to adopt Maria and Leone but had to refuse and plea
that his friends would be angry if he did not go join them at once.

 Years later, when he came back with Emmy (Emmeline Obermayer, his first wife, on
their honeymoon) the boatman who took them over looked at his camera and told of an
American who had photographed Maria and Leone eight years ago. Stieglitz asked after
them. Maria was in Milan, married, with four children. Leone was head baker at the
hotel. Stieglitz said he was the American, and the boatman said he must telegraph Maria
at once. Stieglitz said no, it was all different now. She was married, let her be. But Leone
was not married, so he was told and came—now tall and handsome with big
moustache. He still treasured his pictures, he said, and so did Maria. Stieglitz had sent
them big prints. Emmy impressed.

 Emmy, a spoiled, romantic child, was about to elope with her riding master, and had
to be taken to St. Augustine to forget it. Went with her brother, Stieglitz and others to
Nyack; Stieglitz told her about Venice. On way home on boat, she fell asleep on his
shoulder and brother glowered. At parting she asked him to call two days later. Lived
with her eldest brother at corner of Seventy-third and Lexington. Stieglitz had never
called on a girl before and didn't care much about it now, but went and sat in the
downstairs parlor with her. In time a banging upstairs. Emmy said, "Never mind—it's
just my brother thinking you should go home." Later, more bangs. Spent perhaps three
hours there, primly.

 Two days later her brother Joe, his partner, came in rage and said he must talk to
Stieglitz. Stieglitz was not a marrying man, but what was he to do? Stieglitz laughed and
asked what he was talking about. Stieglitz, the Obermayer family felt, had compromised
Emmy, who was in love with him, and Joe would do anything, he threatened, rather than
hurt her feelings. Stieglitz said he had no money to marry on—Emmy was a nice girl
but he did not love her—and then "like a fool" said, "I'll consider myself engaged for

five years—maybe by then I'll be worth marrying—Emmy in the meanwhile to be free as air and do what she likes and if she falls in love with somebody else, it will be all right with me." Joe asked immediately if he could call Emmy and tell her. Stieglitz said certainly not, but he might tell his brother that night. Stieglitz went to dinner there, and being left alone with Emmy afterward, saw her fall asleep holding his hand.

Stieglitz père delighted when Stieglitz told him; would settle $3,000 a year on Stieglitz —probably equal to what Emmy had. Stieglitz said he had no idea what Emmy had—he just wanted to go on living simply. Stieglitz père said there was no business as reliable as the brewery business (source of the Obermayer wealth). It was he who hastened the marriage, believing long engagements unhealthy. And insisted on a diamond solitaire to match the Obermayer fortune. Emmy showed it around to everybody—but ten years later asked if she might change it for pearls, she hated diamonds. Stieglitz said yes, of course, so did he.

Emmy quite dulcet and charming up to the wedding. Then a judge came drunk and Stieglitz stood on the wrong side of the bride. After wedding she became a stern prude; would not allow him to take nudes of her "to show all his friends." On their European honeymoon the thing became a tragic farce. Emmy feared heights, would never go above the fourth floor of a hotel, and refused to use the funicular at Mürren. So, after a hysterical scene where she said he wanted to murder her—in public—he hired a guide and, carrying his own thirty-pound camera equipment, set off up the mountain at a pace the guide felt was impossibly fast for a man carrying weight in the Alps. Emmy could not bear the smells of the fisherfolk nor any part of them. Stayed at hotels in tears, hysteria, and reproaches, while Stieglitz got up at 4 A.M. and went out photographing like mad all day. He invited her to share all he was getting, but she would have none of it.

All this time she would not let him touch her. Joe's stories of his youthful sexual exploits or maybe merely dark hints as to his glamorous past may have scared her. In any case Joe had been ready enough to believe Stieglitz really had compromised Emmy, instead of enduring a boring and decorous evening. Anyway, now that she had caught this strange, magnetic young man, who must have been very beautiful in his dark brilliance, she was fearful of him. An absurd situation, but Stieglitz, in whom she aroused no desire anyway, patiently put up with it. She was furiously jealous if she saw his interest flare in another woman, but he gave her no cause for serious alarm, coming home faithfully every night to the far too elaborate dinners. When the table was cleared, he went to work, which bored her, since she couldn't understand why he wasted his time on photography, and artists, and such trash. Or he might play the piano. He was quite good as a pianist, not of professional quality but expressive of his passionate devotion to music. Emmy couldn't take that either—too passionate, too loud, too legato, too unusual. Why not a pleasant waltz or a little light night music? One night Stieglitz shut the piano and never touched it again. He had it removed and told Emmy he had sent it to be tuned. Finally she rearranged the living room. Then in the fourth winter of their marriage he fell so ill he was not expected to live. Emmy,

contrite, came to him and begged him to live; she promised she would try to be really a wife to him. His brother Lee finally managed to save him, and ordered them both to Florida. But Florida just then was not much more sunny than New York—no basking, no swimming. Emmy, however, lived up to her promise, and the marriage was finally consummated. As Stieglitz remarked, "There was ice on the orange blossoms."

When Kitty was born, he began photographing her, especially in her moments of delight and discovery. A delicate and tender series he called "The Diary of a Baby." But Emmy objected that he was spoiling the child's fun and making her self-conscious. So he stopped. But in 1908 he photographed her again, long curls, hair ribbon, starched, frilly summer dress, in Autochrome, a new color process he, Steichen and Eugene were experimenting with. The transparency is faded now, though its loveliness can still be felt. And Kitty's face is not a happy one.

19 March 1942

Told how his nose got broken. His mother, when he was about six months old, sat dozing in front of the fire with him in her lap. She awoke to find he had slipped out and fallen on his face—fortunately, not in the fire. She rushed him to the doctor, who examined his nose and said it was *not* broken. "So," said Stieglitz, "the doctor was satisfied, my mother was satisfied, and I had the broken nose. I've never been able to breathe except through one nostril." He told how when his teeth were being straightened, he used to take out his plate while playing baseball and put it on a stump or stone or something—very sanitary! So it was out more than half the time, yet the dentist was much pleased by his progress. Says he has always regarded the doctors as comic and disregards their instructions.

Catalogue of present diseases, incomplete, of course: bad heart, colitis, sinus, hyperacidity causing skin trouble, and some ailment of the tongue. Says his skin is such that he can rarely take a bath, and O'Keeffe finds it amazing how clean and sweet he nevertheless remains. He always has been more or less ailing.

2 June 1942

Went to say what is probably goodbye to Stieglitz for the summer. Found him muffled up in a barber's cloth, having his hair cut by the same devoted German who has cut it for the last forty or fifty years. Stieglitz's cold finally settled in sinus; he no longer looked as if he were disintegrating, but he was not up to any real conversational feats. Also Dorothy's leaving, that morning, had probably exhausted him; he mentioned how frightened she was each time lest she should never see him again. His heart is getting more and more uncertain.

He seemed very pleased with Beau's idea for protecting his prints with a daguerreotype-like case. We went out back and arranged with Andrew Droth about photographing the collection. Andrew comes in Mondays, Wednesdays, Thursdays, and is usually there from 9 to 4. I am to telephone him when to expect me. He is to

bring me the photographs I need and put them back. I am to work in either the main or little showrooms.

12 July 1942

One day, Stieglitz in a black mood was complaining that essentially he was all alone: everyone left him eventually — Steichen, O'Keeffe, even Dorothy. The old faithfuls, such as Zoler, however kind and good, were not creators. And he, the old romantic, the old idealist, the old fighter, proclaimed, "But I'll stand to the end!" I then, very humbly, volunteered whatever help he might think me capable of giving, if he would accept it, promising I would always be faithful to the needs of the Place.

He thought a moment, with that deep inward look, as though he were listening. Then he said, "No. I would accept, and you would *now*. But you, like all the others, will be swept away. You won't be able to help it. But I do think you will always carry some of this, whatever it is," with a gesture including the whole Place, "with you."

Undated

O'Keeffe came to my little apartment on West Fifty-third Street. It was very simple: one high, tall room, with shutters at the three tall windows, but no curtains, a fireplace with fire ready for lighting as mood or weather indicated, and a few old pieces of New England provincial furniture, simple and honest, silhouetted against pale walls where photographs glowed. There were usually a few fresh flowers. She liked it. She thought Stieglitz would also find something here he would like very much.

Apparently she told Stieglitz, who could not afford even the simple effort of taking a taxi down Fifty-third Street to see. But he remembered. And, at a crucial moment when he was at outs with both Georgia and Dorothy, he proposed moving in with me.

My God, it seemed to me like being appointed guardian to the Holy Grail. This frail, beautiful and exacting old man — he was eighty — and I didn't have even a room where he could lie down in peace. No staff to bring him breakfast or dinner or care for him, should he be ill, when I was away during my usual fourteen-hour days. I thought of hiring the hall bedroom next door, I thought of trying to adjust my hectic schedule to his needs. And what of all the people I was entertaining, much in his own spirit at 291? For I was trying, as he once had, to convince photographers that what they had in common was more important than their differences. My hospitality had to be utterly spontaneous, happening when people came together. I did think briefly of the scandal; people would certainly misconstrue the move. And how hurt and angry both Georgia and Dorothy would be with me — and after all these years during which I had so carefully tried not to get involved.

Still, it was with sorrow that I had to tell him I could not, under the present circumstances, offer mere physical shelter to him, who had so often been my spiritual shelter in time of trouble.

Undated

PAUL STRAND At the opening of the Steichen show (*Road to Victory*) I rather diffi-
dently told Strand about the Stieglitz biography and asked him to come talk to me and
have dinner. To my surprise he accepted with alacrity. I had expected him to be one of
the most difficult witnesses. So he came, with his wife Virginia Stephens, and simply
amazed Beau and me by his love for Stieglitz and his definite and eager talk about
him.

Summary of his present view: feels that the Equivalents and the other later work are
too personal; prefers the earlier direct and simple work. Of all Stieglitz's photographs,
the one he picked out as the one he most loved and would like to live with was the very
one which Stieglitz said was the summary of the Mexican portfolio: the little peasant
girl with the milkpail and the hobnail boots.

Feels that the objectives Stieglitz has fought for are outmoded as well as impossible.
Art was a burning issue before World War I; yet even then Stieglitz was to some extent
wrong in trying to support the artist by a small circle of the investment-minded rich. We
pointed out various examples of Stieglitz's trying to get the masses to support art, such
as the "291" Steerage, and the Minnesota experiment, which he had not heard about.
Strand said that Stieglitz drew the wrong conclusion from his experiments: not that the
people were deluded by cheap magazines and so on and had little or no leisure to devel-
op a feeling for art — which is Strand's view — but that the people didn't like art.
Virginia, a warm and pretty little actress with a flair for social history and psychology,
attributed the strange course of all Stieglitz's intimates to the master-pupil relation. I put
forth the theory that Stieglitz is a dual personality: a great creative genius with the
inevitable tendency to destroy others, and a selfless, loving leader who wants above all
to cherish, encourage and protect other talented people; the war between the two is his
own tragedy.

 29 May 1942

Strand was born in 1890, of Bohemian Jewish parents, and brought up in New York.
Went to Ethical Culture School. Lewis Hine, assistant teacher in botany, started a
small course in photography in 1907, and took the class, about seven, to 291 to see
an international photography show. The show crystallized young Strand's life ambitions:
he wanted to be a photographer. Joined the Camera Club. After graduating became
an office boy in father's enamel business at $4.00 a week. Later the business was
sold and when his new employers had learned all he knew, they fired him. Had a
promise of an insurance job in two months time; decided to go to Europe, March to
April, 1911. Sailed on a Cunarder to Naples. Traveled by night and went sightseeing by
day.

After insurance job sickened him—he said he wouldn't have stayed if they had made
him president—he set up as professional photographer in a small way, doing portraits
and advertising jobs. His family provided food, clothes and shelter, and he had the facili-
ties of the Camera Club. This grew unpleasant. There was, he said, considerable anti-
Semitism as well as debate as to whether professionals should be allowed the use of

the darkroom. Some member made torsos which included the genitals left hanging up to dry in the darkroom. They were impounded by the man in charge of the house, named Banks, who boarded with the future Mrs. Steichen II and her mother. Banks was mysteriously without support, yet always around. He brought these nudes up in general meeting. (They were attributed to Strand, who certainly might have made them but claims he didn't.)

It was voted to expel Strand for pornography. Then an uncle of Strand's who "had something on" the president of the Camera Club, an important official in many big corporations, brought pressure to bear and the matter was dropped.

Strand went back to 291 now and then, studying the new art and becoming increasingly abstract. In 1915 he went to Stieglitz feeling he really had something to show at last. Stieglitz thought so too — said, "It's your Place now. I'm sure the other fellows will think so too. Come whenever you want to." So he had a show at the time of the Forum show and two issues of *Camera Work* were devoted to him. He describes Stieglitz as the cement which held 291 together. Said he was one of the most intimate friends when 291 collapsed. Stieglitz was allowed to use a loft in the building; paintings stacked against the walls. People still came to talk. Strand himself became part of a medical unit doing X-rays at a base hospital. After war, set up making movies of operations, but doctor of firm proved in bad repute; firm failed and when Strand returned the Akeley camera, they asked why he didn't keep it and use it? Made all kinds of film shorts, commercials, and the like.

Undated

Paul and I were working together on his great retrospective exhibition, to be held in the Museum of Modern Art in the spring of 1945. I was to write the catalogue, in this case a short monograph, with a plate section, a chronology, and a brief bibliography. During the preparation for the latter, he told me, with tears in his eyes, of his break with Stieglitz.

He was slow to adjust, he said, after the disorientation of World War I. Even though he had not been sent overseas, his roots were all torn out and his creative momentum shocked to a standstill. Back in New York with Stieglitz, he was overwhelmed by the thousand-imaged portrait of O'Keeffe and, like so many others, fell under the spell of her austere beauty. When he married, he could not help reflecting something of that experience when he photographed Becky. But Becky was not Georgia, and he was not Stieglitz; what in their collaboration was a poignant revelation, made with great tenderness and deep insight, became with him and Becky, forced and theatrical. He did not realize this, nor that Stieglitz was irritated by the imitation, and tried, as when he photographed Becky in the sparkles and clear swirls of the Lake waters (Stieglitz may have been thinking of certain Rubens nudes in water), to show him what potentials he had for a totally new approach. Strand was hurt when, working on one of the decaying old barns at Lake George, Stieglitz snapped at him, "Don't do that again. I've done it. Find something else."

It was the same with the dying poplars and chestnut trees, and other isolations of natural details. The same with the Strand's solemn, devoted imitations of Stieglitz and O'Keeffe, who were both irritated and amused. The message was still too painful to accept, however. Neither he nor Becky realized that Stieglitz and O'Keeffe did not want simulacra of themselves to succeed them when they should grow old. They hoped for people who would take up the work and go beyond them in fresh and new directions. Or so they believed.

Nevertheless, Paul, who was now making enough as a commercial-movie cameraman to afford a summer month or two in other regions, began going to Colorado, to Maine with Marin and Lachaise, to the Gaspé and, at Mabel Dodge Luhan's invitation, to New Mexico. Stieglitz could no longer say he was using the same motifs. In the Maine series, closeups of dew, cobweb, fern, rock, and forest, he achieved a formal majesty and rhythmic lines of force beyond Stieglitz's Equivalents dealing with similar subjects; the Equivalents are always metaphors for human emotion, incisive as lightning into the complexities of pain and ecstasy. Strand's images are the thing itself, seen through a somber mood of meditation.

Strand's vision is almost always tragic; Stieglitz, who ran the full gamut — joy and gaiety, satire and wit, loveliness and beauty, compassion, stark reality, and tragedy — commented that Paul had no sense of humor, especially about himself and his work. Indeed the mere recollection of Paul's Mexican movie, *Redes* (Nets), known here as *The Wave,* a story about poor fishermen trying to get due prices, could send Stieglitz off into gales of laughter — "those men in the white hats!"

But during those summer months with his 8 x 10, his Graflex and the 4 x 5, Paul, who had been searching for a new creative direction, found it in *the spirit of place.* In the Gaspé series he was working, fast, for the moment when waves, men, horses, clouds and light came suddenly into expressive balance.

In New Mexico, he became aware of how the savage rhythms of the earth and sky shaped the people and the architecture. In Mexico, he saw how the Suffering Christ and the Immaculate Virgin dominated the emotions of the masses; he could not help but see the beauty of the poor and their hatred of gringos. Now, he said, he could go on forever: sensing the basic rhythms, conditions, ideas and images which produced a region and its people.

In Stieglitz's opinion, the Gaspé series was the best Strand ever made, apart from the early New York series. But when he installed at the Place, in 1932, that two-man show of Paul's photographs and Becky's paintings on glass, he was, as Dorothy said, diabolical, showing up their weaknesses. He was also being funny about the show, and friends told Strand about it. Some thought Stieglitz did this because Strand had gone beyond him and Stieglitz, now nearing seventy, was therefore jealous. Paul was deeply, bitterly hurt. The message hit home at last, but his friends persuaded him that, since he was now the greatest photographer in the world — an opinion he has held ever since — that he should break with the jealous and traitorous old man.

So, he said, without a word, no recriminations, not even a farewell, he went to Stieglitz one day and handed back in silence the key to the Place.

Stieglitz said of my little monograph on Strand, "I must have been your biggest problem. You handled it very well."

1944

The touch of invisible things is in snow, the lightest, tenderest of all material.
I have lain in the calm deep of woods with my face to the snowflakes
falling like the touch of fingertips upon my eyes.

14. A sample page of Ansel Adams's illustrated edition of John Muir's *Yosemite and the Sierra Nevada* (1948). The Additive Caption serves a dual purpose. Phrases from the text, which is presented by itself in the first half of the book, appear opposite each photograph in the last half of the book. These phrases recall the text and accentuate the mood of the photograph.

The Caption
THE MUTUAL RELATION
OF WORDS/ PHOTOGRAPHS

PERHAPS THE OLD LITERACY OF WORDS is dying and a new literacy of images is being born. Perhaps the printed page will disappear and even our records will be kept in images and sounds. Perhaps the new photograph-writing—so new we have no word for it—is a transition form, and perhaps, instead, it is, in embryo and by virtue of principles now being discovered and applied, the form through which we shall speak to each other, in many succeeding phases of photography, for a thousand years or more.

We are not yet taught to read photographs as we read words. Only a few thousands, among our hundreds of millions, have trained themselves like photographers and editors to read a photograph in its multi-layered significance. Yet more and more photographers have discovered that the power of the photograph springs from a deeper source than words—the same deep source as music. At birth we begin to discover that shapes, sounds, lights, and textures have meaning. Long before we learn to talk, sounds and images form the world we live in. All our lives that world is more immediate than words and difficult to articulate. Photography, reflecting those images with uncanny accuracy, evokes their associations and our instant conviction. The art of the photographer lies in using those connotations, as a poet uses the connotations of words and a musician the tonal connotations of sounds.

The number of those for whom really great photographs speak a language beyond words is steadily increasing. But most of us still need verbal crutches to see with. And the most explicit photograph may not reveal to the most omniscient eye of editor or historian the precise place and day it was made. Therefore the association of words and photographs has grown to a medium with immense influence on what we think, and in the new photograph-writing, the most significant development so far is in the "caption."

What *is* a caption? The word itself is old, but in its new photographic usage it is so new it has not yet reached the dictionaries. (In the old newspaper glossary, the caption was the headline or title over a picture and what we now call the caption was known—with a pungency caption writers will appreciate—as the cutline.)

How does *caption* differ from *title* and from *text?* How does it function with them? How does it influence the photograph, and what are its common contemporary forms and its future potentials?

Let us begin with what everybody knows, and propose that something like the following be added to the usages listed in the dictionary.

Title:

(Photographic usage, in the United States) an identification, stating of whom or what, where and when a photograph was made.

A title is static. It has no significance apart from its photograph.

Caption:

briefly stated information, usually occupying no more than four short lines, which accompanies a photograph, adds to our understanding of the image, and often influences what we think of it.

A caption is dynamic; it develops title information into why and how along a line of action. It makes use of connotations of words to reinforce the connotations of the photograph. It loses half of its significance when divorced from its photograph.

Text:

main literary statement accompanying a series of photographs, usually presenting information about the theme and its background not contained in photographs and captions. Text, no matter how closely related to the photographs, is a complete and independent statement of words.

There appear to be four main forms of the caption. There is the *Enigmatic Caption,* a catchphrase torn from the text and placed under a single photograph. The sequence of interest runs like this: the eye is caught by the photograph, then by the caption, and then the irritated owner of the eye finds himself, hook, line, and sinker, compelled to turn back to the attached article and read it. This type is found in full classic purity in *Time.*

Then there is the *Caption as Miniature Essay.* This again usually accompanies a single photograph and constitutes with it a complete and independent unit. *Life's* "Picture of the Week" and "What's in a Photograph?" series offer examples, and a glance at any *Illustrated London News* will provide dozens more. (It is probably the most ancient form of caption; it has survived since the monumental bas-reliefs of Babylon and the wall paintings of Egypt.)

The *Narrative Caption* is, of course, overwhelmingly the common contemporary form and is familiar to everybody through magazine journalism. It directs attention into the photograph, usually beginning with a colorful phrase in boldface type, then narrating what goes on in the photograph, and ending with the commentary. In a photo story, it acts as bridge between text and photograph.

The *Additive Caption* appears to be the newest from, risen into prominence to answer a new need. It does not state or narrate some aspect of the photograph; it leaps over facts and adds a new dimension. It combines its own connotations with those in the photograph to produce a new image in the mind of the spectator — sometimes an image totally unexpected and unforseen, which exists in neither words nor photographs but only in their juxtaposition. A fine early example occurs

in *La Revolution surrealiste;* the photograph shows three men bending to look down an open manhole and the caption reads: *"The Other Room."* Indeed, the Additive Caption may be the one of the many rare and fantastic forms those intrepid explorers, the surrealists, domesticated for the rest of us.

Recent domesticated and photographic examples can be found in the late flood of "zoo" books, wherein snatches of ordinary conversation transform photographs of animals into acute burlesques of human behavior, and in Philippe Halsman's wildly successful *The Frenchman,* where between the printed questions and the photographs of one man's facial expressions surprising answers come to mind. The Additive Caption already has performed what seemed the impossible: giving a means of applying the light touch of wit and the penetration of humor to a medium as essentially tragic as what it reflects and which records the unconscious pathos of an attempt to be funny while recording the humor in deep tragedy.

The first two forms, the Enigmatic Caption and the Caption as Essay, are more literary than visual in their aims and techniques. The Narrative and Additive Captions, however, involve a host of problems in the new language of photo-writing.

The Narrative Caption belongs to journalism, and journalism is a collective art. Editor, writer, photographer, researcher, art director, publisher, and to a surprising degree, the public, are all involved in the production of a single photo-story. Who should write what how is the crucial question. For the caption does influence the photograph. John R. Whiting, in his *Photography Is a Language* (1946), pointed out, "It is the caption that keeps you moving from one picture to another. It is very often the *caption* you remember when you think you are telling someone about a *picture* in a magazine." The caption can call our attention to one detail and cause us to ignore others. It can be so *slanted* that different captions can cause us to feel rage, tenderness, amusement, or disgust toward one and the same photograph. We all remember how photographs from the files of the Farm Security Administration, made to arouse our active sympathy toward a huge tragedy happening among us, were *slanted* by the Nazis to convince Europeans that all Americans were or would be as destitute as the Okies. Again, where the public *itself* has been slanted, the caption also takes on a different meaning. The Communists lifted from the pages of *Life* a photo story about a race riot where the text honestly expressed the indignation felt by the majority of Americans. Reprinted with scrupulously literal translations, it became to foreign eyes a damning proof of our much advertised fine speaking and evil doing.

The basic trouble about captions, according to editors and writers, starts with the photographer. His or her aim is to get a photograph so expressive no words are necessary. Indeed, the editors and writers suspect he regards words as a nuisance. Take the news photographer, for example. After rushing to drama or catastrophe (or having it happen to him or her on a routine job), after pushing, persuading, performing acrobatics of body and brain until he somehow manages to sum the

situation up in a single picture, or at least squeeze out a poignant angle of it, then rushing back to develop and in five minutes get a dry print on the editor's desk, the photographer feels he has accomplished a minor miracle and is entitled to at least a cup of coffee and a hamburger. He should now sit down and peck out the essential data on a typewriter? What are the rest of you guys hired for — decoration?

Spot news is spot news; drama and disaster break forth anytime, anywhere, and are uncontrollable and usually unpredictable. The nearest staff photographer will always have to jump, and the responsible staff reporter or editor will have to do what he can. But a fury of haste has descended even on magazines that never handle spot news and that, allowing for major fluctuations in public opinion, might plan nine-tenths of each issue more than a year in advance.

Magazine photographers also have their woes. There is the frantic story conference with the editor, not infrequently by transcontinental or transoceanic telephone, inciting you to photograph a story of terrific importance. By superhuman effort you get it — then more recent events crowd it onto a back page or two or throw it outright into the morgue. There is the story that you personally believe to be absolutely essential to the world's understanding, which, either by editorial whim or publisher's policy, or merely by poor layout and inadequate captions, gets distorted or emasculated.

On a more humble level, there is the new staff researcher, just out of school, whose ideas for stories are as impossible to the camera as to the gorge of the average citizen. There is the "name" writer who arrives before or after you do, when the situation you are working on together has changed, so that photographs and story don't jibe. There is the caption writer who calls you up an hour before your plane leaves for Africa for more details on a story you did on a biscuit factory a year ago. There is the caption material you peck out in mad split seconds in madder places, which arouses yells of "inadequate."

There is the business of becoming what Henri Cartier-Bresson once called a "silkworm" — endlessly loading, exposing, and unloading film, writing data, loading the lot on a plane for New York, and not knowing until you are three weeks and two thousand miles away from the subject whether the second strobe went off. And finally, there is the magnificent once-in-a-lifetime shot, developed and printed by the magazine's laboratory on a contact sheet with seven others, seen by an editor in a hurry, cropped to its detriment, and used as a visual footnote.

Turning the above recital inside out, the trouble a photographer can cause an editor or writer concerned with text and captions may be clearly seen. First catch your photographer. If you succeed, try to get his sympathetic ear about your need for more words.

But an editor or writer has his own peculiar woes, according to Al Hine, whose "Look, Jack, I'm Busy," appeared in December 1951, in the *American Society of Magazine Photographers News:*

In the first place…he [the writer] is engaged in fighting a rearguard action in defence of literacy and the written word. Second, he is not infrequently entangled with his superiors over both the function and the format of the caption itself. Third, he is subject to continuous terrorism, flank attacks, surprise raids and nerve warfare from photographers who consider getting any more information than "somewhere around Biloxi" an asinine imposition by chair-bound freaks….[T]he caption turns into a headlinish appendage of the picture, instead of a editorial unit destined both to help the photograph and be helped by it. Our hero, who, if he is conscientious, may spend some time working out a proper caption scheme for a picture or picture sequence, suddenly finds that his importance has become that of a display typographer. The integrated captions of his series are forcefully replaced by punchier, shorter, bold-type legends, lending themselves to such comic-created sure-fire words as WHAMM! WHOOSH! ZOWIE! and the like….

Fighting our editor alongside these forces is the type of art direction which lays out a page with admirable attention to visual beauty, attention so admirable, in fact, that no space is left to explain what the photographs represent. Or which, due to arbitrary values of photo display, gives the caption writer a space of sixty-four characters in which to list the names of six people and describe the function they are attending, and then allows a space of 960 characters to caption a photograph for which, perhaps, the simple legend "Dawn" would be more than sufficient. For your best caption writer is by no means always a fighter for more caption space. Rather his interest is in fitting the best caption to each picture, and since this may sometimes mean four lines for one photograph and two words or none for another, his pleas become the despair of the tidy mind of the art director. Particularly of the art director who follows the well-nigh universal trend of demanding that all captions fit precisely flush into box-like squares or rectangles.

Needless to say, the art director is convinced the others are bent on the destruction of their own best interests as well as his best ideas, and the researcher knows that he is the forgotten man or woman.

Small wonder that most photo stories emerge with the marks of this brutal confusion still upon them. The miracle happens when out of this minor hell a really great photo story is born. In Eugene Smith's "Nurse Midwife" (*Life*, December 3, 1951), the photographs, words and layout seem natural and inevitable to each other. The photographs are so intense that the photographer and his means of photographing have become invisible. The words are so sensitive an extension of the photographs, and the layout so clear and quiet that we ourselves are there, looking with our own eyes and hearts upon these people.

Another extraordinarily poignant series by Smith, his "Spanish Village," was published by *Life* in four different forms, and a comparison among them illuminates certain aspects of the value and functions of captions. The first presentation was five spreads (ten pages) in *Life*, April 9, 1951; the layout had space and the text and captions were kept sharp and quiet to let the photographs speak. Then *Life* brought out, as a prestige item, eight more reproductions from the one hundred and fifty

photographs Smith had made, published them in a folder with text on the inside cover, but with neither titles nor captions. Compare these eight, which were not used in the first publication, with those which were and a strange fact leaps forth: those first selected were generally incomplete without captions whereas the eight needed neither titles nor captions. Here new light is cast on the photojournalist's ancient sob that his or her best stuff is seldom if ever used. Yet of those I have seen, the three greatest did appear in that first presentation; the *Guardia Civil* received a dominant position in a spread, the *Threadmaker* became a kind of major footnote, the *Mourners for the Dead Villager* was given a full spread. Then the *Mourners* appeared as a subject for a "What's in a Picture" caption essay; sincerely the writer tried to extend our participation in the photograph—and still the photograph spoke more strongly than the words. Finally, in the Memorable *Life* Photographs exhibition, all three of the dominant photographs were shown, with bare titles. And here the *Threadmaker* could be seen in its full stature, at once a village woman at work and an image haunting and eternal as a drawing by Michelangelo of one of the Three Fates.

The main conclusion to be drawn from these comparisons seems to be that a great photograph outlives any words that may from time to time be attached to it, just as a great book outlives many attempts to illustrate it.

To make "Spanish Village," Smith read long and looked long before opening his cameras. In other words, he worked like an artist and a professional. If the trouble with photojournalism actually does begin with the photographer then the solution seems obvious: make the photographer solve it. While photographing, he has within hand's reach the raw material needed for text and caption. *He knows the situation from both inside and outside, because he has to be both in order to photograph.* Often he has a vivid, if immature and untrained sense of words, and the spontaneous phrases embedded in the chaos of his notes express an experience more succinctly than the best deliberations of a writer remote from the event. No one is more concerned about his work than the photographer; until he sees his negatives and prints them, he feels half blind. Why not make him responsible for the whole photo-story in its preliminary state? Give him the time to conceive and realize his job completely. Let him sketch out what is to happen on the pages allotted to his subject. Then editor, writer, and art director will have an integrated whole, however raw, to polish and perfect, instead of a jigsaw puzzle to initiate and assemble.

Just suggest this to an editor, even the most sympathetic, and chances are he will turn to you in shocked surprise. *The photographer? Responsible for text?* Why, an editor, so editors say, thanks God when he finds a photographer with intelligence enough to cover a story and bring back photographs of it, let alone one who can put two words together without falling over them. Photographer responsible for picking out his own best work, as other professional artists do? Why, the photographer, in the editor's opinion, has ridiculous attachments, generally either technical

or sentimental, to the least interesting pictures. His ideal layout is one photograph to a page or even to a spread, either bled or with an acre of white paper around it. (And his most brilliant suggestion for magazine makeup is usually that a whole issue or at least a half be devoted to his latest story—no captions; the pictures don't need any. Just a short introduction about the subject and how he managed to photograph it.)

Well, what is wrong with photographers that this libel is uncomfortably true? Are we people with a profession to measure up to, or are we a set of mechanical eyes unfortunately attached to egos?

Let us not lose sight of the editor, however. As the conductor of this mad orchestra, assembling the photo-story and fitting it to the printed page is his job and his form of expression. Perhaps he enjoys the power of x-ing out sheaves of contact prints, greening the captions, reslanting the text, recasting the layout. Perhaps he likes the battering of a multitude of deadlines. Yet the real power and joy of his job lies in developing his human and physical material and orchestrating it into a balanced scheme and program. Often the original idea for a story is his, and his the inspiration that gives impact to its final presentation. An editor fits the job to the man, he helps the photographer realize his individual gifts. The young medium itself, huge as it is, opens up because of his sensitivity to its needs. In giving the photographer the challenge of full responsibility for his job, the editor helps the medium expand and himself to eliminate a source of frenzy.

This matter of the photographer's resistance to words, however, deserves further examination. Few good photographers are without it; it seems almost instinctive with time. Stieglitz, for example, never permitted so much as a title to appear with its photograph. Actually the photographer objects to words only when they distract from or duplicate what is said in the photograph. We have already stated that to photographers, and a growing number of others, certain photographs need no words because they speak a more immediate language.

THE ADDITIVE CAPTION What kind of photograph, then, needs a caption?

Obviously, one that is in the general as well as the specific sense documentary, where the photographer is primarily an eye witness and secondarily a creator. Where the photograph completely expresses its subject, it scarcely needs a title Where it transcends its subject, words of any kind become slightly absurd. Such photographs, of course, occur in every one of the manifold branches of photography, from snapshot to scientific. Sometimes they are pure accident. More often they represent a culmination of actuality and personality. When enough photographs whose power can be ascribed neither to chance or fact emanate from one man, we call him a creative photographer; he has mastered the medium.

What happens, then, when the caption, or title, is omitted?

Howls of dismay go up from those who feel lost without their verbal crutches or who are too impatient to read anything longer than a caption. In making *Time in*

New England (1950), Paul Strand and I were working out an additive use of text and photographs. Deliberately we confined the titles, which were only handles for reference anyway, to the table of contents in the front of the book. One reader carried his protest against this system so far as to write every title under its photograph—until he discovered that the page numbers were in the table of contents too.

David Douglas Duncan omitted even titles from *This is War!* and raised a storm of criticism. Those who grumbled at no title for a Strand were outraged to find no identification whatsoever in a whole bookful of "journalistic" photographs of the war in Korea. *Modern Photography* leaped to Duncan's defense, asking, in effect, "Why don't you want to read about these pictures, read what the photographer has written about them in the book?" Duncan, whose purpose was to describe what war is rather than the fluctuations of one campaign, wrote from Tokyo:

> ...your review is the first, among the magazines, which tries to understand...as you pointed out, it makes no difference whether it is one hill, or another; this bend in the road, or that; one man or his brother. It is every man who ever carried weapons in actual line combat...the combat of no glory....It is a story, and as such one must read it all the way through. It's strange, you know, but I thought it was so obvious!

Which points out the curious divided state of our literacy at present. Some of us, even professional critics, will not read, and neither will we look for ourselves. In watching people look at *Time in New England*, I observed that the visually minded skipped from photograph to photograph throughout, then went back to the text, completely ignoring the photographs. Those who read both as they came, for whom one medium was as clear as the other, and who could follow the sequence as it was made, were rare. Yet reading the two mediums so that they coalesce into one is difficult at first only because the form is unfamiliar; as in listening to strange music, the strangeness soon disappears, leaving only the music.

Wright Morris, in his first book, *The Inhabitants* (1946), eliminated titles, wrote verbal equivalents for his photographs, and tried to tie them together with a thread of narrative in caption form. The book received the critical acclaim the first book genuinely created in two mediums by one man deserved, but it stands as a valiant rather than a successful attempt to weld the two into one. Time and intensity are as much to be reckoned with in a book as a film; you cannot remember a thread of narrative when you have a photograph to understand, a condensed paragraph or two to read, and the relation between them to consider before you turn the page to pick up the next wisp of narrative. In his second book, *The Homeplace* (1948), Morris wrote a consecutive novel wherein the action in the text, which appeared on the left, seemed concerned with the images appearing on the right. The caption form he eliminated completely.

In the Additive Caption, the basic principle is the independence—and *interdependence*— of the two mediums. The words do not parrot what the photographs

say, the photographs are not illustrations. They are recognized as having their own force. Archibald MacLeish felt this when he wrote of this *Land of the Free* (1938), that it was

> a book of photographs illustrated by a poem....The original purpose had been to write some sort of text to which these photographs might serve as commentary. But so great was the power and stubborn inward livingness of these vivid American documents that the result was a reversal of that plan.

In *Land of the Free,* the poem becomes what MacLeish called a "sound track." It employs the additive principle so that the reader seems to hear the thoughts of the people in the portraits. Other images also become winged, as, with a view across mountain tops: "We looked west from a rise and we saw forever."

Dorothea Lange, who took most of the photographs used in *Land of the Free,* has, as the social scientist Paul Taylor, her husband and colleague, wrote, "an ear as good as her eye." She listened to the actual words of the people she was photographing and put their speech beside their faces. This direct and deceptively simple technique is perhaps even more powerful in the early "job reports" she and Paul Taylor submitted to various government agencies than in their book, *An American Exodus* (1939), where the typography and layout do not fully implement their intention. But here the Additive Caption rises to real dramatic stature. A worried young sharecropper looks at you..."The land's just fit fer to hold the world together." A gaunt woman, worn with work, smiles wryly as she clasps her head..."If you die, you're dead—that's all."

Barbara Morgan's *Summers Children* (1951) is the most imaginative integration of images, words, and layout I have yet seen. Perhaps this is because it is, to its least detail, her own expression; she not only photographed, listened, wrote, and assembled her sequence—she also designed the format, the layout, and the typography, even to setting the type herself. Each spread expresses in its layout the dynamic tensions, rhythms, or moods of its images. The text is handled with a freedom and a lack of formula unusual in photo books. Here the additive principle is used as a thread of continuity, appearing or disappearing at need. A title may serve as a pivot for a spread or as a launching platform for several spreads. A phrase caught from the children's speech suddenly evokes perspectives into our own memories. Many spreads convey their message through images only—and then there is a section where tiny images of children serve as visual gracenotes to their own songs, chants, and riddles.

The additive principle at this stage looks like a whole new medium in itself. Its potentials seem scarcely explored, like a continent descried from a ship.

To sum up this inquiry: A new language of images is apparently evolving, and with it a new use of words. There are now photographs complete without words as there have for thousands of years been books complete without pictures. Where the two mediums meet, they demand that each complement and complete

each other so that they form one medium. They demand also that they shall be arranged so that their visual pattern is clear to the eye, or, when the words are spoken, that what is heard is timed and cadenced with what the eye sees. And we are only beginning. Photography is a young medium, and we who work in it are still pioneers.

Aperture, no. 1, 1952.

Photography Is my Passion

IN 1940, people were still fighting over the question, "Is photography art?" On the surface, at least, it certainly looked as if the nos had it.

Thousands of amateur photographers, the epigones of a once great movement, pictorialism, were still dimly imitating pale schools of painting dead at least a generation. They believed that by imitating the superficial effects of "art" and following the rules and tricks proposed by various charlatans they were producing "art." A few had exquisite taste, but the overwhelming majority preferred as subjects the cute and the sentimental, the crusty old character and the Vaselined nude—all in soft focus. It was duffers' golf, and the back of a print that was thickly embellished with salon stickers was often justly more admired than the print itself.

On the other hand, the more advanced magazines, annuals, and contests featured the horselaugh, the belly laugh and the luscious pinup all in devastatingly sharp focus and, if possible, color.

Small wonder the staffs of most museums, especially those who had been pressured into giving wall space to either the annual salon or the annual contest, shuddered at "art photography." Here and there a radical museum director did penetrate under the surface and dare to exhibit photographs he found beautiful and dynamic, but his kind were rare and few. So were the galleries that occasionally showed photographs for sale. The two or three who had hailed as art the abstractions and experiments of the 1920s—which again were imitations—had found they weren't "art."

The photographic industry was luring the snapshotter on with fast, precision-built miniature cameras that required an entire new panoply of related gadgets from developing tanks to enlargers. New fast films and flash, even strobe equipment, were coming out, and color, gaudy-bright, was the rage.

Movies were booming, with sound and color, though aficionados mourned the death of the silent black-and-whites. TV was still in the experimental stage. Newspaper photography of the crash-and-flash variety, was beginning to decline, though there were many who praised it still. And a young giant, photojournalism, was flexing its muscles, adapting new and old techniques to its purposes, working

15. Nancy Newhall, *"Lake Eden,"* Black Mountain College, 1946
Ansel Adams, *Alfred Stieglitz and Nancy Newhall, An American Place*, New York City, 1944

out worldwide logistics and evolving the philosophy of the "mind-guided camera," which meant that the photographer was reduced to being the "eye" of the editors.

He or she went where told, tried to photograph according to instruction, and if they disagreed on arriving in a war-torn London or Tunisia, wasted a lot of time noting what really was going on. Still, it was an exciting, highly adventurous life; it had glamour and it paid well. And the gifted young photographers who eagerly entered it soon realized that the editors, writers, and layout men as well as themselves, were all producing too much for quality, and all headed for that terrible whirlpool, the deadline.

Commercial photographers, who were being paid thousands of dollars for a well-staged advertising shot (when Edward Weston was asking fifteen dollars for a print), were crying into their Bourbon that they had sold their souls, and not even beautiful young wives could compensate for the loss. Most photojournalists were soon to join them when they discovered how fatal was the speed and facility demanded of them and how rarely their best work appeared. Yet both groups took great pride in their magnificent competence and in their demanding professions.

Schools of photography were trade schools where slick and shallow formulae for success in fashion photography, portraiture, advertising, illustration, and so forth were taught. So were the specialized skills by which one became a laboratory technician, a helot in a basement copying paintings or detecting fakes, an automaton meticulously recording the discoveries of science, or a chemist working out the permutations of a process or theory. It might not be art, but at least you could eat.

Art critics, with few exceptions, railed against the "machine," and "photographic realism" was the depth of opprobrium. Art historians, again with few exceptions, regarded photography as beneath contempt. It had debased public taste and driven the artist into abstraction. It was the lowest common denominator. To prove how great was some painter's power of organization, you stood in the same spot where he had pitched his easel and took a weak and hasty snapshot for comparison.

Was there a college that would stoop so low as to offer a course in creative photography on the same level as courses in painting or poetry, for credit? Answer: *none*. Was there a university that would grant a degree to even the most brilliant thesis on the history of photography as a fine art? Or even photography as a rich source for historical research in any field? Or the impact of photography, the first and overwhelmingly the most important of the mass media, on world history? A course or seminar inquiring into the influence of photography on the major movements in art during the last century and a half? Or the many different uses and inspirations painters such as Delacroix, Degas, Gauguin, Duchamp, Picasso have found for and in photography? The last, of course, would have been classed as heresy, except by the painters themselves. Reality, motion, distortion, the accidental, the uncanny juxtaposition of images—what artist with a questing mind could pass these by? And the revelations of the invisible world—ignore those strange, beautiful structures and movements? Or fail to hail as equal an artist whose vision and craftsmanship are astounding just because he works with a "machine"? Is a camera any more a machine than a violin? If so, what is wrong with

machines? In the 1920s and 1930s there was a passionate debate about machines, one side exalting the functional beauty of, say, propeller blades and the benefits to all of designing for machine production simple everyday objects, the other side, of course, emphasizing the thumping monotony, the endless reiteration, and the colossal waste both of materials and of human beings.

On the surface, then, in 1940, it was Walpurgisnacht, phantasmagoria.

Like ostriches, most of those involved in these masques of delusion were trying to ignore the dynamic forces working beneath the surface and the warning signs of change that were becoming more and more insistent throughout the 1930s. Not that these forces were united—far from it. Nor would they have agreed that the signs which seemed to them so wildly divergent were all pointing in the same direction.

On the West Coast, in 1932, a few extraordinary photographers—Edward Weston, Ansel Adams, Willard Van Dyke, Imogen Cunningham, and others—decided to call themselves *Group f/64,* after one of the smallest lens apertures that can render overall sharpness. It was their protest against the maudlin mush that flourishes so lushly in southern California, and it was the peak, the acme, of the purist movement, which had been growing for some twenty years on both continents. A sympathetic museum director in San Francisco gave them their first shocking, iconoclastic show. Adams and Van Dyke constituted themselves "the Sanitation Department," wrote, lectured, and tried to clear up the muck in the salons. But, like the older purists, Stieglitz, Steichen, Strand, and others, they knew that sharp focus alone could never be enough: to make a photograph really beautiful, a thing like music or poetry, both of which are much closer to photography than painting, one must reach beyond the literal into the spiritual and emotional. So, having made, with fireworks, their point, they all returned to their own individual quests in search of revelation.

In Europe, an entirely different kind of protest was developing, based on the speed and agility offered by the new miniature cameras. Henri Cartier-Bresson could lasso an instant of time, and the cry, the menace, the joy were caught in subtle lines, juxtapositions, accents. Brassaï, too, could now look, with what Henry Miller called his "cosmological eye," at Paris by night and absorb it in all its loveliness and squalor, the cafés, the brothels, the street fairs, and the drunks down by the Seine. Photographers in Europe, following dada and similar movements, had intense disdain for the fine print. What a waste of time, when the corner drugstore could make glossies that, after all, were merely hyphens between negative and publication.

So the Americans in general thought the Europeans were just making "lucky snapshots," and the Europeans complained that the Americans were making "still life." As Cartier-Bresson discontentedly asked, "Why do all the great West Coast photographers photograph *stones* ?"

Somewhere between these two extremes, there sprang up, in response to the frightful human needs of the Great Depression, the documentarians. The movement, age-old among painters, was worldwide and, in photography, almost a century old: Brady's men, Riis, Hine, and the recently appreciated Atget. In America, it came to its peak in a U.S.

Government agency, eventually known as the Farm Security Administration. The doctrine of the hell-with-the-artist-and-all-art was again an old one, and it was quite a few years before documentarians on all continents woke up to discover that their most effective and eloquent spokesmen were truly artists: Dorothea Lange, for example, who brought you face to face with the migrants, the homeless, the jobless, in all their pride and anguish; or Walker Evans, who brought you the pitiful interiors, the ramshackle stores and churches, the dreary, smoggy factory towns, the clutter and the junk with a poignant clarity. But the documentarians were yelling at the so-called "great" purist photographers to forget "art" and come down from their ivory towers for the sake of suffering humanity.

WHAT IVORY TOWERS? The so-called purists might have shouted back. Most of them—particularly the "great S's" Stieglitz, Steichen, Strand, Sheeler—were no longer speaking to each other. Each had gone his separate way: Steichen had gone into commercial photography, whose prices and standards he had transformed, and he now thought himself retired, back among his beloved plant-breeding experiments; Strand, except for a vacation interlude now and then, was working in documentary movies; Sheeler was, for the most part, painting. And Stieglitz? He was still Stieglitz, a thunderstorm, the most extraordinary force that ever fought for art in America. In his seventies, frail and harassed by various illnesses, he was nevertheless to be found daily, high in a skyscraper on the corner of Madison Avenue and Fifty-third Street, in a little gallery he called *An American Place,* where space flowed coolly and paintings and photographs glowed like jewels on the luminous walls.

And he was still fighting—especially commercialism in all its hydra-headed forms, which he was convinced was strangling America, physically, emotionally, and spiritually. If a young photographer he had once considered promising brought him new work pandering to commercialism, and apologized that he had to make a living, Stieglitz would mercilessly ask, "Why?" If a wealthy patron asked the price of an O'Keeffe, a Marin, or a Dove, he would ask, "How much are you willing to give the artist?" Pressed for a price, he would name one the prospective client often considered preposterous. "Why, I can get a Cézanne watercolor for that!" Stieglitz, who had first championed in America Cézanne, Matisse, Picasso, Brancusi, Nadelman, and many others, not to mention African sculpture and children's drawings, when they all were unknown here, wanted to know why a Cézanne was necessarily superior to a Marin? Because Cézanne was French? It was this snobbish tendency to overlook American artists that had caused him to call this little gallery An American Place. And why was a painting in oils necessarily superior to a watercolor—or a photograph? For Stieglitz, *there were no arts, there were only artists.* And why shouldn't an artist earn, through the sale of his finest work as much, say, as a plumber? If one of his own photographs was sought, he accepted nothing less than a gift of $1,000 to An American Place. Nor would he sell one of Paul Strand's magnificent platinum prints for less than $500. Since Strand's departure for Mexico, he had shown no photographs except, once in a while, his own.

At one little show, of his New York photographs, in 1932, a very tall, very thin young man was standing transfixed. Beaumont Newhall, an art historian already involved in that despised subject, photography, was hit where he lived. There is no way to describe a Stieglitz photograph. There are no tricks, props, mannerisms. You feel that it is alive, that you are seeing the truth. Newhall was almost too moved to speak, but when the little old man with the wild white hair and the long black cape, the greatest photographer in the world, swung toward him, he felt he should say something. Art historians are trained to be impartial and should never show emotion or enthusiasm. So thinking to show he was himself a photographer, he asked, "Mr. Stieglitz, did you use a G filter on this sky?" Thunder and lightning! — it was like asking Michaelangelo what size chisel? There was some consolation for Newhall in that a fellow art historian, then director of the Museum of the City of New York, got an even worse blast that afternoon when he asked for proofs or copies of these photographs for the museum's historical files.

Art historians might know the whole pantheon of major and minor works of art since Sumeria or the caves of Altamira and could with learned delight discuss in several languages why who could not have done what when and where. But *artists!* —those living men and women, explosive, unpredictable, irrepressible, sometimes slovenly, sometimes fanatically immaculate in diet and dress—well-bred art historian shuddered and fled, with his hands over his ears lest some of their eloquence and very plain speaking might pollute and prejudice his calm and endless delight in the dead. Both Newhall and his colleague had just been seared by a very great live artist. They had a lot to learn. Especially about photography and photographers.

Scarcely more than a block away from An American Place, across Fifth Avenue, was the Museum of Modern Art. The young men—and they *were* young, still mostly in their twenties and believing nobody over fifty should have anything to do with modern art—were literally blasting out the walls of the handsome old family mansion one of their many wealthy trustees had given them. They had gutted the place of all but sustaining walls. They had designed movable walls that were freshly painted for each exhibition, and movable lights, so that each show was an entirely new experience in space, light, and color. They were scholars and showmen. The place was a perpetual first night, and wives and husbands came in to help in those last frantic hours before an opening. Those shows drew such crowds that they choked Fifth Avenue, and on one occasion, when there were some five thousand people in the old mansion, firemen had to bar the doors; you could enter only after others left.

Yet there was scarcely a show that Stieglitz hadn't pioneered some twenty years earlier, or an artist of major stature whom he had not introduced to America. Wherever those hard-driving, pelting young men went on their intellectual journeys, they seemed always to meet Stieglitz coming back. This fact infuriated both parties, for the young men were art historians and would not accept what they called

Stieglitz's "mystique." And Stieglitz, on his side, regarded them as misled and mistaken, working for their stark ideals twenty-four hours a day without real love, wisdom, or compassion. When they found, as they frequently did, that a key early work was in Stieglitz's personal collection, they had a very hard time getting Stieglitz to lend it. He did not like lending beautiful things in pristine condition and getting them back marred and dirtied. So sometimes the museum had to send one of its trustees, most of whom Stieglitz had known for years, to beg and parley. Even so, the trustee might come back battered—and empty-handed.

Stieglitz had not acclaimed a new artist in any medium for some years, and in photography not since 1915, when he welcomed the young Paul Strand as "the man who has actually done something from within. The photographer who has added something to what has gone before. The work is brutally direct. Devoid of flim-flam, devoid of trickery....These photographs are the direct expression of today." Stieglitz *was* old now, and frail. He said, of his declining energies, "If I have only one loaf of bread, and divide it into a thousand slices, who will get fed?" He could still feed hundreds with the loaves and fishes of his spirit, but providing actual food for the three or four artists in whom he most believed took what energy he still had left.

So he was not pleased when, on a very rainy day in March 1933, a tall young man with a black beard came into the Place with a portfolio under his arm and a letter of introduction in his hand from a kind San Francisco patroness, who was distantly related to Stieglitz. Stieglitz had heard about this young man from Marin, O'Keeffe, and Strand, all of whom had met him in New Mexico. They said he was a mountaineer, a brilliant musician, a wit, a clown, a poet, and a photographer who had already two exquisite works to his credit, one a portfolio and the other a book, both of original prints. He was also a founder of Group f/64 and doubtless therefore a follower of Edward Weston, whose work Stieglitz had never been able fully to accept. Charming charlatan? Or "ismist"? Purist and doctrinaire? Stieglitz thrust the letter into his pocket, insulted his distant relative as a woman who had nothing but money, told the young man to come back later, and turned away.

Ansel Adams would have knocked him down—but the turned back was so little, so old. Glasses, too. He went out and pounded the wet streets in a fury. So that was Stieglitz!—the old unprintable! (Adams has a command of invective a keelboat man might envy.) What could Marin and Strand have seen in him? How could Georgia O'Keeffe have married him? Damned if he'd go back! But—Stieglitz? *Stieglitz?*— he went back.

Stieglitz opened the portfolio in silence. Adams roosted on the radiator, the one chair in the Place being the camp chair in which Stieglitz was sitting. The silence went on and on, broken only by a rustle when Stieglitz replaced a tissue or by a knock in the steam pipes. Finally Stieglitz closed the portfolio and tied its bows neatly. Adams thought, That's that, and started to descend, nicely grilled by this time from the radiator. But Stieglitz was untying the bows and going back, long and

searchingly, over every print. It is not too difficult to surmise what he was thinking: how can I take on the life and family of this young man?—for that was what an accolade meant to Stieglitz: not just a show but a whole life. But how can I fail to acclaim this marvelous quality, this new vision? Finally he closed the portfolio, tied the bows again, and looking up with those infinitely deep black eyes, said, "Some of the most beautiful photographs I've ever seen in my life."

It was the beginning of a new era, this meeting of two extraordinary forces. Neither ever yielded to the other: Adams could never persuade Stieglitz to come West (for Adams the center of the world) nor send his photographs there, not even to the little gallery Adams himself ran for a while. And Stieglitz could never persuade Adams to come live in New York (for Stieglitz the center of the world) nor abandon making his living by commercial jobs, and devote his life to carrying on the expression of the human condition where Stieglitz, in his Equivalents, had laid it down. There was a deep affection between them always, so deep there were many things they did not need to say to each other. And a delicate, stately courtesy, whose aspects of comedy both enjoyed.

In the spring of 1935, Newhall received from the Studio Publications for review their newest how-to-do-it: *Making a Photograph* by Ansel Adams. On its cover a great thunder cloud towered into the dark sky of high altitudes. Inside, the tipped-in varnished halftones looked like original prints—the finest reproductions of photographs Newhall had ever seen. What pure and intense vision—what a revelation of the world! Again Newhall was hit where he lived. The text was a clear, explicit exposition of straight photographic technique—classic, no tricks, no evasion. In the Introduction, there was this paragraph:

> What is required above all else is a number of centralized institutions which combine competent instruction in theory and practice with library and museum features. Repositories of the most significant photography, past and contemporary, are sorely needed. The understanding of photography as a form of art implies much more than a knowledge of physics and chemistry and a superficial education in the aspect of painting and other media. *It is necessary to study photography itself—*

Titles meant little in the museum of those days; Newhall had scarcely seen his library when he found himself helping the director, Alfred Barr, hang the blazing van Gogh show, where Vincent's letters to his brother Theo appeared beside the paintings. Newhall's passion for photography was neither unknown nor unnoticed, especially after he started doing some photography for the museum and set up a darkroom on a marble ledge in the men's room.

In the spring of 1936, Barr asked Newhall to organize a show of photography; it would fill all four exhibition floors of the old mansion and require the usual scholarly historical catalogue. Newhall, in great excitement, rushed over to Stieglitz: Would he head the advisory council of this epochal show—the first major show a major museum had presented since Stieglitz himself had directed the death song of the Photo-Secession at the Albright Gallery in Buffalo in 1910?

Stieglitz refused, of course. No—he would not let the show and catalog be dedicated to him. Nor would he lend any of his own photographs except perhaps some 1908 experiments in color. And of course the early photgravures were in the public domain. Bitterly hurt, Newhall asked Steichen, once Stieglitz's "great collaborator," the man who sent him from Paris the Rodin drawings, the Cézanne watercolors, and so on. Steichen accepted. Curiously, the American photographer who was the most help of all was that San Franciscan, Ansel Adams.

Newhall, like most art historians, was biased in favor of Europe, and while he asked Adams and Weston and other westerners to send in their work, he was himself in Europe, collecting, when Stieglitz in the fall of 1936 installed Adams's photographs on the walls of An American Place. Newhall thus missed meeting Adams, too. But the museum show!—a huge lens faced you as you entered; behind was a true *camera obscura* literally "dark chamber," into which you could walk and see, upside down on a large ground glass, people entering through the door. Then, in a dim room, there were the daguerreotypes glittering on red velvet—Southworth and Hawes!—and beyond them, in a blue wall, the illuminated calotype negatives of Le Secq, with prints Steichen had made from them. The show was like a spiral curving up through photographic history—the Hills, the Bradys, the Camerons, the O'Sullivans (thanks to Adams), and so on. There was a brilliant wall, lighted and installed by Paul Strand himself, of his rich deep photographs. There might be an overproportion of Europeans of the miniature camera school—Newhall had been very excited by their seeing. Adams, Weston, Brett Weston, and so on, were all there, not as well selected as Newhall could have done had he himself gone to the West Coast. Then every other aspect of photography—news, scientific, with the X-ray of a whole woman standing in a doorway. The museum had done it again. And the catalogue, begun on Thanksgiving Day and published on St. Patrick's Day, was hailed by Lewis Mumford as the best short critical history he knew in any language—except for "the amazing omission" of Alfred Stieglitz. That catalogue has, as of 1970, gone through four editions and a paperback. It has been translated in French and Japanese. It is the one publication the museum has never allowed to go out of print.

The year 1937 was an important one for photography in other ways: Edward Weston was awarded the first Guggenheim Fellowship ever given a photographer. And *Life* and *Look* were founded. Photography was cracking through a few crevices.

The entrance of David McAlpin into this story has its amusing aspects. McAlpin had been excited by photography ever since he was, at the age of ten, given a Brownie, nor had he ever lost his excitement, while serving a year and a half in the navy during World War I, getting his thus delayed A.B. from Princeton in 1920, going to Harvard Law School, and coming out with not only a L.L.B. but a J. D.—Doctor of Jurisprudence. Courses in history at Princeton, under his very good friend, Professor Clifton R. ("Beppo") Hall led him to start collecting

etchings. Then Beppo introduced him to Stieglitz and O'Keeffe. McAlpin became devoted to them both, acquired some beautiful O'Keeffes, and started collecting fine photographic prints.

One winter night, early in 1936, David McAlpin was escorting Georgia O'Keeffe up the aisle of a Manhattan movie house on Fourteenth Street when a man with a black beard shot up out of an aisle seat and clutched O'Keeffe. McAlpin squared off in navy fashion to defend the lady, but the results of this contest will never be known. For the woman clutched the villain back again and turned to her defender in delight. "Dave, this is Ansel Adams!" So they all went uptown to the hotel where Stieglitz and O'Keeffe were living and looked at Adams's new photographs. Stieglitz was so moved he asked Adams for a show in the fall.

McAlpin became an ardent collector of Adams's prints, and what excitement when Adams led him, O'Keeffe, and some of his Rockefeller cousins on photographic and sketching safaris through the Southwest and the Sierra Nevada! What unforgettable days and nights! What a pity Stieglitz would never join them. McAlpin formed the habit of sending photographers whose work he loved, such as Adams and Edward Weston, to whom Adams introduced him, a thousand dollars a year. Sometimes he asked for prints he especially wanted, but more often left it to the photographer's own judgment. (I remember one sloppy winter day in Washington, late 1942; McAlpin had the rank of commander in the navy and was furious that he had been assigned to desk duty.) Newhall, first lieutenant in the Army Air Corps, photo intelligence, had no idea when he was going to be shipped out or to where. And so that miserable day, McAlpin said, "Bring out the black velvet! Here come the jewels!" And they were. Pure and exquisite, mostly little contact prints, by Adams, they said so much to us that day of dire foreboding. It was like hearing Adams himself play Bach. But that experience comes later than this story and belongs here only as a record of how deeply photographs that are poetry and music can delight and solace (to a degree, indeed, that few artists in any medium can achieve, to a degree also that the combat cameraman can seldom achieve, though he may be dying himself and the last films found in his camera, if it survives, are of mortal agony.)

Newhall's catalog was sold out, and he had learned so much that needed to be written down! But most of all, for the next edition, he hoped for a Stieglitz photograph. He told both Adams and Mumford why Stieglitz had refused. Both responded to his plea. Stieglitz certainly could be unreasonable, especially about "institutions." Newhall's questioning about how photographers felt toward just such a centralized institution, as Adams had proposed, with a collection of fine photographs and important books, sent Adams leaping to the typewriter. He wrote to dozens of people; he defended Newhall even against Stieglitz; he urged McAlpin to get in touch with Newhall, whom he himself had not yet met, but whose sound, to him, was of integrity, sincerity, and intelligence.

That spring, Stieglitz was so ill he did not expect to live. O'Keeffe called

Newhall: "You *must* come. He's fussing and fretting about that photograph you want for your book. Of course you won't get it, but come take it off his mind." Newhall stood at the foot of the little bed. "Your decision," said Steiglitz, about the choice of frontispiece and the dedication to him. And then told Newhall that he and Adams had a responsibility to assume: his mantle as the leaders of photography. Both received this inheritance in deep humility, almost in tears. But Stieglitz did recover, to be as exasperating, frail and wonderful as before.

McAlpin's first reaction to Adams's plea was characteristic: he gave to the Print Department of the Metropolitan Museum of Art and to that young man at the Museum of Modern Art a thousand dollars each for collecting fine photographs. Then he sat back and waited. Five years or more later A. Hyatt Mayor at the Metropolitan had a good part of the thousand left; he had bought cagily — Hills, Bradys, and so on. He said, "What's the hurry? Everybody will leave the Metropolitan everything in due time." Newhall *was* in a hurry and nearly every week was excitedly on the phone to McAlpin about a possible new purchase. McAlpin became excited, too, and talked to his cousin, Nelson Rockefeller, about founding the new department.

It was all right with Nelson if Dave would raise the money. He himself had assumed much of the financial burden his mother, Abbie Aldrich Rockefeller, had so quietly and sweetly borne. If, in the museum, you were really in need of help, on something as uninteresting as salaries, for instance, you called "Mrs. R." and she was instantly helpful. Nelson was different; he couldn't see why anything as spectacular as the Museum of Modern Art couldn't pay its own way. It was already doing well with its publications, traveling exhibitions, and film showings. As for photography, certainly that wealthy industry should be able to contribute. So McAlpin became a trustee of the museum and was elected its treasurer.

Newhall, Adams, and McAlpin all wanted to announce the new department with a retrospective show of Stieglitz. It was to be, absolutely and completely, down to the most trivial detail, the way Stieglitz wanted it; the catalog would have magnificent reproductions whose making would be supervised by Adams. Newhall and any needed forces from the museum would help him in any way he wished or needed. Stieglitz yielded, under such combined pressure and, with Newhall, started sorting out his lifetime's work. Anybody who has tried doing something like that about himself knows what excruciatingly hard work it is, even with sympathetic, expert, and dedicated help.

Then Alfred Barr precipitated a crisis. Under the new management Stieglitz had loaned a 1911 proto-cubist sculpture by Picasso to the museum for its Picasso retrospective. Stieglitz said it was shown at "291" in the first Picasso show in America; Barr had his art historian's doubts and wrote in the catalogue, "probably." Furious, Stieglitz broke off relations with the museum and canceled his show.

Newhall, Adams, and McAlpin were very disappointed: the show not only would have announced the new department, but would have been one of three — Frank

Lloyd Wright in architecture, David Wark Griffith in film, Alfred Stieglitz in photography. They could all realize that Stieglitz's protest was really a pretext; that he really did no longer have the physical energy nor creative force to go through his own stuff and make a magnificent show out of it. Yet he would allow no one else to make it, and all agreed he was right. So now what?

McAlpin felt that, with World War II obviously about to involve the United States soon, they should get going anyway—and at once. Adams was one of the few "great" photographers still speaking to everybody—well, almost everybody. Adams and Steichen were chemically allergic to each other and shot off sparks whenever they had to meet—came on, at McAlpin's request, to help enlist support for the proposed department.

Together or separately Adams and Newhall went to see a lot of people in the arts and sciences. It wasn't easy. The Museum of Modern Art had made a lot of enemies by its radical intrasigence and its refusal to bow before local and temporary idols. It might have pried a Marin show out of Stieglitz, but there were hundreds of painters, sculptors, and so on in New York who felt they equally deserved such a dazzling honor. Photographers too—not a single salon winner in Newhall's 1937 show! And no advertising—not a single commercial photograph! Photographers whose fame and fortune might lie in their commercial achievements were indeed represented—but only by their personal work.

Well—they hadn't raised enough money to fund the new department decently, but McAlpin, Adams, and Newhall decided the moment was imperative. So they whipped up an exquisite little show, *Sixty Photographs,* and they didn't care if the space was small—it was at least large as the Place—nor that the life span of the show would be only two weeks. It was an announcement!

Adams had to get back to Yosemite, so it was "tall, gangling, scholarly" Newhall and "balding, snap-eyed" McAlpin whom *Time* featured in their report of the founding of the first Department of Photography as a Fine Art in the world.

Stieglitz made the most important comment. He came, with McAlpin at his elbow, and went around the show with Newhall. It is interesting that his insight was still so penetrating that the prints he did not like were by photographers who have since dropped out of sight—and that he felt there was an injustice to Steichen, who was represented only by the photogravure of the portrait of J. P. Morgan.

In the elevator, on his way down, he met Alfred Barr. They greeted each other cordially, of course, being old friends and enemies, and then Stieglitz said, "He has committed the museum to photography, and that is more important than either you or he yet know."

Now it is 1970, thirty years later. Stieglitz is dead, and his ashes lie somewhere under the clouds he loved on the shores of Lake George. But he will never be dead to anyone who knew him, nor to anyone who comes, even briefly, in contact with his spirit. For his mantle fell not only on Adams and Newhall, who have carried it nobly, but on many others: first, Georgia O'Keeffe, who, as his wife, was executrix

of his estate and saw to it that collections of his photographs are in the National Gallery of Art in Washington, the Chicago Art Institute, the San Francisco Museum of Art, the Metropolitan Museum of Art, and the Museum of Modern Art. Both of the latter had managed, thanks to the generosity of donors like David McAlpin, to have some of his photographs in their collections already, as did the Boston Museum of Fine Arts and the Cleveland Museum of Art. Second, the mantle fell on Dorothy Norman, who asked everyone for their letters, had the letters copied, and then arranged that the whole archive, a vast one, be deposited in Yale University. Recently she founded the Alfred Stieglitz, Center at the Philadelphia Museum of Art by giving them her personal collection of works by Stieglitz, Adams, Marin, O'Keeffe, Strand, and many others. And the mantle has also come to lie on Minor White, who knew Stieglitz only in the last few months of his life, and even, most humbly, on myself. David McAlpin, through all these thirty years, has gone on helping— helping Edward Weston, during those last terrible years when he was stricken with Parkinson's disease, make his great archive of eight sets of some eight hundred photographs that he considered his best; giving photographs to the Art Museum at Princeton as well as, in memory of his friend Professor Hall, some three hundred etchings and engravings, including nine Rembrandts, sixteen Dürers, and a set of Schongauer's woodcuts of the Passion; giving the Museum of Modern Art their choice of his personal collection of photographs, again some three hundred, and giving the rest eventually to Princeton; getting illustrious people in photography to lecture there, and now assisting in establishing a course in the history of photography to be taught by Peter Bunnell, who was trained by Newhall, got his M.A. at Yale while organizing the Stieglitz Archive, and is now curator of photography at the Museum of Modern Art. Bunnell has a touch of the mantle, too.

Is there a major art museum in this country that has not shown a major exhibition of photographs on its walls during these last thirty years? None that I know of. Is there a college or university where a course in creative photography is not offered? Long are the lists of institutions that have important collections of photography, that teach photography as art history, with discrimination and in depth, and that offer graduate degrees in creative still photography. Long also are the lists of awards and honors that photographers have received from other than photographic societies. Any photographer of stature has multitudes of honors from the photographic societies. Stieglitz, for instance, received more than a hundred first prizes, gold medals, honorary fellowships, and the prized Progress Medal of the Royal Photographic Society. Ansel Adams has undoubtedly had as many or more, plus awards from conservation societies and a secretary of the interior. So has Steichen, who, with his military decorations and the Medal of Freedom is perhaps the leading prize and medal winner of them all.

Beyond question, the most important single achievement in these years is the International Museum of Photography at the George Eastman House, Rochester, New York. Rochester is "Siberia" to most travelers, but hundreds of pilgrims come

to George Eastman House across all seas and continents each year. Beaumont
Newhall, its curator since its founding in 1948 and its director since 1958, has built,
on the foundation laid by Cromer and Kodak's own collection of cameras and other
apparatus, the greatest museum of photography in the world. The depth and scope
of its collections in every period and in every aspect, art, cinema, science, and
technology, are something Newhall himself would like to spend another twenty
years exploring. The curatorial staff are almost all dedicated photographers
themselves. Exhibitions by the George Eastman House have traveled throughout
this country to Canada and Japan. Its publications have been wide ranging: from
one-man and annual survey catalogues of contemporary photographers to *The
Daybooks of Edward Weston,* which I edited, and rediscoveries of movements
and artists, such as *The Photo-Secession* by Robert M. Doty, the portfolio *Alvin
Langdon Coburn* by myself, and *Frederick H. Evans* by Beaumont Newhall. The
exhibition *Photo Eye of the Twenties* and the film series *Kino-Eye of the Twenties,*
both directed by Newhall, were done with the collaboration of the Museum of
Modern Art.

The Department of Photography at the Museum of Modern Art now occupies
most of a wing, ably directed by the sensitive and courageous writer and photogra-
pher, John Szarkowski. Steichen, the previous director for some fifteen years, there
demonstrated his belief that photography is a potent form of communication
between man and men, especially in his world-famous show, *The Family of Man.*
Steichen, as he has said, is no longer interested in photography as an art, and proba-
bly he never was in the history of photography, in which he plays a major role.
Under Szarkowski, we can again look at *photography itself.*

And Adams? It was his incredibly beautiful books—*Sierra Nevada, The John
Muir Trail,* 1938, his "bound portfolios"—his own *My Camera in Yosemite Valley,
My Camera in the National Parks,* and Edward Weston's *My Camera on Point
Lobos,* all done in the late 1940s—that started off the boom in fine books by and
about photographers. They proved not only that reproductions scarcely distinguish-
able, even by an expert, from an original print are possible now and here in the
United States, but that such expensive books definitely have a market. Is there a
serious young photographer today who hasn't managed to acquire a notable library
of such works? Adams and I touched off a further extension of this field when we
did *This Is the American Earth,* first of the Sierra Club Exhibit Format books,
which are concerned with the threatened beauty and life of this planet.

It was Adams again, with his *Portfolio I,* dedicated to Alfred Stieglitz and
actually a series of equivalents to the experience of knowing him, who proved to
photographers that portfolios of original prints were viable. Edward Weston, Brett
Weston, and Minor White are among those who have found out that, while such
portfolios and books may not be howling financial successes, there are enough
ardent collectors to pay the costs and reward the photographer for the long, patient,

and excruciatingly exact labor of making them. For they demand the ultimate in discipline and control.

Another trend Adams precipitated is the workshops, which have proliferated all over the country—Florida, Washington, Oregon, Colorado, for example—and which may last from a weekend to two months. Most of them center about contact with a creative photographer or two and their ideas and techniques. Adams's own workshop, held in Yosemite each June, is the oldest and most famous, and justly, for the combination of Adams and the different delights and challenges offered by Yosemite National Park is one that people return to again and again. For many it has been the revelation that sets them off, for Adams, as he says, "simply loads the table and lets each take what he needs or wants."

One of the most unusual workshops is *Words and Images: The Making of a Photographic Book,* conducted at the University of California at Santa Cruz each July by Adams, the Newhalls, and Adrian Wilson, typographer and book designer. In twelve days, some forty or more people photograph, research, write, and design a book so that it is ready for presentation to a publisher. Two of these productions by students have been actually published, and one, on the problems of the aging, was bought by the Office of Economic Opportunity in 25,000 copies for distribution throughout the country.

Three interesting societies have been formed in the 1960s. The Society for Photographic Education now numbers some two hundred members and holds frequent conferences and symposia. Members of the Photographic Historical Society are ardent collectors of cameras, delightedly discovering what elegant and ingenious extensions they are for the human eye and hand. And the Friends of Photography is exactly what it says it is. It is a young society, founded on New Year's Day, 1967, by Ansel Adams, Brett Weston, Wynn Bullock, Rosario Mazzeo, the Newhalls, and others. Through its little gallery in Carmel, California, it is bringing to the West Coast photographers, some old and some very young, it may not have seen before. Moreover, it brings out handsome portfolios of reproductions for those who live too far away to attend its workshops, lectures, and demonstrations.

And then there is *Aperture,* vanguard quarterly founded by Minor White in 1952, with the enthusiastic cooperation of Adams and the Newhalls, who had been talking about starting such a magazine for years but had never gotten around to it. *Aperture* has published many monographs on photographers, young or old, and is now issuing them in books, the latest being on Minor White himself; his protests were overruled. It is also republishing famous but out-of-print books and portfolios, such as Paul Strand's portfolio of *Mexico,* fine reproductions personally supervised by Strand.

This tendency to reprint, in new format, or in facsimile, is widespread; many different houses are now bringing out reprints, some because, like Fox Talbot's *The Pencil of Nature,* the first book illustrated by photographs, they are almost impossi-

ble to buy at any price and you can only peek at them in museums or the rare book rooms of libraries. Some because, like *American Exodus* by Dorothea Lange and Paul Taylor, they are important records of a period that again needs reexamination but which, at the time, were lost in world events, in this case, World War II. One publisher even made a valiant attempt to reprint *Camera Work,* Stieglitz's unparalleled quarterly, but that is impossible, probably, under present conditions; where now is the Japan tissue so tenderly tipped in the backroom of "291" by friends or the variety of reproduction processes? Stieglitz was, briefly, in the photoengraving business and knew how to incite engravers, whether in Germany or in New York, to heights they did not know they could achieve. This surge in reprints or new editions is due to the enormous wave of interest in collecting photography.

Adams, I believe, is probably the only photographer who at present could live on the sale of his prints alone. He doesn't, because his professional abilities are much in demand, and it is hard to turn down old clients who refuse to be content with the young photographers he recommends. So, for most young graduates, the choice is journalism, commercialism, teaching, or working in a museum. There is a greater demand for the last category than there are young people qualified. For only museums such as the George Eastman House and the Museum of Modern Art will bother to bring up a young intern. Most museums do not know enough to help them anyway, and want their curators readymade and wound up to go. So most young photographers go from the lecture room and the workshop to set up as teachers. Therefore, we who were once the young fighters and are now the old fighters—to whom it is funny that we are considered "the Establishment"—find the present teaching of photography repetitious and dull. For all the vast recognition of photography as a medium and an art, don't these young and dedicated people yet know that the imitation of other arts is leading them only back to neo-pictorialism, the old parade of egos Stieglitz and Steichen both left around 1910?

Don't they also know, these young teachers, that, to help students, you have to be more than one jump ahead? That you must bring them yourself, full of all you have known—in this field, you *must* be a photographer—full of desire and delight to share with them the excitement and experience you have had? That is the contagion, that is the importance.

George Bernard Shaw, himself a very poor photographer since he never got exposure, development, and print to flow together, wrote a witty piece about how much more difficult photography is than painting. He wrote only to annoy because he knew it teased his fellow critics. But, essentially, he is right. For you can hide behind the sensuous pleasures of paint or phony up a sculpture with diverting accidentals.

Any craft or profession has its delights, its smells, its tools, and its touches, as well as its agonies and exaltations of the spirit. In every such voyage, in any medium, the artist must discard old images, those of his teachers, his masters from whom he caught fire, and even his own images. There is always, eventually, the

"moment of truth." Your straight photographer faces his "moment of truth" constantly; there is nothing to hedge behind. There is only himself, a flexible instrument called a camera, with changes of lenses, filters, and films; and reality. And he has usually less than an instant to work in. The terrible pull of world events can indeed kill the journalist, blow him up or imprison him, but the average dedicated photographer just tries to face his environment, to face up to what he or she is or is not. Or what the environment is or is not.

There are two other "moments of truth" in photography: first, when you examine your developed negative. Did you think it through? Have you what you hoped to have? Have you yet the discipline and the compassion and the insight? Stieglitz said, "When I make a photograph, I make love." And that is true. But if you don't know enough to get your love into the negative, you will not have the next magic "moment"—when you see your image coming up as a print in the developer. And that is magic. Then you set to work to see how much more revealing you can make your print. Adams, the old musician, says, "The negative is the score. The print is the performance."

The highlights become the flutes and violins, the blacks and the big horns and the drums, the woodwinds all the delicate, intermediate passages. You can achieve cymbals, too, and choirs. But this music is, so far, better done in sequences, in exhibitions, books, or movies. The portfolios can be a great experience but only if still in sequence. For the photographs, while individually of a depth to last a lifetime, are like a single theme or passage from your music, your experience; if by a Stieglitz, Strand, Weston, Adams, or others of equal impact, it doubtless holds multiple melodies and dissonances, and you will rediscover it everyday. It sings to you always a different song.

Photography for the photographer is a deeply religious experience, and it does not matter what your religion may be—Buddhist, Muslim, Zen, Roman Catholic, Jewish, one of the many Protestant sects, atheist, or tribal—when that still small voice speaks to you or you hear visually that voice of thunder, then you know. And you know what you have to do. And then, perhaps, you understand what Stieglitz said, and let us hope you can even hear him thunder— *"Photography is my passion; the search for truth my obsession."*

Commissioned by the *Record of the Art Museum, Princeton University,* 1970, unpublished.

BIBLIOGRAPHY

ARTICLES

Wynne, Nancy (Nancy Newhall). "Against Iconoclasm." *Magazine of Art*, March 1937, p. 136.

Review of *Wood Engraving of the 1930s*, by Clare Leighton. *Magazine of Art*, April 1937, pp. 251-52.

"Géricault's Riderless Horses: The Evolution of an Unpainted Masterpiece." *Magazine of Art*, April 1938, p. 209.

"In the Studio of Leon Kroll." *The London Studio*, April 1938, pp. 202-05.

With Beaumont Newhall. "Horatio Greenough, Herald of Functionalism." *Magazine of Art*, January 1939, pp. 12-15.

"Television and the Arts." *Parnassus*, January 1940, pp. 37-38.

"What is Pictorialism?" *Camera Craft*, November 1941, pp. 653-63.

"Painter or Color Photographer?" *U.S. Camera*, February 1941, p. 42.

"P. H. Emerson." *The Complete Photographer*, April 30, 1942, pp. 1484-88. Reprinted, slightly condensed, in: *The Encyclopedia of Photography*. Edited by Willard D. Morgan. New York: Greystone Press, 1964, pp. 1254-57.

"H. P. Robinson." *The Complete Photographer*, January 20, 1943, pp. 3150-53. Reprinted in: *The Encyclopedia of Photography*, pp. 3258-60.

"Eliot Porter: Birds in Color." *Bulletin of the Museum of Modern Art* 10, 4 (1943): 6-7.

"Helen Levitt's Photographs of Children." *Bulletin of the Museum of Modern Art* 10, 4 (1943): 8-9.

"Four Photographs." *Magazine of Art*, May 1943, pp. 180-83.

"Photography Center." *Bulletin of the Museum of Modern Art* 11, 2 (1943), unpaged.

Statement on the photographic collection of the Museum of Modern Art. *Art in Progress: A Survey*. New York: *Museum of Modern Art*, 1944, p. 148.

"The Need for Research in Photography." *College Art Journal* 4 (1945): 203-06.

Review of *Born Free and Equal*, by Ansel Adams. *Photo-Notes*, June 1946, unpaged.

"Alfred Stieglitz." *Photo-Notes*, August 1946, pp. 3-5. Reprinted in *Stieglitz Memorial Portfolio 1864-1946*. Edited by Dorothy Norman. New York: Twice a Year Press, 1947.

Review of *The Inhabitants*, by Wright Morris. *Photo League Bulletin*, November 1946, p. 2.

"Brett Weston." *Photo-Notes*, May-June 1947, pp. 3-4.

"Ben Shahn." *Photo-Notes*, November 1947, p. 3.

"Alfred Stieglitz." *Formes et Couleurs* 9, 6 (1947), unpaged. In French.

"Emerson's Bombshell." *Photography*, Winter 1947, p. 50.

"The Photo League—A Perspective." *This is the Photo League*. New York: The Photo League, 1948, unpaged.

"Brett Weston: An Introduction." *White Sands*, Portfolio of 10 Original Photographs, by Brett Weston. San Francisco: Grabhorn Press, 1950. Reprinted, in revised form, in: *Brett Weston, Photographs*. Exhibition catalogue, Amon Carter Museum, Fort Worth, Texas, January 27-March 20, 1966, pp. 1-4. Also reprinted in: *Photography*, June 1961, pp. 44-55. Excerpted in: *Program of the Boston Symphony Orchestra*, 74th Season, No. 3 (October 29-30, 1954), pp. 99-100.

Review of *My Camera in Yosemite Valley*, by Ansel Adams. *Magazine of Art*, December 1950, p. 309.

"Journey into Childhood," review of *Summer's Children*, by Barbara Morgan. *Popular Photography*, October 1951, pp. 146-47.

"Edward Weston and the Nude." *Modern Photography*, June 1952, p. 38.

"The Caption: The Mutual Relation of Words/Photographs." *Aperture*, 1, 1 (1952): 17-29.

With Ansel Adams. "Canyon de Chelly National Monument...Arizona." *Arizona Highways,* June 1952, pp. 18-27.

"Sunset Crater National Monument...Arizona." *Arizona Highways,* July 1952, p. 3.

"The Shell of Tumacacori." *Arizona Highways,* November 1952, pp. 5-13.

"Controversy and the Creative Concepts, part 1." *Aperture* 2, 2 (1953): 3-13.

"Paul Strand: Letters from France and Italy." *Aperture* 2, 2 (1953): 16-24. (With note on Paul Strand by Nancy Newhall.)

With Ansel Adams. "Death Valley." *Arizona Highways,* October 1953, pp. 16-34. Reprinted, in condensed form, in: *Catholic Digest,* December 1953, pp. 67-70.

"Paul Strand: A Commentary on His New Work." *Modern Photography,* September 1953, p. 46.

"Edward Weston: He Discusses Color as Form." *Modern Photography,* December 1953, p. 54.

"Nancy Newhall Comments [on Edward Weston's discussion of color as form]. *"Modern Photography,"* December 1953, p. 59.

With Ansel Adams. "Organ Pipe Cactus National Monument." *Arizon Highways,* January 1954, pp. 8-17.

"Mission San Xavier del Bac." *Arizona Highways,* April 1954, pp. 13-35.

"This is the American Earth." *Aperture* 3, 2 (1955): 28-32. (Excerpts from the exhibition designed by Nancy Newhall for the Sierra Club in 1955.)

"Brassaï: Je ne découvre rien, j'imagine tout."/ Brassaï: I Invent Nothing, Imagine Everything." *Camera,* May 1956, pp. 185-215. In French and English.

"Ansel Adams." *Photokina 1956.* Catalogue of the Photokina exhibit, Cologne, Germany, 1956, pp. 170-72.

"A Great Photographer Dies: Edward Weston, 1886 -1958." *Modern Photography,* April 1958, p. 94.

"Epicure Corner [E.C.]: Clam Soup Nita." *Brighton Pittsford Post* [B.P.P.], February 5, 1959, p. 5.

"E.C.: Roast Leg of Lamb Rundel." *B.P.P.,* February 12, 1959, p. 9.

"E.C.: Gravy." *B.P.P.,* February 19, 1959, p. 5.

"E.C.: Roast Chicken with Tarragon." *B.P.P.,* July 9, 1959, p. 9.

"E.C.: New England Clam Chowder." *B.P.P.,* December 17, 1959, p. 9.

"E.C.: Onion Soup." *B.P.P.,* December 31, 1959, p. 5.

"E.C.: Moussaka." *B.P.P.,* September 15, 1960, p. 6.

Introduction. *A Portfolio of Sixteen Photographs by Alvin Langdon Coburn.* Rochester, New York: George Eastman House, 1962, pp. 3-18.

With Ansel Adams. "Sanctuary in Adobe." *American Heritage,* April 1962, pp. 68-75.

"Mary Austen's Country." *Arizona Highways,* April 1968, pp. 2-9.

"Paul Strand, Catalyst and Revealer." *Modern Photography,* August 1969, pp. 70-75.

"Ansel Adams, Brilliant Recorder of Nature's Magnificence." *Modern Photography,* September 1969, p. 66.

"Praise and Questions for *The Woman's Eye:* 'Magnificent',," review of *The Woman's Eye,* by Anne Tucker. *Afterimage,* March 1974, pp.8-9.

BOOKS AND CATALOGUES

Paul Strand: Photographs, 1915-1945. New York: Museum of Modern Art, 1945.

The Photographs of Edward Weston. New York: Museum of Modern Art, 1946.

With Paul Strand. *Time in New England.* New York: Oxford University Press, 1950.

With Ansel Adams. *Death Valley.* San Francisco: 5 Associates, 1954.

Mission San Xavier del Bac. San Francisco: 5 Associates, 1954.

The Pageant of History in Northern California. San Francisco: The American Trust Company, 1954.

A Contribution to the Heritage of Every American: The Conservation Activities of John D. Rockefeller, Jr. New York: Alfred A. Knopf, 1957.

ed. *Edward Weston, Photographer. Aperture* 6, 1 (1958).

With Beaumont Newhall. *Masters of Photography.* New York: George Braziller, 1958.

ed. *Yosemite Valley,* by Ansel Adams. San Francisco: 5 Associates, 1959.

Words of the Earth, by Cedric Wright. San Francisco: Sierra Club, 1960.

With Ansel Adams. *This Is the American Earth.* San Francisco: Sierra Club, 1960.

ed. *The Daybooks of Edward Weston. Volume 1, Mexico,* and *Volume II, California.* Rochester, New York: George Eastman House, in collaboration with Horizon Press, 1961-63.

BIBLIOGRAPHY

ARTICLES

Wynne, Nancy (Nancy Newhall). "Against Iconoclasm." *Magazine of Art,* March 1937, p. 136.

Review of *Wood Engraving of the 1930s,* by Clare Leighton. *Magazine of Art,* April 1937, pp. 251-52.

"Géricault's Riderless Horses: The Evolution of an Unpainted Masterpiece." *Magazine of Art,* April 1938, p. 209.

"In the Studio of Leon Kroll." *The London Studio,* April 1938, pp. 202-05.

With Beaumont Newhall. "Horatio Greenough, Herald of Functionalism." *Magazine of Art,* January 1939, pp. 12-15.

"Television and the Arts." *Parnassus,* January 1940, pp. 37-38.

"What is Pictorialism?" *Camera Craft,* November 1941, pp. 653-63.

"Painter or Color Photographer?" *U.S. Camera,* February 1941, p. 42.

"P. H. Emerson." *The Complete Photographer,* April 30, 1942, pp. 1484-88. Reprinted, slightly condensed, in: *The Encyclopedia of Photography.* Edited by Willard D. Morgan. New York: Greystone Press, 1964, pp. 1254-57.

"H. P. Robinson." *The Complete Photographer,* January 20, 1943, pp. 3150-53. Reprinted in: *The Encyclopedia of Photography,* pp. 3258-60.

"Eliot Porter: Birds in Color." *Bulletin of the Museum of Modern Art* 10, 4 (1943): 6-7.

"Helen Levitt's Photographs of Children." *Bulletin of the Museum of Modern Art* 10, 4 (1943): 8-9.

"Four Photographs." *Magazine of Art,* May 1943, pp. 180-83.

"Photography Center." *Bulletin of the Museum of Modern Art* 11, 2 (1943), unpaged.

Statement on the photographic collection of the Museum of Modern Art. *Art in Progress: A Survey.* New York: *Museum of Modern Art,* 1944, p. 148.

"The Need for Research in Photography." *College Art Journal* 4 (1945): 203-06.

Review of *Born Free and Equal,* by Ansel Adams. *Photo-Notes,* June 1946, unpaged.

"Alfred Stieglitz." *Photo-Notes,* August 1946, pp. 3-5. Reprinted in *Stieglitz Memorial Portfolio 1864-1946.* Edited by Dorothy Norman. New York: Twice a Year Press, 1947.

Review of *The Inhabitants,* by Wright Morris. *Photo League Bulletin,* November 1946, p. 2.

"Brett Weston." *Photo-Notes,* May-June 1947, pp. 3-4.

"Ben Shahn." *Photo-Notes,* November 1947, p. 3.

"Alfred Stieglitz." *Formes et Couleurs* 9, 6 (1947), unpaged. In French.

"Emerson's Bombshell." *Photography,* Winter 1947, p. 50.

"The Photo League—A Perspective." *This is the Photo League.* New York: The Photo League, 1948, unpaged.

"Brett Weston: An Introduction." *White Sands,* Portfolio of 10 Original Photographs, by Brett Weston. San Francisco: Grabhorn Press, 1950. Reprinted, in revised form, in: *Brett Weston, Photographs.* Exhibition catalogue, Amon Carter Museum, Fort Worth, Texas, January 27-March 20, 1966, pp. 1-4. Also reprinted in: *Photography,* June 1961, pp. 44-55. Excerpted in: *Program of the Boston Symphony Orchestra,* 74th Season, No. 3 (October 29-30, 1954), pp. 99-100.

Review of *My Camera in Yosemite Valley,* by Ansel Adams. *Magazine of Art,* December 1950, p. 309.

"Journey into Childhood," review of *Summer's Children,* by Barbara Morgan. *Popular Photography,* October 1951, pp. 146-47.

"Edward Weston and the Nude." *Modern Photography,* June 1952, p. 38.

"The Caption: The Mutual Relation of Words/Photographs." *Aperture,* 1, 1 (1952): 17-29.

With Ansel Adams. "Canyon de Chelly National Monument...Arizona." *Arizona Highways,* June 1952, pp. 18-27.

"Sunset Crater National Monument...Arizona." *Arizona Highways,* July 1952, p. 3.

"The Shell of Tumacacori." *Arizona Highways,* November 1952, pp. 5-13.

"Controversy and the Creative Concepts, part 1." *Aperture* 2, 2 (1953): 3-13.

"Paul Strand: Letters from France and Italy." *Aperture* 2, 2 (1953): 16-24. (With note on Paul Strand by Nancy Newhall.)

With Ansel Adams. "Death Valley." *Arizona Highways,* October 1953, pp. 16-34. Reprinted, in condensed form, in: *Catholic Digest,* December 1953, pp. 67-70.

"Paul Strand: A Commentary on His New Work." *Modern Photography,* September 1953, p. 46.

"Edward Weston: He Discusses Color as Form." *Modern Photography,* December 1953, p. 54.

"Nancy Newhall Comments [on Edward Weston's discussion of color as form]. *"Modern Photography,"* December 1953, p. 59.

With Ansel Adams. "Organ Pipe Cactus National Monument." *Arizon Highways,* January 1954, pp. 8-17.

"Mission San Xavier del Bac." *Arizona Highways,* April 1954, pp. 13-35.

"This is the American Earth." *Aperture* 3, 2 (1955): 28-32. (Excerpts from the exhibition designed by Nancy Newhall for the Sierra Club in 1955.)

"Brassaï: Je ne découvre rien, j'imagine tout."/ Brassaï: I Invent Nothing, Imagine Everything." *Camera,* May 1956, pp. 185-215. In French and English.

"Ansel Adams." *Photokina 1956.* Catalogue of the Photokina exhibit, Cologne, Germany, 1956, pp. 170-72.

"A Great Photographer Dies: Edward Weston, 1886 -1958." *Modern Photography,* April 1958, p. 94.

"Epicure Corner [E.C.]: Clam Soup Nita." *Brighton Pittsford Post* [B.P.P.], February 5, 1959, p. 5.

"E.C.: Roast Leg of Lamb Rundel." *B.P.P.,* February 12, 1959, p. 9.

"E.C.: Gravy." *B.P.P.,* February 19, 1959, p. 5.

"E.C.: Roast Chicken with Tarragon." *B.P.P.,* July 9, 1959, p. 9.

"E.C.: New England Clam Chowder." *B.P.P.,* December 17, 1959, p. 9.

"E.C.: Onion Soup." *B.P.P.,* December 31, 1959, p. 5.

"E.C.: Moussaka." *B.P.P.,* September 15, 1960, p. 6.

Introduction. *A Portfolio of Sixteen Photographs by Alvin Langdon Coburn.* Rochester, New York: George Eastman House, 1962, pp. 3-18.

With Ansel Adams. "Sanctuary in Adobe." *American Heritage,* April 1962, pp. 68-75.

"Mary Austen's Country." *Arizona Highways,* April 1968, pp. 2-9.

"Paul Strand, Catalyst and Revealer." *Modern Photography,* August 1969, pp. 70-75.

"Ansel Adams, Brilliant Recorder of Nature's Magnificence." *Modern Photography,* September 1969, p. 66.

"Praise and Questions for *The Woman's Eye:* 'Magnificent',," review of *The Woman's Eye,* by Anne Tucker. *Afterimage,* March 1974, pp.8-9.

BOOKS AND CATALOGUES

Paul Strand: Photographs, 1915-1945. New York: Museum of Modern Art, 1945.

The Photographs of Edward Weston. New York: Museum of Modern Art, 1946.

With Paul Strand. *Time in New England.* New York: Oxford University Press, 1950.

With Ansel Adams. *Death Valley.* San Francisco: 5 Associates, 1954.

Mission San Xavier del Bac. San Francisco: 5 Associates, 1954.

The Pageant of History in Northern California. San Francisco: The American Trust Company, 1954.

A Contribution to the Heritage of Every American: The Conservation Activities of John D. Rockefeller, Jr. New York: Alfred A. Knopf, 1957.

ed. *Edward Weston, Photographer. Aperture* 6, 1 (1958).

With Beaumont Newhall. *Masters of Photography.* New York: George Braziller, 1958.

ed. *Yosemite Valley,* by Ansel Adams. San Francisco: 5 Associates, 1959.

Words of the Earth, by Cedric Wright. San Francisco: Sierra Club, 1960.

With Ansel Adams. *This Is the American Earth.* San Francisco: Sierra Club, 1960.

ed. *The Daybooks of Edward Weston. Volume 1, Mexico,* and *Volume II, California.* Rochester, New York: George Eastman House, in collaboration with Horizon Press, 1961-63.

Ansel Adams, Photographs, 1929-1963: The Eloquent Light. Exhibition catalogue, M. H. deYoung Museum, San Francisco, California, 1963.

Ansel Adams. Volume I, The Eloquent Light. San Francisco: Sierra Club, 1963.

ed. *Edward Weston, Photographer: The Flame of Recognition.* Rochester, New York: Aperture, 1965, and *Aperture* 12, 1 and 2 (1965). Reprinted, in revised and expanded form: Grossman, 1971.

ed. *"A More Beautiful America..." The President Speaks: Excerpts from Speeches by Lyndon B. Johnson.* New York: American Conservation Association, 1965.

With Beaumont Newhall. *T. H. O'Sullivan: Photographer.* Rochester, New York. George Eastman House, 1966.

With Ansel Adams. *Fiat Lux: The University of California.* New York: McGraw-Hill, 1967.

With Beaumont Newhall and Ansel Adams. *Twelve Days at Santa Cruz.* Workshop project, Images and Words Workshop, University Extension, University of California, Santa Cruz, June 26-July 8, 1967.

With Beaumont Newhall, Ansel Adams, Adrian Wilson and Pirkle Jones. *Project FIND in Santa Cruz County, California.* Workshop project, Images and Words Workshop. University of California, Santa Cruz, July 1-13, 1968.

With Beaumont Newhall. *A Collection of Photographs.* New York: Aperture, 1969, and *Aperture* 14, 2 (1969).

With Ansel Adams. *The Tetons and the Yellowstone.* Redwood City, California: 5 Associates, 1970.

P. H. Emerson: The Fight for Photography as a Fine Art. Millerton, New York: Aperture, 1975.

PICTURE CREDITS

INDEX

Action photography, 2
Adams, Ansel, 11
 book work, 13; on contemporary art, 13; love of
 the West, 13; MOMA and, 110; as musician, 12;
 Stieglitz and, 102, 151; White and, 93
Albright Show, 1910, 105
Allan, Sidney, on Coburn, 27
America
 Stieglitz on, 65, 67, Weston and industrial, 80
American Amateur Photographers, 65, 105
America and Alfred Stieglitz, 100, 115
American(s)
 camera variety of, 5; as documentarians, 5;
 photojournalism, *Life* and, 4; photojournalists as
 purists, 4; print concern, 8
An American Place, 68, 105
Annan, J. Craig, work of, 28
Aperture, 95, 159
Armitage, Merle, 83, 91
Art of Edward Weston, The, 83, 91
Atget, Paris photos of, 18
Autochrome, introduction of, 31

Banthélemy, Victor, Paris photos of, 18
Book of Harlech, The, Coburn and, 43
Book(s)
 Coburn photographs in, 31; photography, 158
Bourke-White, Margaret, *Life* and, 4
Brandt, Bill, European philosophy of, 4
Brassaï, 16
 cinema work, 21; European philosophy, 4;
 Kertész andi photography introduction, 19;
 Paris de Nuit and, 19; Paris photos, 18; photos,
 theatrical use of, 20; personality, 20; room, 18;
 techniques, 20
Brett Weston Photographer, 91

Caffin, Charles, Stieglitz and, 106
California and the West, 85
Cameron, Julia Margaret, work of, 52
Candid photos, Strand and first, 73, 75
Captions, 135
Camera(s)

American multiple, 5; big, 2; miniature, 148; as
 part of photographer, 2; 35-mm, impact of, 2;
 view, ideas about, 2
Camera Club of New York
 Stieglitz and, 65; Strand and, 72
Camera Notes, Stieglitz and, 67, 119
Camera Work, 26, 27, 6, 119
Cartier-Bresson, Henri, 1
 people as subject for, 3; photography style, 2;
 show prints, 3; on texture, 3
Chavez, Carlos, Strand and, 76
Children, Levitt photography of, 60
Clement, Edith, Coburn marriage to, 38
Cloud, The, Coburn edition of, 38
Coburn, Alvin Langdon, 21
 abstraction and, 42; American authors and, 29; on
 beauty, 44, 45; *The Book of Harlech* and, 43;
 book illustrations of, 35, 39; break with tradition
 by, 40; broadcasts of, 46; *Camera Work* and, 27;
 Century Magazine and, 29; *The Cloud* and, 38;
 color work of, 31; Day as mentor for, 25; in
 Edinburgh, 28; focus ideas, 38; Henry Hames
 and, 29, 32; Japanese art and, 26; literary portraits
 by, 27; magazine work of, 301; marriage of, 38;
 Men of Mark, 38; George Meredith and, 28;
 More Men of Mark, 39, 43; music and, 39; mysti-
 cism and, 44; *"Old Masters of Photography,"* 39;
 Orient and, 24; "Photograms" and, 40;
 photogravure and, 35; and Photo-Secession, 26;
 place interpretations of, 26; as portraitist, 27, 28,
 29; Ezra Pound and, 39; Royal Photographic
 Society and, 30, 44, 45, 47; G. B. Shaw and, 30,
 36; shows of, 26, 34, 47; Steichen and, 25;
 Stieglitz and, 26; success of, 34; techniques of,
 25; theatre work of, 35; Vortex movement and,
 40; H. G. Wells and, 29; Western photos of, 36
Color work, start of, 31

Daumier, Paris and, 18
Day, F. Holland, as Coburn mentor, 24
Demachy, Robert, Coburn and, 25
Differential focusing, Emerson and, 54

Documentarians, 5, 148
Dow, Arthur, Coburn and, 26
"The Dumping Ground," Coburn and, 25

Eastman. *See* George Eastman House.
Editor, role of the, 5
Eisenstaedt, Alfred
 Life and, 4; narrative photography of, 2
Emerson, Peter Henry, 50, 53
 books by, 55, 56, 58; changes in, 57; differential
 focusing of, 54; on nature, 53; photogravure and,
 28; subjects, 54; success, 55
En Passant, Brassaï photos and, 20
Equivalents, The
 for the MOMA Collection, 108; Stieglitz and, 68,
 106
Europe, photography in, 1
European(s)
 people as subjects for, 3; photo journalists, 1
Evans, Frederick, Coburn and, 25, 27
Evans, Walker, 5
Exhibition prints, 3

Fenallosa, Ernest, Coburn and, 24
50th Anniversary Portfolio, Weston, 91
Films, Strand work in, 76
Film and Photography League, 61
Focus, Coburn ideas on, 38
Friends of Photography, 159
Frontier Films, Strand and, 76
Fugett, Dalett, Stieglitz and, 109

Gaspé, Strand work in the, 75, 76
George Eastman House, 95, 157
Gordon, D. J., Coburn exhibit by, 47
Goupil Gallery, Coburn show at, 34, 37
Grossman, Sid, Photo-League and, 61
Group f-64, 4, 9, 84, 148
Guggenheim fellowships, Weston, 84, 89

Hartmann, Sadakichi. *See* Allan, Sidney.
Halász, Gyula. *See* Brassaï.
Helmholtz on images, 53, 54
Hine, Lewis, Strand influenced by, 71

Image of Freedom competition, 93
International Museum of Photography, George
 Eastman House, 157
Intimate Gallery, Stieglitz and, 68, 109

Käsebier, Gertrude, 26, 119
Keiley, Joseph, Photo-Secession and, 30
Kertész, André, Brassaï and, 19

Lake George House, Stieglitz and, 110
Landscapes
 Strand, 75
 Weston, 82
Lange, Dorothea, 5
Leaves of Grass, Weston photos for, 85
Le Randez-Vous, Brassaï photos and, 20
Levitt, Helen, 60
Libsohn, Sol, Photo-League and, 61
Life, American photojournalism and, 4, 5
Light
 Adams use of, 12; Weston use of, 7
Linked Ring, formation of, 58
"Little Galleries of the Photo-Secession, The," 30, 67
Lumière Brothers, color process of, 31

Making a Photograph, 103, 152
Man Ray, reality and, 2
Marin, John, Stieglitz and, 101
Mass-production seeing, photography as,
 9, 85
MacAlpin, David, as collector, 153
Men of Mark, 38
Mexico
 Strand work in, 75, 76; Weston in, 81
Miller, Henry, Brassai and, 19, 20
Modotti, Tina, Weston influenced by, 80, 81
Moholy-Nagy, trick photography and, 2
MOMA
 Adams and, 110; Department of Photography,
 155, 158; early years of, 150; Equivalents shown
 at, 108; photography show, first, 153
Montross Galleries, Coburn show at, 37
More Men of Mark, 39
Museum of Modern Art. *See* MOMA.
Museums, photography and, 157

Native Land, Strand film, 76
Naturalistic Photography, 56, 58
Nature
 Emerson on, 53; photos, Strand, 74
New School of American Photography, The, 25
Newton, Sir William, on photography, 51
"New Vision," 2
New York the Magnificent, film, 74
New York, 1910, 35
New York: Twelve Photographs, 1949, 90
Norman, Dorothy, 100, 113

O'Keeffe, Georgia, Stieglitz and, 68, 116
"Old Masters of Photography," 39

Painting and photography, 2, 50
Paris de Nuit, 8

Paris, photos of, 1, 18
Phedre, Brassaï photos and, 20
"Photograms," Coburn and, 40
Photographer, cameras as part of, 2
Photographic Historical Society, 159
Photographs and words, relationship of, 135
Photography
 as art, 145; books, 158; commercial, 147; in
 Europe, 1; as mass-production seeing, 9, 85;
 museums and, 156; and painting, 2, 51; schools,
 147
Photogravure, 28, 35
Photojournalist(s)
 Cartier-Bresson as, 1; European, 1; as purists,
 American, 4
Photo-League, The, 61, 64
Photo-Notes, 63
Photo-Secession, 26
 Buffalo show of, 36; Coburn and, 70; Stieglitz
 and, 67, 118; Strand and, 71
Pictorialists, 2, 25, 39
Portraiture
 Coburn and, 27; Weston and, 7
Prints, printing, 3
 American concern for, 8; papers for, 75;
 Weston and, 83

Reality
 Man Ray and, 2; Strand and, 72
Reproductions, Stieglitz and, 118
Rivera, Diego, Weston and, 81
Robinson, Henry Peach, work of, 50, 52
Rodin, Coburn and, 31
Royal Photographic Society, Coburn and, 30, 44, 45,
 47

Salomon, Adam, work of, 52
Salomon, Erich, people subjects of, 2
San Francisco photographers, 1
Shaw, G. B., Coburn and, 28, 30, 36
Sheeler, Charles, Strand and, 74
Shell photos, Weston, 82, 83
Shore, Henrietta, Weston and, 82
Sierra-Nevada: The John Muir Trail, 103
Society for Photographic Education, 159
Soft-focus photography, 51, 52
Space Analysis, White and, 95
Speed, concern about, 3
Stackpole, Peter, 4
Steichen Eduard
 Coburn and, 25; color work of, 31; MOMA and,
 158; personal life of, 121; Stieglitz and, 118
Stieglitz, Alfred, 65
 Adams and, 102, 151; *American Amateur*

Photographer, 65, 105; Caffin and, 106; Camera
Club of New York and, 65; camera magazines
and, 119; *Camera Notes* and, 67; *Camera Work*
and, 67; Coburn and, 26; Emerson and, 55;
Equivalents and, 68, 106, 108; family life, 124;
galleries, 68; ideas on America, 65, 67; The
Intimate Gallery and, 109; Käsebier and, 119;
Lake George House and, 110; Little Galleries of
the Photo-Secession and, 67; Marin and, 101;
Dorothy Norman and, 113; Notes for a
Biography of, 97; O'Keeffe and, 68, 116; person-
ality of, 98; philosophy of, 65; Photo-Secession
and, 67, 118; reproductions and, 118; Steichen
and, 118; Strand and, 72, 73, 114, 130; "291"
and, 67; Weston and, 7; Whitney Museum and,
111
Strand, Paul, 71
 Camera Club and, 72; candid photos of, 73, 75;
 Chavez and, 76; commercial photography of, 72;
 first show, 73; Frontier Films and, 76; Gaspé
 work of, 75, 76; influence of, 73; influences on,
 71; landscapes, 74, 75; Mexico work, 75, 76;
 movie work, 74, 76; nature photos, 74; New York
 City scenes, 73; printing papers and, 75; reality
 and, 72; Sheeler and, 74; Stieglitz and, 72, 73,
 107, 114, 130; *Time in New England,* 107
Subject interpretation, *Life* and, 5
Szarkowski, John, at MOMA, 158

Techniques, concern for, 3
This Is the American Earth, 108
Time in New England, 107
Trick photography, Moholy-Nagy and, 2
20 Photographs of Mexico, 76
"291"
 end of, 123; shows at, 31, 34; Stieglitz and, 67

View cameras, ideas about, 2
Vortescope, Coburn and, 41
Vortographs, Coburn and, 40

Wave, The, Strand film, 76
Weber, Max, Photo-Secession show and, 36
Wells, H. G. Coburn and, 29, 35
West
 Adams love of the, 13; Coburn photos of, 36
Weston, Brett, 87
 Armitage and, 91; army career of, 89;
 Guggenheim Fellowship, 89; in Mexico, 81;
 portfolios, 92; painting and, 90; techniques, 87;
 See also Weston, Edward.
Weston Edward, 6, 79
 Armitage and, 83; Brett and, 84; changes in work
 of, 80, 84; children photos, 80; exhibitions, 83;

family, 79; followers, 84; Guggenheim
Fellowship, 84; industrial America and, 80; inter-
pretations of works of, 10; landscapes, 82; light
use by, 7; mass-production seeing and, 9; in
Mexico, 81; portraiture, 7; print verity of, 83; as
purist, 9; Rivera and, 81; shell photos, 82, 83;
Shore influence on, 82; Stieglitz and, 7; subject
variety of, 85; techniques of, 8. *See also* Weston,
Brett.
White, Clarence, 4, 26
White, Minor, 93
Adams and, 93; at George Eastman House, 95;
museum training of, 93; space analysis and, 95;
teaching career of, 95
White Sands, 90
Whitney Museum, Stieglitz and, 111
Words and photographs, relationship of, 135
Writers, Coburn portraiture of, 39